The Herbert History of
ART AND ARCHITECTURE

EARLY CHRISTIAN AND BYZANTINE

Irmgard Hutter

Foreword by Otto Demus

The Herbert Press

Published in Great Britain 1988 by
The Herbert Press Ltd, 46 Northchurch Road, London N1 4EJ

Copyright © Chr. Belser, Stuttgart
English translation © 1971 by
George Weidenfeld & Nicolson Ltd, London

Translated by Alistair Laing

Printed and bound in Hong Kong by South China Printing Co.

A CIP catalogue record for this book is available
from the British Library.

ISBN 0-906969-91-3

CONTENTS

FOREWORD

The greatness of the art of the Eastern Empire and its significance for the West, long misjudged, are now being gradually assessed at their true worth. For this we must thank not only the specialists in Byzantine art history who, for two generations, have devoted themselves to a better understanding of their subject, but also those scholars in other fields—theology, literature, and history—who have illuminated and interpreted Byzantine art. Because of their labors, Byzantine art is no longer the jealously guarded preserve of Byzantinists but, in the context of European and oriental art, can and must be seen as the great connection between classical antiquity and the medieval world. Yet Byzantine art not only preserved classical forms and constantly revived them but also handed on oriental forms to the West. The development of these Eastern forms resulted from a choice of only those that lent themselves to fusion with the classical tradition. Thus, with respect to the West, Byzantium worked, above all, as a filter against that which could not be assimilated.

Rooted in Greece and the Orient, with prestigious political backing, Byzantine art, even after satisfying the early pictorial hunger of new, still barbarian peoples, inevitably made an overpowering impression on the West. The magisterial perfection of its techniques was only one of the qualities that assured its primacy. Some of these techniques—notably mosaic and cloisonné—were eagerly imitated, yet long remained a Byzantine monopoly; others, such as panel painting, became the basis for vital developments. The icon is the root-form of the European picture; in the political and religious spheres, its traditional subject matter long satisfied the needs of the West. Here, in easily adaptable compositions, were the models for everything the Western world needed—on every scale, from the monumental to the miniature, from the portrait of a ruler to scenes from the Passion. All these formulas had a public, almost impersonal character; they were both solemn and neutral—and, for that very reason, generally applicable. The very weaknesses of this art—its dryness and lack of humor, its moderation, excluding both strong emotion and the grotesque—only reinforced its effect on the West.

This book depicts the nature of Byzantine art and traces the principal lines of its development. The works that illustrate it have been chosen for their importance, not for their singularity. Thus, a balanced representation of Byzantine art and of its successor, Early Christian art, has been achieved—a representation that will, we hope, long preserve their validity.

<div align="right">Otto Demus</div>

INTRODUCTION

The earliest Christian art stems from a time when the Roman Empire was threatened with decay from within and from without. The political, administrative, economic, and military reforms that Diocletian (284–305) introduced and Constantine (306/24–337) completed insured the continuance of the empire but also converted it into a centralized autocracy—an autocracy that gradually dissolved the old Roman social order and introduced the Byzantine. The crucial dates of this period are marked by acts of Constantine: the official recognition of Christianity in 313, after the victory of the Mulvian Bridge over his co-emperor Maxentius, and the founding of Constantinople in 324, after the institution of the Universal Monarchy (dedication, 330). The Christian religion, which, like countless other salvationist Eastern faiths, had swept the West in the chaos of the 3d century, had two advantages over them: the exclusivity of its monotheistic claim to rule the world and an episcopal constitution whose hierarchical organization was modeled on Rome. To bind this religious cadre to the state, to invigorate the collapsing ancient order with the social and spiritual forces of Christianity, and to imbue the emperor with the divinity pertaining to God's earthly representative were the objects of Constantine's politico-religious decision to accept Christianity. The Council of Nicaea (325), the first of the ecumenical councils (the others were Constantinople, 381; Ephesus, 431; Chalcedon, 451) which in the wake of bitter religious factionalism laid down the dogmatic basis of the Christian faith, met under him. Tenacious pagan opposition was ended when Theodosius I (379–95) established orthodox Christianity as the sole state religion.

The founding of the new capital in the East, Constantinople, in the old Greek colony of Byzantium on the Bosporus—an ideal strategic and commercial situation—correponded to the new confrontation: The city would resist the incessant thrust of Germanic peoples from the north and the Sassanic Persians from the east. Despite catastrophic defeats, the Eastern Empire survived this century-long struggle for its existence—thanks to the greater economic reserves of the rich Eastern provinces and to its subtle policy of alliance, by which the Germanic elite was assimilated into Roman civilization—while the Western Empire simply went under in the flood of Germanic invasions. By the 4th century, despite the consciously refined and developed level of its pagan aristocratic culture, Rome had in large measure lost its prominence. After the division of the empire in 305, Milan became the capital of the emperor Honorius, until in 404 it lost this position to the secure naval base

Ravenna. In 410, Rome was taken for the first time, and Africa and the western provinces were lost. After 476, Germanic kings ruled in Italy, of whom Theodoric, king of the Goths (493–526), was the most imbued with (East) Roman culture. Only the might of the papacy preserved the significance of Rome for the West.

Rome's real heir was Constantinople, the "New Rome." Modeled on Rome in layout, in the splendor of its public buildings and its imported statues, possessing the same privileges and partially settled with Romans, Constantinople stood visibly in line of descent from the old Rome. But at the same time it was destined to be utterly different: Constantinople was founded as a Christian city; it was established in a Greek-speaking territory of Greek-Hellenistic culture. In the course of the 5th and 6th centuries, Greek replaced Latin as the language of the empire. In the university, founded in 425, classical Greek philosophy, poetry, and science had for centuries an important center of influence. The other Hellenistic cities as well—above all Antioch and Alexandria, until their fall—preserved their classical tradition, which also immensely enriched the Christian religion. Greek philosophy molded the minds of the great church fathers, who were striving for the true knowledge of God, teaching and defending their faith with verbal and spiritual power. Thus, the transfer of the center of the empire to Constantinople was a visible expression of the comprehensive transformation that took place in the late classical world, a transformation that carried the Roman Imperium over into the Christian Byzantine empire.

Christian art is appreciably more recent than Christianity itself: For religious reasons, the early church had refused all pictorial representation of its faith, in conscious contrast to pagan idolatry. It also denied itself a specifically sacred edifice, for the church, God's earthly temple, was formed by the body of the faithful, not by a chapel. Only in the 3d century, as more and more pictures were created, which were regarded as instructive support of preaching or as symbolic tokens of the articles of faith, did Christianity gradually develop a positive attitude toward art. Simultaneously, the idea of the sanctity of the place of worship took root, and with it the theological basis of a Christian architecture was laid. Official recognition of Christianity provided the legal preconditions for its development in the early 4th century.

Christian religious architecture is fundamentally different from that of pagan antiquity —that is, from the temple—in that the building is not simply the house of God but also the place of assembly and worship for the community; it includes altar, priests, and the faithful, and is the place of sacrament and prayer, and, with the burgeoning cult of martyrs, the witness of relics. The realization of this idea meant the end of ancient religious architecture but not the total abandonment of the ancient tradition of building. For centuries, in fact, Early Christian architecture made use of building types and forms of antiquity—above all, of those whose significance and function were related to the needs of Christianity (for example, the pagan heroa, or mausoleums for historic or mythical heros, became the prototype for the Christian martyrs' memorials)—but it transmuted their formal structure. In place of the unified building of antiquity, composed of a balanced system of plastic elements, there emerged a vertically oriented building composed of differentiated elements: The classical relationship of load and support yielded to structural organization in terms of

openings and closed surfaces, whose most important feature was the arcade. Artistic emphasis was placed on the interior rather than the exterior. In taking this course, Christian architecture was actually extending a development that had its origin in pagan architecture early in the 3d century, while investing it with a novel sacred significance.

The pressing need of the Christian community for churches brought about many opportunities for building and, consequently, the development of extremely varied types of building. The influence that the demands of the Christian liturgy exerted on the creation of particular layouts—certainly a factor—remains tantalizingly uncertain. The most prominent type of early church was the spacious basilica, a longitudinal structure with aisles and a nave—or central aisle—lit by windows in the walls over the side aisles. The basilica was frequently the seat of a bishop, whose place was with the clergy in the apse (a recess behind the altar), while the nave was reserved for the congregation and the vestibule for the as-yet-unbaptized converts. In the Eastern galleried churches, the upper story (matroneum) was set apart for women.

As long as the rite of baptism took the form of immersion, the baptistery (baptisterium) stood adjacent to the basilica as an independent building. Very numerous in the early centuries were memorial buildings erected on the sites of holy events—these were called memoria and sometimes had a basilica attached—or over the graves of martyrs (martyria). Since, in the West, the bodies of saints were usually buried in the church itself, a special place under the chancel, called the crypt (krypta), evolved. The oldest churches were built so that the priest celebrated the Mass from behind the altar on the west facing east, the direction of Christ's coming on the Last Day. In the 5th century, the orientation of churches was generally adopted.

In the figurative arts, too, a radical transformation took place, as Christian art emerged. At the beginning of the 3d century, official art began to be influenced by artistic ideas that had long been prevalent in Roman folk art and in the art of the Eastern provinces, with its pronounced oriental cast. The rise in importance of these two only lightly Hellenized artistic traditions meant a retreat from the classical principles of antiquity. This transition took place in the entire Roman world, but gradually and with varied pace. On the one hand there were the Greek territories, which clung tenaciously to their Hellenistic traditions; on the other hand there was Rome itself, whose inclination to subjective realism in art was strengthened and affirmed by the new tendencies in the Late Antique period.

The radical change in Late Antique art was in fact a retreat from the classical conception of autonomous, organically articulated forms, free to move in naturalistic space. The surrender of this ideal meant the end of monumental free-standing sculpture, of the kind of relief conceived as a kind of section through a three-dimensional scene, and of the illusion of depth in painting. The human figure was now generally placed frontally before an abstract ground, which robbed its surroundings of measurable depth. In this ambience, a figure became two-dimensional; the suggestion of free movement in space was replaced by static concentration on the surface. This constriction brought with it a loss of realism but also produced a new linear vitality. Closed contours set figure off from ground, and often almost geometric subdivisions organized the surface. Abrupt junctions of angular details

of limbs and clothing and stark juxtapositions of color replaced the smooth transitions of organic modeling. The typical visual effect of Late Antique art is vivid, almost jarring contrast between alternating lights and darks and solid, physically compact forms. Composition was governed by the same abstract linear principles that were applied to the single figure. Symmetry, uniform height (isocephaly), and rhythmic repetition of the same forms rigorously controlled the surface. The center of the painting or relief was accentuated by a central shape or by an empty space, so that the figures were emphatically confronted in dialogue or action. But "action" in this case rarely implied a realistically represented event. The significance of the picture was ordinarily to be inferred from the placement of the figures, their attitudes, their size as differentiated by rank, and from a fixed vocabulary of gestures and attributes. The representational yielded to the symbolic; that is, figures assumed an overriding symbolic function—they pointed beyond their physical existence to greater matters, into which the observer was directly drawn.

Christian art of the 3d century, popular in origin, instantly seized on this new artistic vision, which was to be most radically realized in the highly anti-organic, geometrical, and expressive (though often technically crude) works of art executed around 300 under the Tetrarchy (the arrangement by which the Roman Empire was headed by four co-rulers). (The porphyry statues of the Tetrarchs outside S. Marco in Venice are splendid examples.) By the late Constantinian period, Christian art was developing into a sophisticated art, and by the time of Theodosius I, around 400, the genesis of a unified Christian style was consummated. It was permeated by an exalted spirituality which marks the crucial difference between Early Christian art and the self-fulfilling visual conception of antiquity. The history and character of Early Christian art were determined by two great intellectual tendencies, *traditio* (reliance upon ancient art, much diluted and transformed) and *renovatio* (its conscious revival). The manifold aspects of Early Christian art derive from the fluctuating effects of these two formal influences, and by their constant interpenetration, the intermingling of the Middle Ages with the antique. The great service and significance of Early Christian art consist in the fact that it did not break with the past but adapted and modified the classical repertory of forms to the new religion. It perpetuated the antique tradition and a knowledge of and sympathy for its work, leaving itself open to influence from it into the Middle Ages. Its transcendental quality remained predominant for centuries, and—though themes and forms varied with the era and in keeping with differing peoples and their cultural traditions—Early Christian art retained its solemnity and force, its spiritual tension and function as religious declaration.

The formulation of Christian iconography was in large part accomplished during the Early Christian period. The goals and themes were formulated, and the manner in which religious content would be pictorially represented was determined. This development took place chiefly in the 4th and 5th centuries. All the ecclesiastical and religious centers were involved to varying degrees: Rome, then Milan and Ravenna in the West; Constantinople, Antioch, Alexandria, Syria, and Palestine in the East.

Critical for Late Antique art was the rapid predominance of painting over sculpture. This trend, which had already begun in the pre-Christian period, became dominant in the

Christian era itself, for Christianity increasingly equated religious sculptural representations with idolatry. Only in court art did free-standing and monumental relief sculpture retain a certain importance. In Byzantium they flourished only late and to a limited extent. In the West, sculpture did not achieve a splendid rebirth until the Romanesque period. Sculptural representation in the Early Christian period was restricted to reliefs on sarcophagi, works in ivory—diptychs, whose inner faces served as writing tablets, book covers, caskets, and salve or toiletry containers (pyxides)—metal vessels for sacred and secular use, and gems.

Painting assumed the critical functions of art, and great pictorial programs in mosaic or fresco soon covered walls and vaults of the churches. Mosaic—that light-reflecting, seemingly substanceless painting with gold, colored stones, and glass pastes (enamels)—was superbly able to displace a subject into an unearthly sphere where it escaped all reality and was made spiritual and transcendental. Furthermore, the shining splendor and preciousness of mosaic (which was frequently complemented by the many-colored marble revetments on the lower walls and floors of the churches) was the perfect adornment of the house of God, which was conceived of as the earthly mirror of heavenly majesty, as inscriptions frequently reiterate. In more modest places of worship, as also in the catacombs, an attempt was made to approach the splendor of mosaics through imitation in fresco of the pattern of their incrustation and of their color.

The art of book illumination flourished as never before in Christian hands, and would later become the medieval branch of painting *par excellence*. It had been practiced by the ancients, at first in the form of simple drawings in treatises, but later as pictorial narrative to accompany works of imaginative literature, and chronicles, as copies executed from the 4th century on demonstrate. For Christians, however, books had profound sacred significance: Was not the Bible, "Holy Writ," the Word of God, hallowed history and the immediate source of revelation? This novel "sanctification of the book" explains the high artistic standing of book illumination, its richness of production, and not least its importance as an iconographic source, for book illustration was closely tied to text, which, it was felt, guaranteed the authenticity of the pictorial formulas. The earliest Christian illustrations were probably confined to portraits of authors (e.g., the evangelists) and to pictures accompanying the concordance to the Gospels introduced by Eusebius in the early 4th century. Often relying upon earlier, sometimes Jewish precedents, extensive illustrative cycles, literal and true to the text, which accompanied most of the books of the Bible, were produced probably in the 4th and 5th centuries in Antioch, Alexandria, and many other centers. The most important books and groups of books—Genesis, the Book of Psalms, the Octateuch, the Book of Kings, the Gospels—contained cycles composed of hundreds of separate scenes. A basic change in the book format favored the rapid development of Christian book illustration: In the 4th century the old papyrus roll was replaced by the codex with its succession of parchment sheets, allowing the use of body color. Simultaneously, a strong influence from monumental painting affected the originally simple type of illustrations: They became full-page and concentrated on one or a few key scenes, they were framed, and they were enriched with the illusionistic spatial settings of the antique period. Copied through the centuries, these intimate pictures continued to be faithful to the text as

well as to the artistic tradition of antiquity. More than once, in the West and in Byzantium, book illustrations provided the inspiration for a *renovatio* of the classical heritage.

Religious panel painting also had its beginnings in the early days of Christian art. From the 4th century onward, written sources record the existence of pictures of Christ, the apostles, and saints, and even simple scenes, which were linked—through their technique of encaustic (wax tempera on wood or linen) and their type (generally tall half-figure representations)—to the ancient tradition of portraiture (mummy portraits). Nothing has survived, however, from before the 6th to 7th centuries.

The iconography of Early Christian art developed in close association with its functions, often borrowing antique prototypes. Wherever thematic analogies existed, ancient depictions were pressed into the service of Christianity: Nike, the winged goddess of victory, became an angel; the evangelists were given the likeness of ancient philosophers; the oldest portrayals of Christ stemmed from representations of the Good Shepherd and other bucolic pagan scenes. For illustrating the Old Testament Christianity could turn to a Jewish cycle—one of which survives partially in the synagogue of the Roman border town Dura Europos, on the Euphrates, dating from the beginning of the 3d century, one of the oldest Christian places of worship. For the choice of themes and their conjunction in cycles, and for the emerging preference for certain themes and programs, theology was largely responsible, influencing religious consciousness, and in so doing delimiting and guiding the development of iconography.

The themes of the catacomb frescoes and sarcophagi, the earliest Christian art, disclose the otherworldly aspirations of the faithful. The simple symbols—such as the peacock (for the Resurrection) and the fish (for Christ)—and allegories (orans [praying] figures, the Good Shepherd, the wine harvest) were enriched in the early 3d century and thereafter by the addition of selected scenes from both Testaments that supplied visual evidence of succour or that related to Baptism and the Eucharist—for example, Daniel in the lions' den; Shadrach, Meshach, and Abednego; the sacrifice of Isaac; accounts of Jonah, Noah, and Susanna; Moses striking the rock; the handing down of the Tablets of the Law; the baptism of Christ; the feeding of the five thousand; Cana; the raising of Lazarus. During the 4th century there was an increase in the number of scenes from the life of Christ and episodes from the Apochrypha, such as the life of Mary and the Acts of Peter. Christ's Passion was not depicted until the middle of the 4th century, and even then only in a few scenes (such as Pilate's washing his hands); the symbol of the cross in token of victory indicated the death and resurrection of Christ.

With the ascendance of Christianity, Roman imperial iconography was adapted to the service of religious revelation. Hitherto represented as youthful in eternity, Christ soon began to appear, frequently magisterially bearded, as Lord of the World handing down the law to the apostles, or residing in heaven (Paradise) in the circle of the apostles, or like an emperor receiving their homage.

In the later 4th century and in the century that followed, iconography developed along two lines. Some artists sought to present sacred personalities and events as authentically as possible. Particularly in the East, artists turned to the great illustrative cycles from the Bible

and the Apocrypha and the legends of the saints. Based generally on apocryphal descriptions, particular types were created for the various saints. Peter was henceforward distinguishable by his broad head and short, white hair; Paul by his narrow face with high forehead and pointed beard; Mary increasingly tended to wear the maphorion, the matronly veiled cloak of the East. The image of Christ was given what was to be its classic form in the East—severe, slight, bearded—following the acheiropoiiton, the picture "made without the agency of hands," which, according to legend, Christ himself had sent in the form of an impression on cloth (mandylion) to King Abgar of Edessa.

At the same time, theological programs determined the decoration of churches. Worldly Dominion and the Last Judgment, the Incarnation and Triumph of the Cross, the Eucharist and Ecclesia were among the principal themes. The most varied forms, scenes, and symbols were assembled to provide multiple layers of meaning. A symbolic canon evolved—the Cross and Christogram in the laurel crown; the Lamb of the Apocalypse on the Hill of Paradise, with the twelve apostle-lambs; the hand reaching out of the clouds, symbolizing God the Father; the dove representing the Holy Ghost; the throne prepared for Judgment (Etoimasia); and various others. The century of the great doctrinal disputes over the fundamental Christian truths was aptly characterized by a tendency to clothe the articles of faith in symbolic form.

Our knowledge of Early Christian art and its development is limited by the small number of surviving monuments. Each work is therefore all the more precious, as visible testimony from the period that laid the basis of Christian art and contributed vitally to European culture.

CONSTANTINIAN ARCHITECTURE

The history of Christian religious architecture begins with constructions by Constantine in Rome, Constantinople, and the Holy Land. By the 3d century, there were simple chapels in private houses, but it was only the civil recognition of Christianity that provided the conditions for a monumental, public architecture. One cannot overestimate the fundamental importance of the period from Constantine to Theodosius for the history of architecture. It was then that the two types of church that would occupy all the subsequent endeavors of Christian ecclesiastical architecture—basilical and centrally planned—were created. It was then that the formal vocabulary was developed to give artistic expression to Christianity and its needs.

The basilica of S. Giovanni in Laterano in Rome—"chief and mother of all churches," founded by Constantine as church of the Roman bishops in 313—is the striking first evidence of the new Christian determination to build and is the key building in the development of the Early Christian basilica (*Ill.2*). It served as model for the church over the grave of the leader of the apostles, St. Peter, which was begun in 324 (*3–5*). Unfortunately, neither church survives in its original form. Plain brick buildings, they revealed their artistic character only within. They were entered from the atrium, a square courtyard surrounded by arcades. In the buildings proper there were five aisles altogether. In each case, the broad nave was flanked by narrower and lower aisles, and flowed, framed by an arch (often called a "triumphal arch"), into the crossing, or transept. Beyond the crossing, the nave terminated in a vaulted niche, the apse, which contained the episcopal throne, priests' stalls, and altar. In both churches the walls of the nave and aisles were supported by columns; those of the aisles were linked by arches into arcades. The nave of the Lateran Church was also bounded by arcades, but at St. Peter's, the middle rows of columns carried a straight architrave. The walls of the nave were penetrated by a row of large arched openings, the clerestory windows; similar windows pierced the apse, transept, and the wall through which one entered the churches. The roofs were probably open timber but may have had flat wooden ceilings.

These imposing churches represented a synthesis of very diverse elements. Some of these were derived from building types (such as market or palace basilicas). Others were introduced from an essentially pragmatic sphere (practical architectural engineering), most notably the subsequently important articulation of walls. Still others were entirely original (for example, transepts). What was decisive, however, was that all these heterogeneous elements served one artistic idea, namely, the subordination of all parts to a hierarchical ordering organized around the altar as spatial, optical, and liturgical center. From without, this principle could be seen in the longitudinal sequence of architectural units; within, it determined the rhythmic impulse of the rows of columns toward the altar, the accentuation of the nave by the triumphal arch, the subordination of the aisles, and the spacious pause of the crossing before the apse. No member had independent value or was used for itself alone. The spatial effect was that of a structure of stratified and interrelated parts; its boundaries were not clear but were optically evoked by light, shade, and color. The walls, suspended over the light arcades, were made to appear thin and without substance by virtue of their

costly facing with colored marble tablets and mosaics, but above all by the ingenious manipulation of light, which set off the upper zone from the lower, darker one, and the nave from the dusky subsidiary areas. The columns were incorporated into the wall and became light as they lost their round solidity. In these early basilicas, a novel spiritualization of form is evident; in them, the transcendental spirit of Christian worship finds its complete esthetic counterpart.

This spiritual character is inherent not only in the basilica. The centrally planned building, which had certain special functions—it was used for baptisteries, martyria, and mausoleums—adopted circular, cruciform, and octagonal schemes from classical heroa and public baths. The mausoleum of Helena in Rome (Tor Pignattare) is a round building with a dome. The oldest baptistery, that of the Lateran Church, was a simple round building with a wooden roof. The stylistic principles developed in the basilica were soon applied to the centrally planned building: A spacious, light, domed core was surrounded by a lower and darker round or polygonal outer place in which to walk (ambulatory). In the mausoleum of Constantine's daughter Constatina in Rome, now S. Costanza (6–8), an arcade of twelve double-columns carries the high cylinder of the dome; the ambulatory has a tunnel vault and alternately round or rectangular niches in the walls. Directional emphases are grafted onto this basic central plan: In the chief axes, and most strongly in what was to be the main axis, the niches were enlarged like apses, the interval between the columns was made greater and the arcade higher. Thus a complex structure, evolved from ancient prototypes but with a new, specifically Christian symbolism expressed through dome, cross, and focus on the altar, opened the development of the centrally planned church.

In addition to these two types, the 4th century saw the most varied solutions for a multiplicity of religious needs. The three-aisled basilica on a trough-shaped ground plan, in which the nave walls with a clerestory rested on massive pillared arcades, served the cult of the dead in Rome—for example, S. Sebastiano (10) and old S. Agnese. The grouping together of several buildings—for example, two basilicas with a baptistery in Trier, two halls in Aquilaea—probably arose to meet the needs of worship. Occasionally a basilica was associated with a mausoleum (as in Rome, S. Agnese with S. Costanza, and most notably the Church of the Apostles with the mausoleum of Constantine in Constantinople, in which the sarcophagus of the emperor, equivalent to that of the apostles, stood near the cenotaphs of the Twelve). The most showy complexes were Constantine's constructions over the great holy places of the Christian religion. In the Church of the Holy Sepulcher in Jerusalem—which was constructed along one axis and dazzlingly decorated—stairs, portico, atrium, five-aisled basilica, and peristyled court led to the Holy Sepulcher, which toward the end of the 4th century was surrounded by the famous columned rotunda (12). In the five-aisled Basilica of the Nativity in Bethlehem (11) a longitudinal and a centrally planned building were coupled: The octagon containing the natal cave (for which Justinian substituted the still-extant trefoil ending) took the place of an apse. The holy place is thus the sacred center of the building and dominates by virtue of its spatial autonomy. This solution was to have numerous successors in the West—for example, St-Bénigne, Dijon, and SS. Annunziata, Florence.

2 S. GIOVANNI IN LATERANO, ROME. From a fresco in S. Martino ai Monti, Rome, showing the donation by Constantine of the Lateran Palace to the bishop of Rome, 313. First monumental Christian building, originally dedicated to Christ. First in line of development of the Early Christian basilicas, its typical traits already fully realized: five aisles, transept, clerestory, columned arcades carrying walls, and dynamic pull toward apse, dematerialization of substance of building and its plastic members into a thin, two-dimensional structure made to seem transparent by effects of light and dark and by colored revetment on walls. The emphasis on interior space marks a fundamental reversion from monumental sacred architecture of antiquity. Classical columns and capitals were plundered from ancient buildings. The complex included a baptistery, a simple circular building whose outer walls are preserved in the present octagon, built under Sixtus III in the 5th century.

3 OLD ST. PETER'S, ROME. Plan. Begun by Constantine in 324 over Peter's grave, previously marked only by a simple confessio. Razed by Pope Julius II for a new building in the 16th century. Five-aisled basilica with marked-off transept arms, the northern one serving as baptistery.

4 OLD ST. PETER'S, ROME. As it appeared in Middle Ages, with numerous additions (some mausoleums). Converts gathered at the fountains in the atrium for ritual ablutions. Basilica for congregation and clergy, also seat of synods. Simple exterior except for the sculpturally decorated portal construction.

5 OLD ST. PETER'S, ROME. Section. Related in style and type to S. Giovanni, with classicizing tendency of late Constantinian art recognizable in nave colonnades. High altar over Peter's grave distinguished by ciborium-like structure. Innovative mosaic decorative program known from drawn copies.

6 S. COSTANZA, ROME. Interior toward the east. Mausoleum of Constantine's daughter Constantina (died 354), perhaps planned as baptistery. As in the octagon in Antioch, application of the stylistic basilican principles to a centrally planned building: circular with ambulatory, twelve radial double-columns bear dome on high drum. Light flooding in from above through twelve large windows in drum contrasts with dark shadow of ambulatory. Alternately rounded and rectangular niches (for sarcophagi) in the outer wall, in classical tradition of centrally planned single rooms, enlarged to apses in the main axes.

7 S. COSTANZA, ROME. Exterior. Stepped, concentric body with tent-roofed dome. Bare but meticulously executed walling, marble used only on frame of portal.

8 S. COSTANZA, ROME. Southern arc of ambulatory. The contrast in space and lighting between the center and ambulatory is clearly observable. Typically Late Antique are the impost blocks over the double-columns. Only in the ambulatory does the once resplendent mosaic survive.

9 S. COSTANZA, ROME. Plan. Clear concentric rings with hint of a cross. The outer, lower colonnade, vaulted porch, and oblong vestibule no longer exist.

10 S. SEBASTIANO IN VIA APPIA, ROME. First quarter of 4th century. Once Church of the Apostles ad catacumbas. Rebuilt in Baroque era. Three-aisled pillared basilica, aisles curved in semicircle around nave. Cemetery church, graves occupying walls and floor, sepulchers without.

11 CHURCH OF THE NATIVITY, BETHLEHEM. 326–33. Plan. Founded by St. Helena. Five-aisled, compact basilica with colonnades. Apse replaced by octagon, in the center of which an opening connects with the underground chapel over the natal cave; rebuilt by Justinian with a trefoil ending.

12 CHURCH OF THE HOLY SEPULCHER, JERUSALEM. 326–36. Plan. Founded by Constantine. Destroyed. From east to west: colonnade, steps, atrium, five-aisled galleried basilica without transept, in the apse twelve columns with silver vases (symbols of the apostles), another atrium (with huge cross erected by Theodosius), with circular building over Holy Sepulcher at the end.

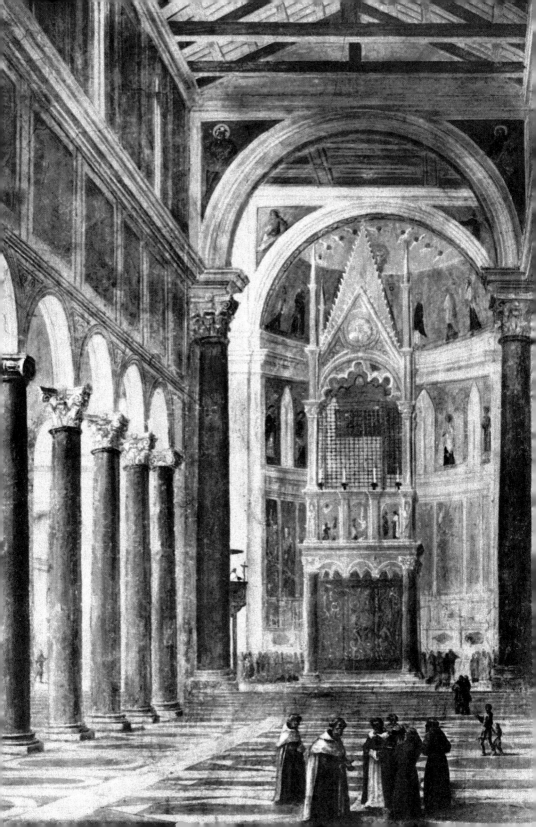

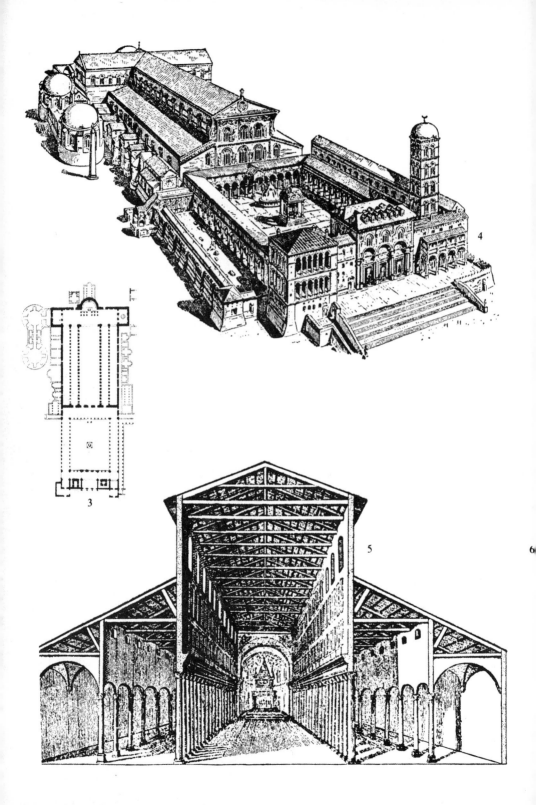

3

4

5

6

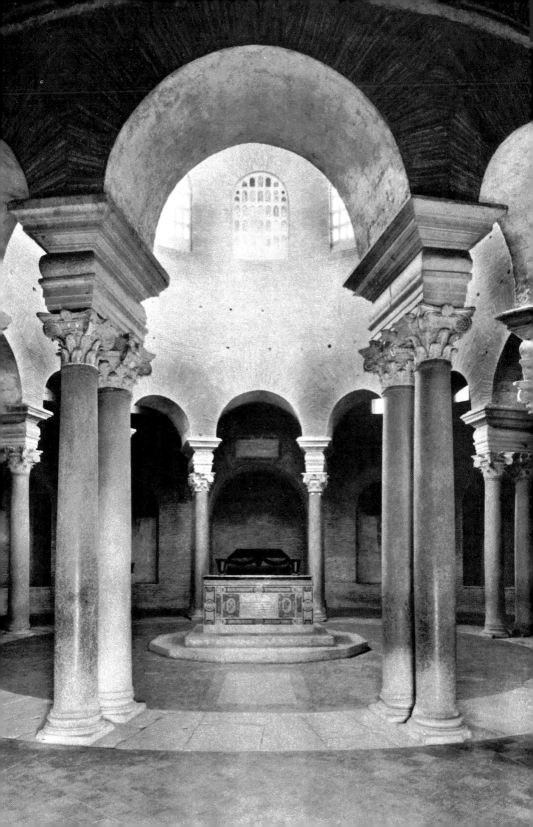

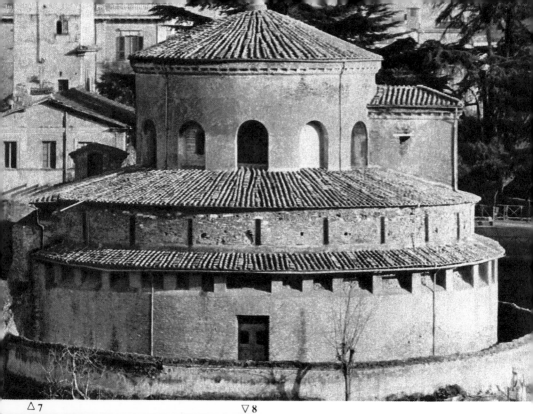

△ 7

▽ 8

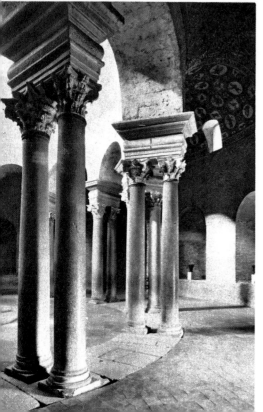

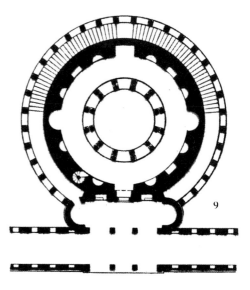

9

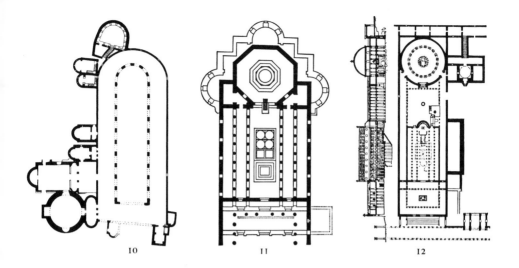

10 11 12

PICTORIAL ART
OF THE 3D AND 4TH CENTURIES

The earliest Christian art was funerary. Wall paintings decorated underground burial chambers, and figural reliefs adorned the sarcophagi. Catacomb frescoes in Rome and Naples, which date from the early 3d to the 6th century, mirror the phenomena and mutations of high art, generally at the level of popular craftsmanship. The decorative system followed that of late Roman interiors, in which walls and vault, renouncing spatial illusion, were compartmented by a geometric pattern of colored lines on a light ground. In the first phase, these circular and trapezoidal fields were occupied by figures and scenes, garlands, vases, and creatures that seemed to float in a shallow foreground, painted with impressionistic delicacy in light, airy colors (22). Sarcophagal sculpture, which can be traced back to the middle of the 3d century, was also based on pagan prototypes at first (15), taking over the irregular spacing of single figures and scenes within a single strip. The figures, almost sculptured in the round and only loosely tied into the spatial background, with agitated attitudes and convincingly modeled drapery, are conceived in the tradition of classical relief.

Around 270, a decisive change took place in all spheres of art, and it led to the extreme anticlassical style of the Tetrarchy and the early Constantinian period. Numerous catacomb frescoes were executed in the new compact linear and planar style, which blocks out the figures with broadly drawn contours and subdivisions, sets off some colors against a light ground, and achieves starkly expressive effects of gaze and gesture (21). Related stylistic trends appear decisively in official and court art. The most renowned example is the Arch of

21

Constantine in Rome (13), a triumphal arch erected after the victory of the Mulvian Bridge (312) by the Senate for Constantine's jubilee of ten years' rule in 315. While in type the arch follows classical tradition, the reliefs are a singular mixture of actual spoils from various earlier imperial monuments and newly created friezes, medallions, and figures celebrating Constantine's victories. In marked contrast to the individual, fluidly executed, pirated reliefs, the newly executed reliefs are expressively weighted with ponderous, stiff, block-like forms. The figures are mostly frontal and are arranged repetitively and symmetrically, in long friezes, around the emphatically enlarged form of the emperor. Each individual figure is an isolated sturdy block without the smooth transitions of earlier relief (14). The deeply drilled furrows forming the folds of drapery geometricize the surface. The solemn expressivity of these reliefs, with their complete lack of classical nuance, is achieved by abstract means: by an emphasis on the quality of the material, flatness, surface contrasts of light and shade, and stylization of each form, notably the outsized, eloquent heads and hands. These stylistic traits are also found in a group of Christian sarcophagi from the same workshop, among them Lateran No. 104 (16).

A related artistic trend is seen in sculptural portraiture, as in the colossal head of Constantine from the basilica of Maxentius (18). His features are starkly symmetrical on the massive block-like head; each individual detail is overemphatic yet at the same time is a part of a geometric schema, as, for example, are the curved eyes, eyelids, eyebrows, tear-ducts, and fringe of hair. There is no animation in the face; everything fleeting and all realistic immediacy are drained away into the massive material by the severity of abstract organization, which removed this truly monumental head into an unearthly, timeless realm.

During the twenties of the 4th century, currents from the Hellenistic tradition, which had never been wholly interrupted, began to weaken the extreme anticlassicism of the early part of the century and thus to prepare a new orientation toward antiquity, which became dominant in the late- and post-Constantinian period. Thus, for instance, a reversion to Augustan models is detectable in the trophies on the Capitoline steps in Rome. Among the many examples of classically inspired art are the painted caskets with portraits of empresses and figures of children (putti) from the Constantinian palace in Trier and the many extant floor mosaics in Antioch. But in their abstract surface composition, some of these floors, such as those in the so-called Villa of Constantine, reveal influence from the prevailing anti-classical style. There is a similar ambivalence about the vault mosaics in the ambulatory of S. Costanza in Rome (24): The vineyard scenes and straw pattern with birds, fronds, and tableware, the dancers, putti, and geometric pattern on a white ground are permeated with the Hellenistic spirit, yet nevertheless have a certain immobility and inorganic rigidity. The mosaics of the dome also followed pagan decoration: Over a genre-like marine landscape, acanthus scrolls supported by maidens split the vaulting into twelve fields, in which, however, Christian scenes now appear. Similarly, in the pavement mosaics of Aquilaea, Christian scenes (Jonah) and imperial portraits were woven into a typically late Roman decorative scheme.

The renaissance of classical art, which took a powerful hold even on Christian art in the late Constantinian period, cannot be rated too highly. For Christian art now joined the

mainstream of classical high art and thereby laid the European foundations—European in the broad sense—of both Western and Byzantine art. The return to the antique style had a political aspect as well. In the classicizing of official art, the renewal of the Universal Monarchy found artistic expression. For Christian art, this *renovatio* meant genuine competition with surviving antique pagan art and culture—with, for the first time, parity of means, and soon also of artistic achievement. Particularly in the Roman senatorial families, determined opposition to the new state religion persisted: From 361 to 383, Emperor Julian attempted to restore pagan worship. Christian art withstood this challenge by taking over the forms and iconography of the old imperial art (*23*).

Among the most important works of this *renovatio* is a series of Roman sarcophagi, in which, for the first time, the Taking of Christ, Pilate, and other episodes from the Passion were depicted. In the first phase, around 340, less chunky, more organic figures detach themselves from the ground of the relief (for example, the Sarcophagus of the Brothers, in the Lateran). The typical sarcophagus of this series is one- or two-tiered and columned, and under the classicizing colonnades or arcades each scene forms an autonomous composition. Fully rounded figures move unconstrictedly in real space, and there is a new understanding for proportion and organically supple movement. In the richest and finest sarcophagus, that of Junius Bassus (*17*), the forms follow the prototypes of classical nudes and drapery with great confidence. Characteristic of this first renaissance phase is the fresh immediacy of imitation and the often lyrical animation of fine, delicately modeled and strongly individual heads. A similarly delicate and sensitive beauty and suave delineation of folds distinguish a statuette of Christ in Rome (*19*). Not much later, an ivory casket in Brescia (*20*) was created in another artistic milieu, under Eastern (or perhaps north Italian) influence. The clarity of its composition; the organic solidity of its figures, rising freely out of the relief ground; the graded transitions in relief from broadly rounded modeling to delicate, agitated folds; the soft, expressive faces—these qualities already announce the Theodosian style.

13 ARCH OF CONSTANTINE, ROME. North side. 313–15. Erected by the Senate for Constantine's decennary after his victory at the Mulvian Bridge. The type continues that of former imperial triumphal arches, e.g., that of Severus in the Forum. The re-use of reliefs from the reigns of Trajan, Hadrian, and Marcus Aurelius is a political expression of the same universal idea of empire. The new reliefs glorify the deeds of Constantine: four friezes over the side arches (treating his siege of Verona, battle of the Mulvian Bridge, his army marching in and away, his address to the people, his bounty); on each side of arch are medallions of the Sun and Moon; in triangular fields above the arches are allegories of victory; on the column bases, prisoners and victories.

14 ARCH OF CONSTANTINE, ROME. North side, frieze over the west arch. Detail: the emperor gives officials the order for distributing bounty. Typical of the extreme anticlassicism of Tetrarchal and early Constantinian art are the abstract composition and formation of the figures, using symmetry, uniformity, unorganic compactness, geometrizing articulation by lines, drilled furrows rather than modeling, contrasts of light and shadow, awkwardly heavy, expressive depiction of hierarchy.

15 SARCOPHAGUS. c.270. S. Maria Antiqua, Rome. Center: orans (praying) figure, philosopher, Good Shepherd; left: Jonah scenes (prayer in ship, whale, gourd in leaf); right: Baptism of Christ, fisherman. New systematic program, typological opposition of Old and New Testament scenes (Jonah/Baptism as rebirth). This type of tub-shaped sarcophagus with one zone of decoration followed classical tradition; the landscape setting and the type and pliant modeling of the figures correspond to contemporary pagan sculpture.

16 SARCOPHAGUS. c.315. Lateran Museum, Rome. Above: Creation of Eve (the Trinity as three persons is unusual), Entry into Paradise, the Serpent. Below: Adoration of the Magi, Healing of the Blind, Daniel in the lions' den, Peter's denial of Christ and arrest, Moses strikes the rock. This is a stock piece, as the round shield (clipeus) of the bridal pair is only blocked out. From the Arch of Constantine workshop. Constantinian type of frieze sarcophagus: continuous succession of scenes in one or two strips, figures tightly packed, squat but relatively supple, not drilled. An agelessly youthful depiction of Christ.

17 SARCOPHAGUS OF THE CITY PREFECT JUNIUS BASSUS (died 359). Caves of St. Peter, Rome. Above: Sacrifice of Isaac, Peter's arrest, Giving of the Law to Peter and Paul, Ecce Homo, Pilate washes his hands. Beneath: Job, the Fall, Entry into Jerusalem, Daniel [restored] in the lion's den, Paul on the way to martyrdom. Earliest scenes of the Passion, but still without the Crucifixion and Resurrection. Masterpiece of the neoclassical type of the arcaded sarcophagus, with rich, finely chiseled colonnades and arcades. Closed, spacious compositions with sculptural nudes and clothed figures with flowing drapery, revealing classical inspiration.

18 CONSTANTINE THE GREAT. c.315. Palazzo dei Conservatori, Rome. Head from the seated portrait in the apse of the basilica of Maxentius, completed by him. Marble. Height 2.6 meters (whole statue once 10 meters). Found in the 15th century with other fragments. Exaggeration of realism to the surreal and timeless, extreme blocklike abstraction.

19 ENTHRONED CHRIST. c.350–60. Museo Nazionale, Rome. Marble. Height 72 cm. Masterpiece of the idealized Apollonian Christ after a Middle Roman model. A sculptured portrait of Christ was highly unusual at this time.

20 IVORY CASKET. 360–70. Museo Civico, Brescia. $22 \times 24 \times 32.7$ cm. Main fields: Christ as Teacher, Healing of the Woman with an Issue of Blood, the Good Shepherd; on the sides and back, miracles, the Risen Christ, etc. In the narrow registers, the Old Testament (in front: Jonah, Susanna, Daniel). Busts of Christ and the apostles. Cover: the Passion. May have originated in northern Italy. Sensitive, Eastern-influenced classicism with masterfully differentiated figures in precisely carved relief.

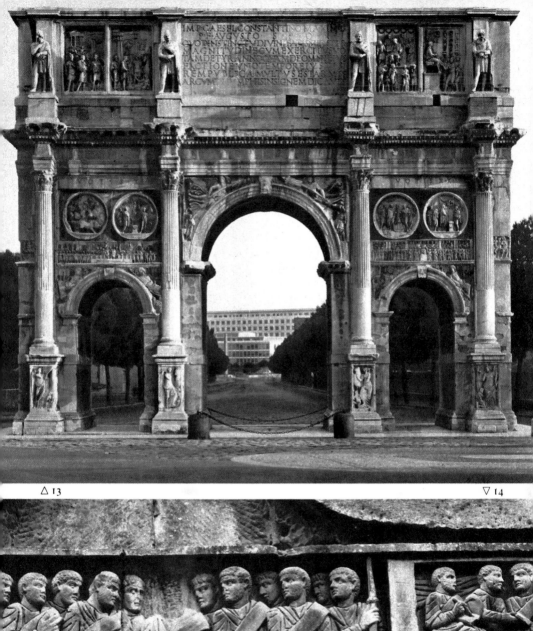

△ 13

▽ 14

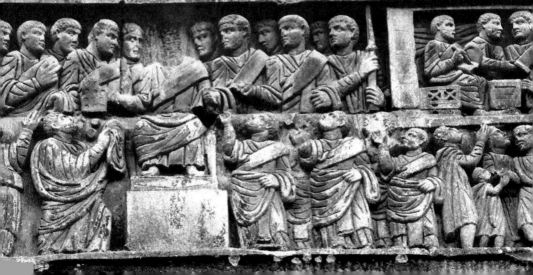

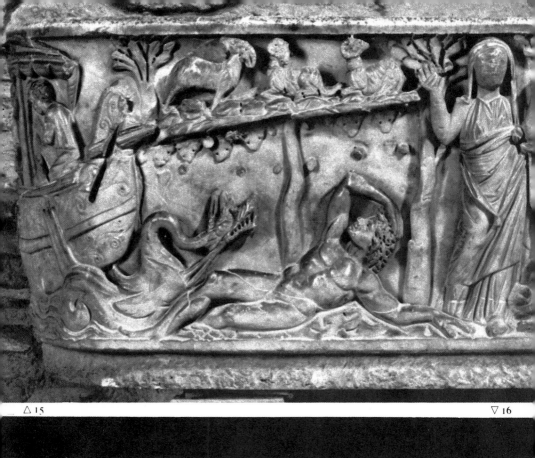

△ 15

▽ 16

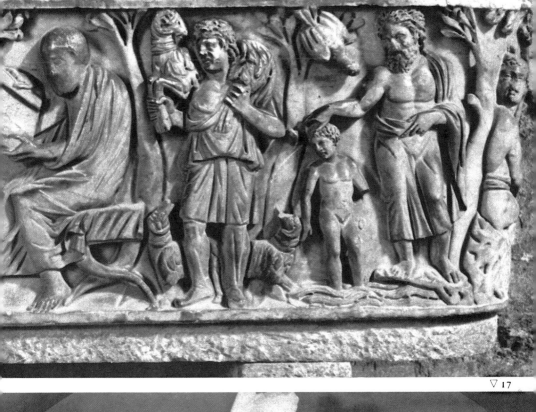

▽ 17

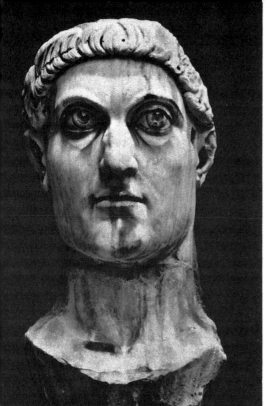

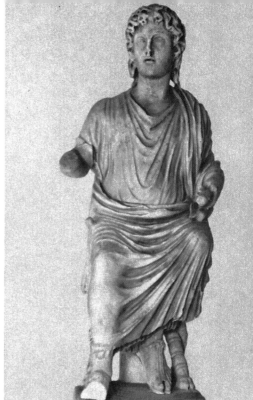

△ 18

△ 19

▽ 20

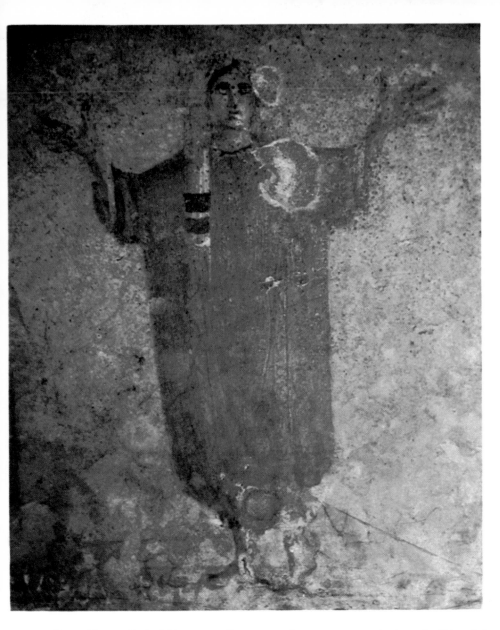

21 ORANS FIGURE. End of 3d century. Cata-
combs of Priscilla, crypt of the Velatio Vir-
ginis, Rome. Fresco in the lunette over an
arcosolium (tomb niche set into arch in the
wall). There are paintings of a teacher and
mother with child (perhaps representing
Mary or the church) beside the orans fig-
ure. Site is one of the oldest cemeteries,
developed from a family vault. Style of the
frescoes corresponds to early Tetrarchal
art of c.300. The figure is a compact, dark
patch set off from a light ground, with
terse, angular contours and lines of artic-
ulation, emphatic gestures (note the hands).
The orans figure in a typical attitude of
prayer is a cardinal leitmotif of Early Chris-
tian art; signifies soul of departed in anti-
cipation of eternal glory.

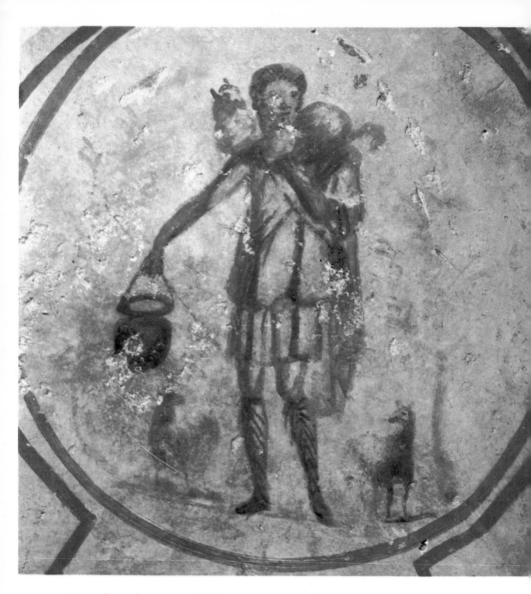

22 THE GOOD SHEPHERD. Mid-3d century. Catacombs of Callixtus, Rome. Center medallion of a ceiling fresco in the Lucina section, belonging to the earliest examples of Christian cemetery art. Bucolic pagan idylls inspired the motifs and style—a delicate, eye-deceiving impressionism. Geometrical partition of fields with red lines and without attempt at spatial illusion.

23 CHRIST. Mid-4th century. Catacombs of Domitilla, Rome. Arcosolium fresco beside the crypt of Ampliatus. Detail from Christ Teaching in the Company of the Apostles. Theme and semicircular composition taken over from monumental painting. Painterly flexibility and flowing lines and movements related to post-Constantinian art.

24 FEMALE BACCHANTES AND PUTTI IN CIRCULAR ORNAMENTS. Mid-4th century. S. Costanza, Rome, from the vault mosaic of the ambulatory. Mid-4th century. Decorative type and motifs are classical pagan, yet the liveliness and freedom of classical figures have been somewhat curtailed.

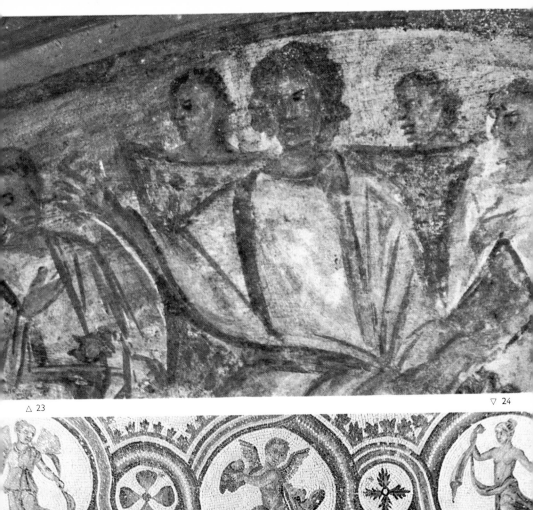

△ 23

▽ 24

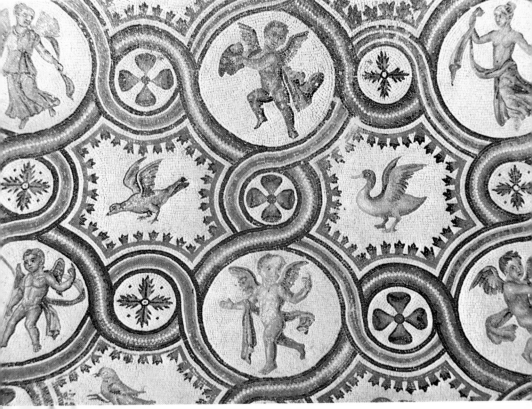

The classicism of late antiquity and the Early Christian era reached its apogee around 400. In the East, the court art of Emperor Theodosius I (379–95), which placed Constantinople in a position of cultural leadership, gave this period its spiritual and artistic profile. The classical orientation was far more comprehensive than previously: The victory columns of Theodosius and Arcadius are fully in the tradition of Roman triumphal art, and statues of the emperors (27, 29) and of dignitaries depend in type and style on works of the imperial period. However, the classical prototypes have been translated into a hieratic, symbolic mode, and are infused with a new, spiritual dignity, expressive of the spirituality of the refined courtly culture and of a Christian view of the world as the earthly mirror of the divine hierarchy. On the reliefs of the base of the obelisk of Theodosius (26), and also on his Missorium (25), virtually every suggestion of action has yielded to solemn, almost sacral representation. The figures are posed in strict frontality, symmetry, and (on the obelisk base) isocephaly before a smooth ground suggestive, like the gold ground of mosaics, of depth. Instead of spatial recession there is surface overlap; naturalistic spatial relationships are sacrificed to hierarchic perspective, in which size is ascribed to the figures according to their rank. Rhythmic uniformity binds all the figures into a system of corresponding forms, lines, and movements; yet each preserves its sculptured individuality through the soft, sensitive modeling of body and drapery. A great deal less abstract and stylized is one of the few surviving Christian works from the East, the Sarcophagus of the Princes from Sarigüzel (33), whose superb angels with their masterly foreshortening and untrammeled sense of

25 MISSORIUM OF THEODOSIUS I. 388. Royal ▷ Academy, Madrid. Lightly gilded, cast silver. Diameter 74 cm. Theodosius in consular garb enthroned before the tribunal, handing a diptych to an official; to the sides, reduced figures of the younger Augusti, Arcadius and Valentinian II, each with two German bodyguards. Putti in the pediment, a personification of Earth underneath. An imperial present on the occasion of the decennary (border inscription). Ritualized ceremonial depiction. Confirmed as Eastern work by the similarity of the pedimented arcade to the Theodosian façade of H. Sophia, but even more so by the classicizing, elegant but also hieratically solemn style.

26 OBELISK OF THEODOSIUS. Base relief. c. 390. Hippodrome, Istanbul. Marble. 2.4 × 3.15 × 2.8 meters. Pedestal of the obelisk of Pharaoh Thutmosis erected in 390. Relief on the northwest side: Theodosius I with Valentinian II and sons Arcadius and Honorius enthroned before the tribunal, officials and bodyguards to the sides, tribute-bearing Persians and Dacians below. Similar scenes on the other sides reflect ceremonial at Hippodrome chariot races. Inscription and scenes of transport and erection of the obelisk on the socle beneath. Severest form of abstract and spiritual court art. Reversal of perspective in favor of the hieratic representation of the emperor and court.

27 VALENTINIAN II (375–92) c.390. Archeological Museum, Istanbul. Marble. Height 1.79 meters. Found in and probably originally from the baths of Aphrodisias, but inspired by Constantinople. Repetition of a classical Roman type of statue, with convincing body and drapery. The frontal and emphatic pose axiality, especially evident in the square compact head, are typically Theodosian. The ponderousness and stiff severity are provincial characteristics.

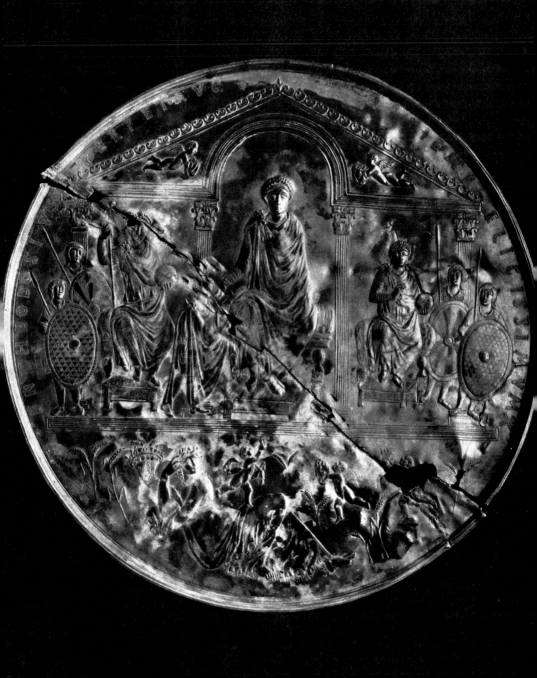

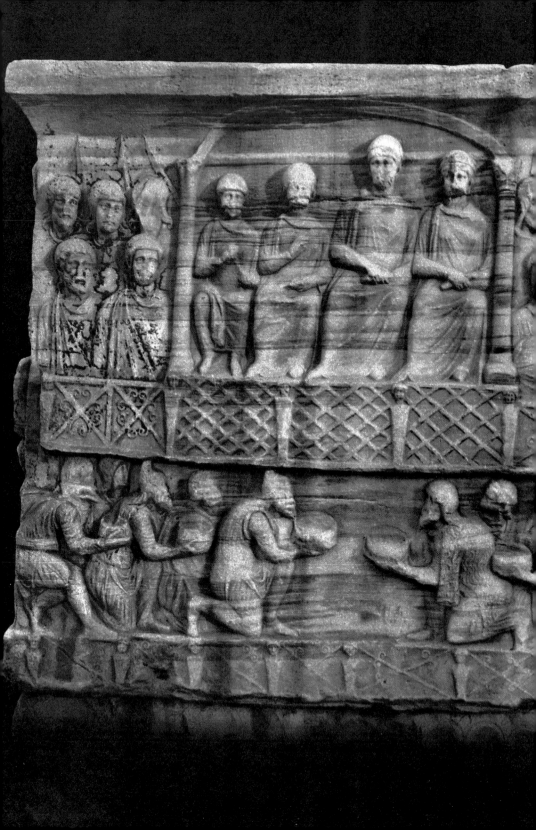

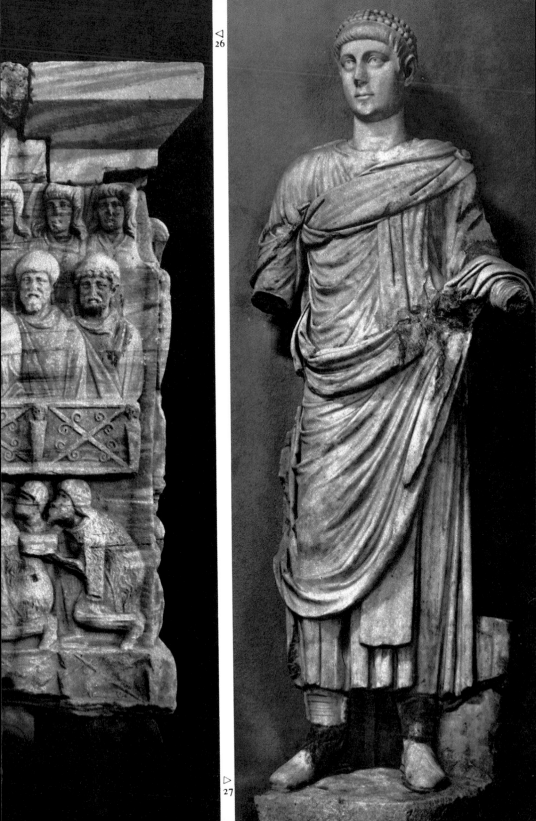

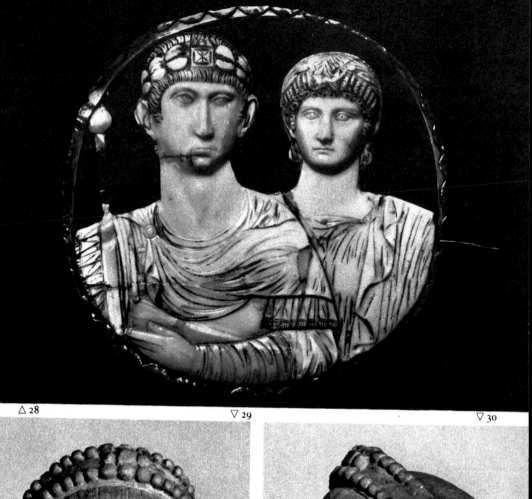

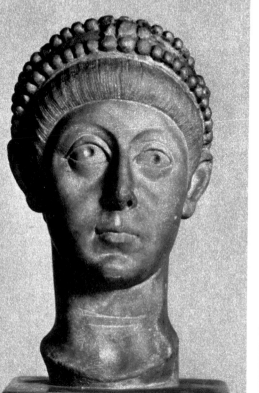

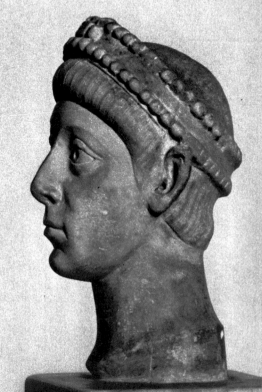

movement come very close to the classical conception of figures that emerge from the relief to expand freely into space.

It was particularly Milan in the West that took up the courtly classicism of the East, as the Stilicho diptych (*38*) and the Honorius cameo (*28*) demonstrate. These display a feature typical of many works of this period in its most accomplished form: the exquisite charm of exceptionally refined treatment of the surface, which derives from superb technical skill. In the Christian sphere, the imposing "city" sarcophagi combine strongly Eastern stylistic components with high relief of Roman origin to produce a formalized monumentality that makes these last works of Roman sarcophagal art its highest achievement. The mosaics in the apse of S. Aquilino and elsewhere in Milan similarly owe to Eastern influence their rhythmic surface organization and delicate shaping, without however achieving in this the sensitive elegance and impressionist looseness of purely Eastern mosaics—in the St. George rotunda in Salonika, for example. Rome, by contrast, remained conservative; the heavy, agitated forms and the rich coloring of, for instance, the mosaics in the apse of S. Pudenziana are firmly in the local tradition. Political expression of the pagan opposition is represented by such works as the Symmachi-Nicomachi diptych (*39*), which in spirit and style reaches back to Augustan classicism. Christian ivories also tend in this direction. Though lacking such academic perfection, they achieve a new, richly supple plasticity and an intense, psychological interpretation of the theme, which points toward the future (*37*). The most direct dependence on classical prototypes is found in silverwork: Themes, style, and techniques were often taken over with confusing literalness—for example, the silver dish with Attis and Cybele from Parabigio; the Esquiline silver treasure, including a bridal casket of the Christian maiden Projecta with pagan scenes (*36*). One of the purest Hellenistic works is the reliquary from Milan (*35*), whose classical style of modeling softens the severity of the composition with a gentle vitality.

The earliest surviving examples of book illumination date from around 400, and they provide precious insights into the book production of late antiquity and the Early Christian period. Especially informative is the deluxe edition of the Roman calendar for 354, which is transmitted to us in reliable 17th-century drawings. It includes personifications of the months and of the imperial capitals, as well as full-page imperial portraits in rich architec-

28 HONORIUS AND MARIA. 398. E. de Rothschild Collection, Paris. Cameo, two-layered chalcedony. Diameter 15 cm. Set in an early 13th-century quatrefoil frame with gold filigree. Probably worked in Milan in 398 for the marriage of Emperor Honorius to Stilicho's daughter Maria. Highest technical refinement; unsurpassed example of Late Antique gem carving.

29 ARCADIUS (383–408). c.395–400. Archeological Museum, Istanbul. Marble. Height 32.5 cm. Work from Constantinople. Compared with the massiveness and the additive quality of the features in the portrait of Valentinian II, this of Arcadius displays a nervous tension, an exceedingly refined, lively surface texture, and a firm integration into the whole. Common to both are the nobility and concentrated spirituality of a high court culture.

30 ARCADIUS. Profile view. The fusion of portraiture with idealization is typical. Note the emerging dominance of line (extreme expressiveness of the contours).

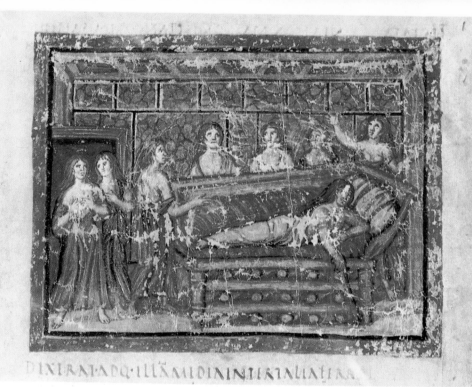

DIXIRAI·ADQ·ILLAMIDININITAIIATIA

tural frames, which appear later as portraits of the evangelists copied during the Carolingian and Macedonian renaissances. Both pagan and Christian books may have been illuminated in a single scriptorium—a suggestion supported by two fragments from around 400—the Quedlinburg Itala (a handful of pages from the Book of Samuel) and the Vatican Virgil (*31*). Common to both is glowing, richly nuanced color, atmospheric background, and, in the Virgil especially, the exceeding complexity of the composition. The manifold adoptions of classical traits in Christian book production, which constantly instilled them with new life, perhaps derived from such common workshop enterprises.

31 DEATH OF DIDO. Vatican Virgil. Beginning of 5th century. Vatican Library, Rome. 17.5 × 17.8 cm. Roman in origin. Mostly framed single pictures, 50 of c.250 miniatures from the Aeneid survive. Among the varied settings are interiors with box-construction perspective. The painterly handling of color is typical.

32 PORTRAIT OF A NOBLEWOMAN WITH SON AND DAUGHTER. Perhaps c.400. Museo Civico, Brescia. Gilded glass medallion, blue enamel ground, portraits etched on gold and silver leaf. Diameter 6 cm. Greek artist's inscription. Added to the front of a large 7th-century processional cross. Superlative technical and artistic quality. Recently dated at c.220–25 by Helga von Heintze on the grounds of marked stylistic and artistic analogies with works from the time of the oriental Severan dynasty, but it is not unlikely that this is a copy or imitation in the court art style of c.400, closely related in esthetic refinement and sensitivity.

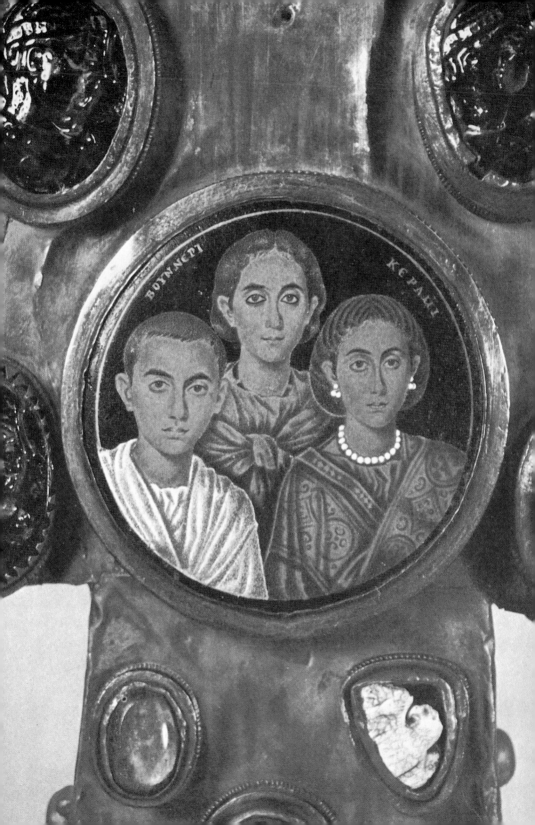

33 SARCOPHAGUS OF THE PRINCES. End of the 4th century. Archeological Museum, Istanbul. Found in Istanbul-Sarigüzel. Flying angels bear wreath with cross. At each end is a large cross flanked by two apostles. Eastern sarcophagal type: no narrative scenes, a few figures before a smooth ground in a shallow box-like space. Largely classical manner. The three-dimensional motion of the angels, sailing diagonally outward, their foreshortening, their rippling plastically modeled drapery, their idealization are especially evocative of classical norms of beauty and form.

34 SARCOPHAGUS. c.395. S. Ambrogio, Milan. Front: youthful Christ before town gate architecture enthroned above the Hill of Paradise as teacher of the apostles. Back: bearded Christ standing, acclaimed by the apostles. Ends: Assumption of Elijah, Noah, Handing down of the Tablets or Abraham's sacrifice, teaching scene. On cover: clipeus of bridal pair, Adoration of the Magi, three youths refuse to sacrifice to the emperor. Side pediments: Christ-child in the crib and christogram. Unified pictorial program influenced by St. Ambrose's preaching. Monumental masterpiece of the so-called city sarcophagi, of the Eastern-influenced type of the second half of the 4th century. Closely related to Milan court art in the stylization of the slender figures, and the flimsy, loose-hanging drapery. Figures stand as compactly sculptured forms before the architectural background, which determines their rhythmic uniformity.

35 RELIQUARY. c.382. S. Nazaro Maggiore, Milan. Beaten silverwork, lightly gilded. 17.5 × 20 cm. Perhaps worked in Milan. Front: Adoration of the Magi; other sides: Judgment of Solomon, Joseph forgives his brothers, three youths in the furnace. Cover: Christ enthroned between the apostles. One of the earliest Christian works in silver; classically inspired—the Magi as Cynic philosophers, Christ-child still naked —and with the full, supple plasticity of the work of antiquity.

36 BRIDAL CASKET OF SECUNDUS AND PROJECTA. c.380. British Museum, London. From the Roman Esquiline Treasure. Partially gilded silver. 28 × 56.6 cm. On the casket: under arcades, the toilet of the bride, serving maids carrying toilet articles. Cover: Venus combing her hair with Nereids and others; bride led into the bridal chamber. Roman work. Despite splendor and the wealth of classical motifs, a slackening of organic and plastic tension.

37 THE WOMEN AT THE SEPULCHER AND CHRIST'S ASCENSION. c.400. Bayerisches Nationalmuseum, Munich. Ivory. 18.7 × 11.6 cm. Perhaps the center section of a five-part diptych originating in northern Italy. Close stylistic relationship to pagan ivories, but less academic. Supple, ample, easily flowing plasticity, new psychological intensity of message.

38 STILICHO (c.360–408). c.400. Cathedral Treasury, Monza. Right wing of ivory diptych. 32.2 × 16.2 cm. Stilicho as consul and *magister militum*. (Left wing: wife Serena and son Eucherius.) Sensitive refinement in style and in the technique of the flat, finely articulated relief are characteristic of Milan court art.

39 DIPTYCH OF THE SYMMACHI-NICOMACHI. c.400. Victoria and Albert Museum, London. Right wing: priestess of Bacchus before the altar of Jupiter. Ivory. 29.9 × 12.4 cm. (Left wing: priestess of Ceres before the altar of Cybele. Musee de Cluny, Paris.) Probably the wedding diptych of two old Roman senatorial families. Originated in Rome. Masterly return to the Greek-inspired classicism of Augustan art.

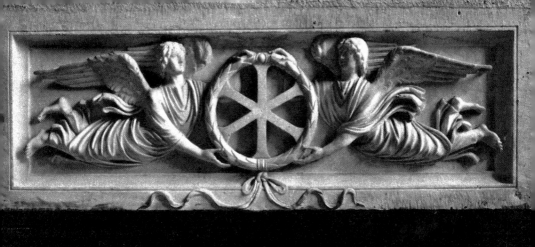

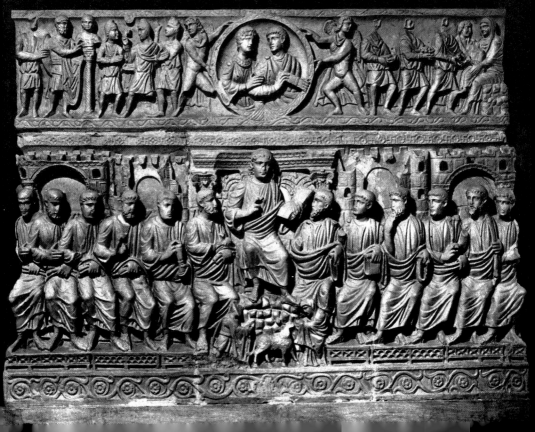

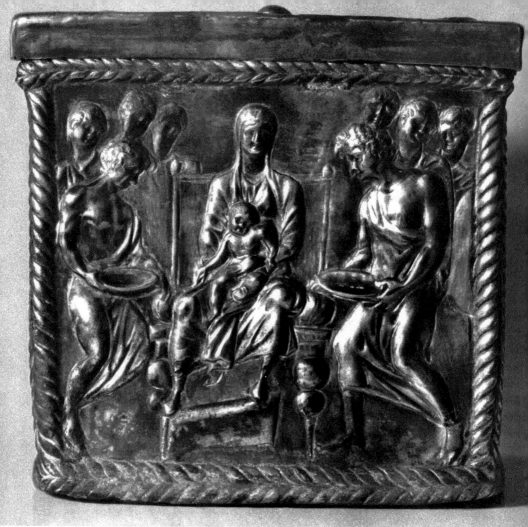

△ 35

▽ 36 ▷

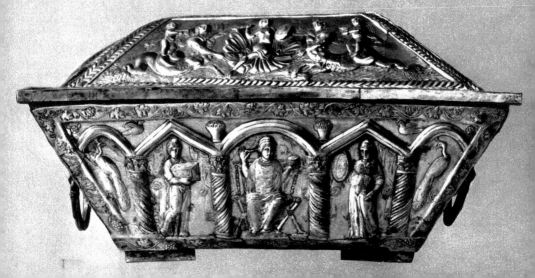

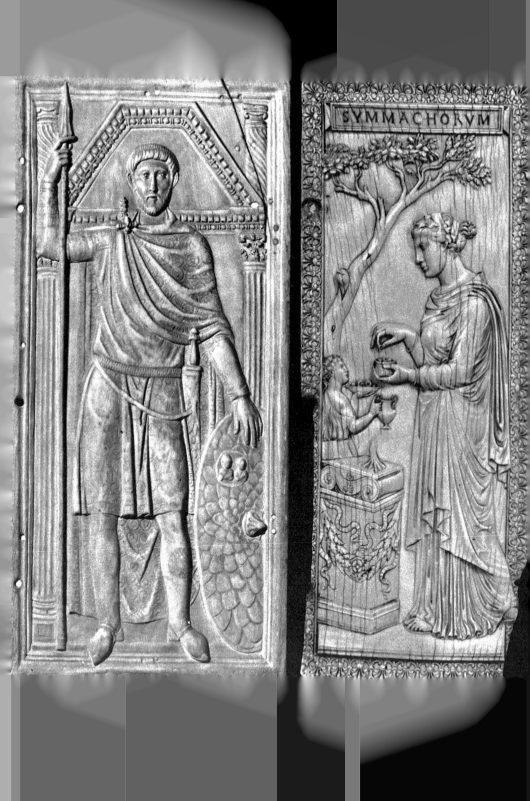

At the end of the 4th century churches began to be built in increasing numbers throughout the empire. Regional traditions of construction and forms of worship operated upon the Constantinian prototypes, and autonomous highly differentiated provincial styles proliferated. The East soon became the focus of architectural development, with Constantinople in Asia Minor and Antioch in northern Syria taking the lead. Rome, although no longer the universal arbiter in architectural matters, remained highly influential in the West chiefly through the three-aisled, usually transeptless basilican church which was developed there around the middle of the 4th century and endured for hundreds of years. This classic basilica (40, 44) retained the basic Constantinian articulation and esthetic and spiritual character; but the layout was simplified and the proportions altered so that the elongation of the body of the church was further accentuated. Also heightened was the contrast between the darkness of the narrow, windowless aisles and the core of the church brightly illuminated from above by large windows in the clerestory and apse. The tall, slender arcades—the architrave in S. Maria Maggiore, which emphasizes the weight of the walls, is exceptional—and the narrower, color-encrusted wall area above contribute to the effect of suspended lightness and measured clarity of these basilicas, exemplified by S. Sabina in Rome and the churches of Ravenna (46).

The five-aisled basilica was infrequently resorted to; the last such building (and also the last imperial construction) in Rome was S. Paolo fuori le Mura (386). In North Africa, this type was amplified into the many-aisled and thus cross-directioned church (Timgad had nine aisles) which would be influential for Islamic architecture.

In type and style, the basilica of the Eastern Empire differed markedly from that of the West. Hellenic Greek tradition survived in the more emphatically structural organization of space, in the renunciation of optical illusion and dynamic effects in favor of more sculptural, static articulation. Eastern churches have aisles in two stories; fine fifth-century examples are the Studios Monastery, Constantinople (41), which has no transept, and the church of the Acheiropoeitos, Salonika. These aisles are sometimes extended around the transept, as in H. Demetrios, Salonika (42). The eastern end was not merely attached to the nave, as in the West, but structurally interlocked with it. The chancel, introduced into the transept area, thus gained importance; and, as the focus for the solemn ceremonial of the Eastern liturgy, undoubtedly influenced the new disposition. Stylistically, these modifications were of the greatest consequence: Via the encircling aisles and galleries, the double rows of colonnades or arcades, the architraves and cornices, horizontals came to predominate in the shaping of space and wall (45). These Eastern churches exhibit a balance of length, breadth, and height. They are shorter and broader than contemporary Western ones. The intervals between the columns are greater. The light from the windows in the outer walls is more evenly diffused throughout. Large expanses of mosaic surfaces are lacking. In their exterior aspect, too, these basilicas are clearly articulated, solid with sculptured details, such as the polygonal sheathing of the apse and the framing of the windows. The façade is a monumental, classicizing showpiece with rows of columns, portico, broken pediment, and

undercut entablature. Good examples in Constantinople are the Theodosian additions to the Constantinian church of H. Sophia (415), and the Studios Church (463). The influence of the Eastern galleried basilica in the West is attested to in Rome by the present east end of S. Lorenzo from the 6th century and by S. Agnese from the 7th.

The cruciform church underwent an important development in the eastern Mediterranean area in the 5th century. Four, customarily barrel-vaulted arms of approximately equal length were extended from a projecting, towerlike, central area (the crossing), which is often domed. From outside, as from within, these buildings, which soon became common throughout the empire, appear as austerely membered, sculptured units graduated hierarchically upward— for example, the mausoleum of Galla Placidia, Ravenna (47). The variants are legion; one was achieved by the addition of long cross-like arms to an originally self-contained, square, domed martyrium—for example, the church of St. John in Ephesus (43). In the most splendid martyrium-pilgrimage church of this type, Kal'at Sim'ān in northern Syria (52, 53), four monumental basilicas converge on a wide, elevated, tower-like octagon with the column of St. Simeon. To adapt the martyrium to congregational use, an apse replaced the eastern arm; the western arm, containing one or three aisles, was extended, to produce a longitudinal building balanced by an emphatic east end. This grouping of units, this tension between the urge lengthwise and the urge upward was to be of basic significance for the West.

A no-less-important precursor of Romanesque architecture evolved in Syria, whose architectural repertoire was otherwise divergent from other Early Christian styles. Aisleless chapels were erected and also three-aisled transeptless basilicas of massive hewn stone (ashlar) with short, widely spaced, pillared (or, more infrequently, columned) arcades. The aisles were barrel-vaulted; small windows usually were cut into the smooth, thick walling of the lower zone, whose stone construction remained exposed. The east end (bema) is a typical feature; the large, externally polygonal, internally round apse is flanked by two adjoining areas (pastophoria), used as sacristies or for other specific liturgical purposes. Just as the interior impresses by its use of stone and its ponderousness and simplicity, the exterior is effective as a vigorous cubic mass, dominated by a powerful twin-towered façade with a loggia between the sturdy towers (50). The rich plastic articulation of the heavy ashlar walls is indicative of the Roman and oriental traditions in which these buildings were rooted. Excellent examples of the rich Syrian inheritance are the so-called Syrian cathedrals Dêr Turmanin, Qalb Lauzeh, Ruweha, and Kal'at Sim'ān. Tripartite façades, pediments, rows of small columns (which also appear in the window zones of the interiors), strongly profiled cornices, and other features give a rigid organization to the whole exterior, especially to the façade and apse (48, 49). Simultaneously, decorative, unclassical motifs make their appearance, such as the bent cornices and portal frames and the band-like relieving arches over the windows.

In the heart of the Eastern Empire in Constantinople and Asia Minor, a further innovation, important for the future of Byzantine architecture, took place—the incorporation of the dome into the basilica, a mingling of elements of centralized and longitudinal construction. The dome had been used to mark the area before the apse; greatly enlarged, it spanned extended arcades and disrupted the longitudinal flow of the church with its massive piers

—for example, at Meriamlik in Asia Minor (54). But with the transposition of the dome to the middle of the basilica it was not long before a happy, reposeful balance was struck—for example, at Alahan Manastiri, though here with the older form of a wooden dome over corner niches (51, 55).

Extraordinarily complex plans were characteristic of centrally planned buildings. They were octagonal or quatrefoil, surrounded by a concentric or square-niched ambulatory (as at Esra, at Bosra, and at S. Lorenzo, Milan). In spite of the focus on the apse, the cross shape was often emphasized—for example, at S. Stefano Rotondo, Rome. The contrast between a lofty, light center and low, dim ambulatory was retained, but it was enriched by picturesque intersections and influxes of light.

40 S. SABINA, ROME. 422–32. Plan. Mature type of three-aisled basilica without transept, very long with broad nave.

41 CHURCH OF ST. JOHN OF THE STUDIOS MONASTERY, ISTANBUL. Consecrated 463. Plan. Now a ruin. Typical galleried basilica with colonnades, polygonal apse, and narthex. Broad, compact nave, system of fixed proportions in plan and elevation. Clear, plastic articulation of the façade.

42 H. DEMETRIOS, SALONIKA. Plan. 5th-century building, slightly altered after fire in 7th century (alternation of supports, larger transept). Reconstructed after fire of 1917. Five-aisled galleried basilica with clerestory, three-aisled transept, and raised east end over crypt.

43 CHURCH OF ST. JOHN, EPHESUS. State in 5th century. Plan. Originally simple square, domed martyrium over saint's grave; cross-shaped basilical arms added, eastern end enlarged to five aisles with apse. Rebuilt in the 6th century by Justinian. Destroyed.

40
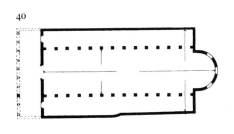

41
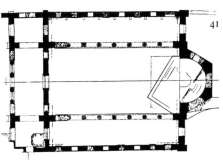

42
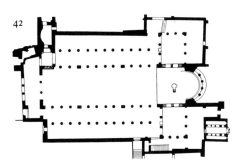

43
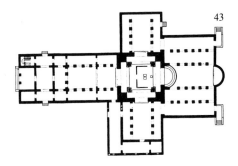

44 S. Sabina, Rome. Interior toward the east. Classic 5th-century basilica: light, longitudinal emphasis, slender arcades (classical columns), large windows, very thin walls.

45 H. Demetrios, Salonika. Interior toward the east. Most monumental example of the Eastern galleried basilica; full-bodied, graceful structure.

46 S. Apollinare in Classe, Ravenna. 535–49. View from the east. Three-aisled basilica, subsidiary apses (pastophoria), raised east end over crypt, narthex. Atrium destroyed. Medieval round tower. In the Ravennate basilical tradition, fusing Roman and Eastern elements: well proportioned, large windows, apse polygonal without, shallow wall relief with relieving arches around the windows, "windswept" acanthus capitals. Pastophoria contribute to the crystalline, plastic structure of the east end.

47 Mausoleum of Galla Placidia, Ravenna. After 425. View toward the southeast. Formerly built onto the narthex of the palace church of S. Croce. Centrally planned cruciform building. Somewhat longer north arm. Pendentive dome over raised center. Austere units bound firmly to the central core. Decorative blind arches.

48 Kal'at Sim'ān (near Aleppo, Syria). Monastery church of St. Simeon Stylites. 460–90. Façade of the south church. Motif of the Roman triumphal arch applied to porch. Arcades on columns or pilasters, broken pediment. The horseshoe-shaped discharging arches and ribbon-like window surrounds are characteristically Syrian.

49 Kal'at Sim'ān. Apses of the east basilica. Massive central apse with two rows of columns, cornice, and arcaded frieze.

50 Dêr Turmanin (northern Syria). 5th century. Exterior reconstruction. With Kal'at Sim'ān, Qalb Lauzeh, Ruweha, and others, one of the so-called Syrian cathedrals. Basilica in finest ashlar. Square and fortress-like in proportions and in the massive effect of load and support. Broad-columned arcades in Dêr Turmanin, solid pillars in Qalb Lauzeh and Ruweha. Classicizing pilasters and columns, within and without, some unclassical ribbon-like arches. The monumental façades can be called important precursors of the Romanesque: note the tower-like corner projections on the façade with a loggia between them above and monumental arched doorway below at Dêr Turmanin. Main front and towers with large windows and pediments, emphatically tiered.

51 Alahan Manastiri (Asia Minor). Perhaps 5th century. Interior toward the west. Domed basilica. Stronger centralization and penetration of verticals and horizontals: wooden dome on squinches shifted toward the center and raised. Uncompromising squareness of masonry and space. Ashlar. Classicizing detached columns.

52 Kal'at Sim'ān. Exterior reconstruction. Monumental layout, clear, graduated grouping of geometrical units.

53 Kal'at Sim'ān. Plan. Four three-aisled basilical structures merge as a cross into a broad octagon (either open or with a wooden dome), in whose center stood the saint's column (an object of pilgrimage). Three apses in the east arm.

54 Meriamlik (Asia Minor). 5th century. Plan. Domed basilica. Insertion of a centralizing element into a longitudinal building: a dome on solid piers between the apse and the basilical nave. Barrel vaults over aisles.

55 Alahan Manastiri. Plan.

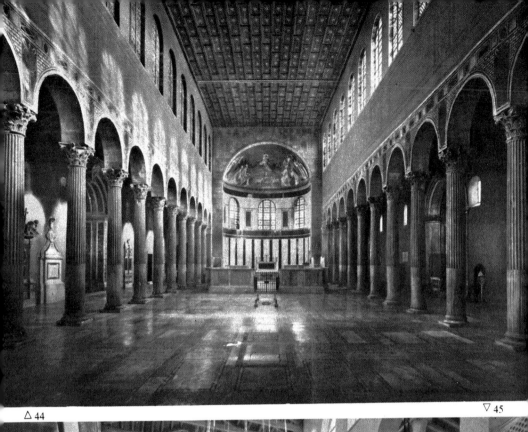

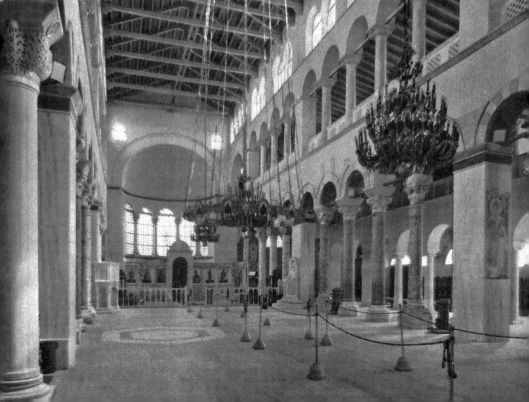

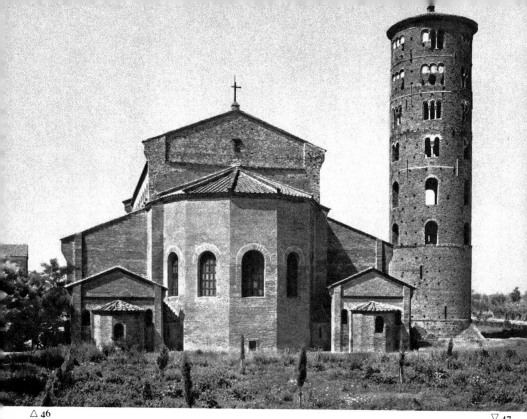

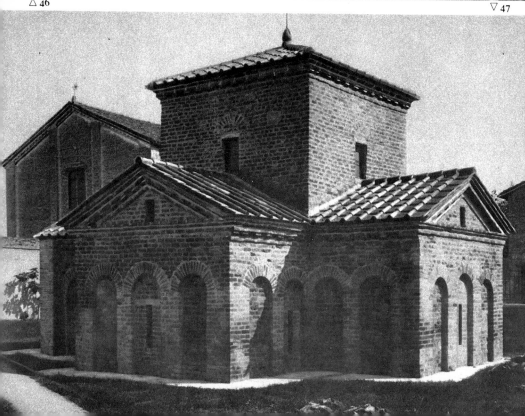

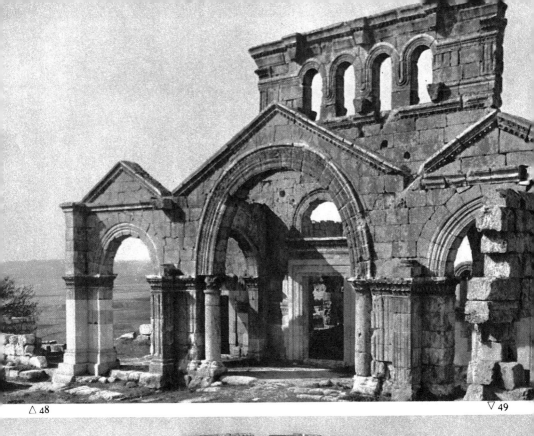

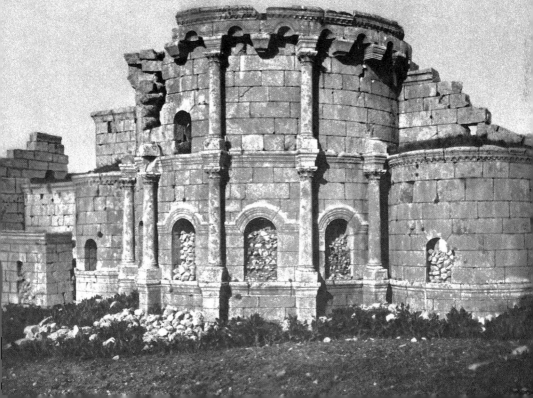

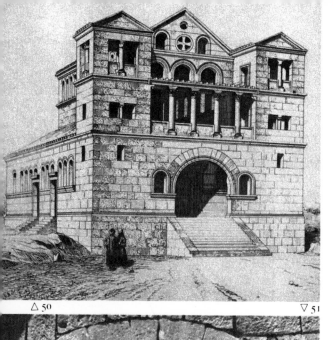

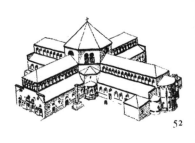

52

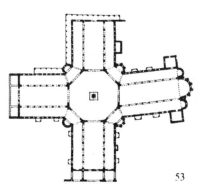

53

△ 50

▽ 51

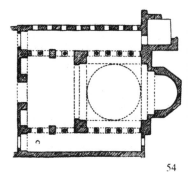

54

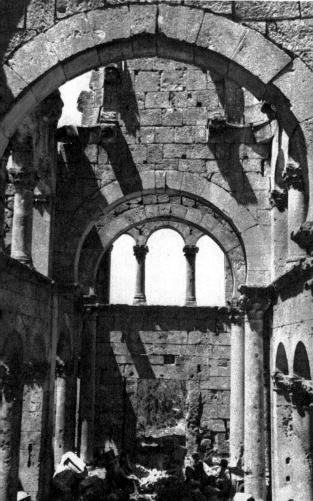

55

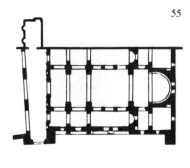

At the beginning of the 5th century an abrupt stylistic change brought about by the resurgence of the anticlassical aspect of the Late Antique led to the virtual negation of classical forms. The strength of this new style lay less in its esthetic values than in the expressiveness of its affirmation of the otherworldly and transcendental. The new stylistic tendency is already perceptible in an early 5th-century statue of an official from Aphrodisias (60). The limbs have rigidified; they have been absorbed into the massive, compact block, on which thin, geometrizing folds of drapery are inorganically inscribed. Fifty years later this tendency to abstraction reaches its most pronounced form: The Ephesus portraits (61) are exaggeratedly or ascetically wasted, reduced to planes and prominent details, dry in features, but at the same time ecstatic and visionary. Similar developments can be observed in ivory reliefs—excellent examples of which are the (Western) consular diptychs. (The Boethius diptych of 487, 65, represents a late phase). The religious tablets achieve an easy-to-read forceful narrative style. Composition is less rigid: The squat, compact figures with expressive faces of the London Passion Tablets (63) of c.420 contrast markedly with the figures from a later book cover in Milan, which are compressed and thin and whose lively movements give the ivory its vivid expressiveness. The wooden doors of S. Sabina in Rome (which shows strong Eastern influence) are superb, varied examples of this planar, expressive style. In one of the panels the gently modeled ground of the relief has been assimilated into the over-all flow of motion (Ascension, 64).

Among the mosaics surviving from this period (in Rome, Naples, Capua, and elsewhere) those in S. Maria Maggiore in Rome are remarkable for their high quality; they furnish rare evidence of the full program of an Early Christian decorative scheme. This provided for Old and/or New Testament cycles in the nave, and concentrated theological and ceremonial themes in the arch before the apse, in the apse itself, and in the dome. The mosaics also are a classic example of singular stylistic divergences (which occur continuously) conditioned

56 MAUSOLEUM OF GALLA PLACIDIA, RAVENNA. c.425–50. Mosaic lunette on the entry wall: Christ as Good Shepherd. The sculptural solidity and full color, a Roman legacy, are rigidly stylized into an axial, geometrized composition.

57 S. MARIA MAGGIORE, ROME. Mosaic on the arch before the apse. Detail: Annunciation, Adoration of the Kings (with Mary/Ecclesia and the Synagogue). The church was rebuilt and decorated with mosaics by Pope Sixtus III (432–44). On the triumphal arch the youth of Christ symbolically interpreted according to the decision of the Council of Ephesus, 431 (dogma of the two natures of Christ, and Mary's Divine

Motherhood). Monumental style, disappearance of depth to enhance the solemn representation of classically statuesque figures in the foreground plane. Somber color.

58 S. MARIA MAGGIORE, ROME. Nave mosaic: the Jews' insurrection against Moses. Characteristics of the impressionistic style of the period in which this Old Testament illustration was engendered are still evident. The richly detailed scenes (Abraham, Jacob, Moses, Joshua partially destroyed) possibly taken over from book illumination. Period style: sculptural abbreviation, violent gestures, strips of color used as atmospheric ground.

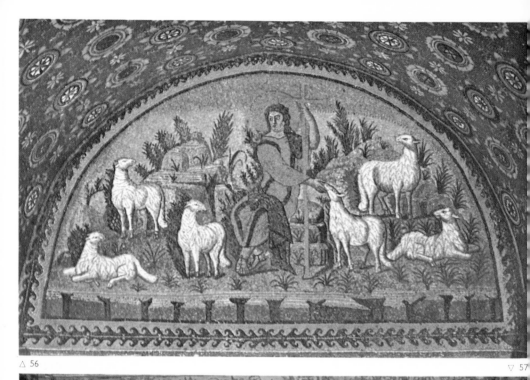

△ 56

58

by subject matter; for figures and scenes frequently preserve certain stylistic traits from the period of their invention. Thus the Hellenistic legacy continues to leaven the Old Testament scenes in the nave (58) with its brightly colored narrative style and small naturalistically expressive figures set in an atmospheric landscape. But even here the newer style that predominates on the triumphal arch (57) partially intrudes. The simple, dramatic New Testa-

55

ment scenes in these mosaics, which represent the youthful Christ triumphant, are executed in a hieratic style: Flat, monumental forms, starkly outlined, are tightly grouped on a shallow foreground stage. They adhere to Roman tradition in their weightiness and rich coloring but to the style of their time in spiritual intensity and graphic rendering. At this point the cultural center of the Western Empire is no longer Rome but Ravenna.

Influenced by Rome and northern Italy but above all by Byzantium, the art of Ravenna continued the tradition of Eastern court art, with its own interpretation of classical prototypes, and displayed a special partiality for complex theological programs. This explains the traits which are so distinctively its own in all its phases—great splendor and hieratic remoteness. The sarcophagi can be clearly differentiated from Roman ones. Following Eastern tradition, they show only one scene—for example, *traditio legis* (*62*)—with few figures and frequently only with symbols. The architecturally framed boxes with high vault-like covers are worked on all four sides; the figures stand on a shallow stage before a smooth ground and are made spiritually effective by their sweeping gestures. Soon, however, the rigid compositions of these sarcophagi slackened; the rounded plasticity of the smooth, classically modeled figures, following the anticlassical stylistic trend, was simplified into flatness, and the compositions finally petrified into dry, sketchy lines.

59 MAUSOLEUM OF GALLA PLACIDIA, RAVENNA. Interior toward the east. Mosaic on classic blue ground above a marble plinth. Proportions distorted by raising of the floor. In the east lunette St. Lawrence triumphantly advances to the gridiron (building originally intended as a chapel to St. Lawrence), Good Shepherd in opposite lunette. Apostles in the lunettes under the dome adore the cross in the starry sky. Symbols of evangelists in the dome, and four additional apostles in acanthus scrolls in vaults of east and west niches.

60 HIGH OFFICIAL. Beginning of 5th century. Archeological Museum, Istanbul. Marble. From Aphrodisias. Late example of Theodosian court art. Rigidified body; thin, geometrized folds of drapery. Spiritual portraiture.

61 PORTRAIT BUST OF EUTROPIUS. Mid-5th century. Kunsthistorisches Museum, Vienna. Marble console from Ephesus. The extremely elongated, ascetic shape fully serves the visionary expression.

62 RINALDO SARCOPHAGUS. c.430. Ravenna Cathedral. Front: Christ enthroned; Peter and Paul proffer wreaths. Other sides: symbols. Sealed vault cover, architectural frame, plastically modeled, delicate figures, rigorous organization.

63 PANELS OF THE PASSION. c.420. British Museum, London. Fragments of an ivory casket; Pilate; Carrying of the Cross; Peter's denial; death of Judas; Crucifixion (the earliest surviving); Marys at the tomb; doubting Thomas. Originated in northern Italy.

64 WOODEN DOOR. c.430. S. Sabina, Rome. Detail: Christ's Ascension. 18 of 28 panels survive. Scenes from both Testaments, profound symbolism. Eastern influence on iconography and style.

65 THE CONSUL BOETHIUS. 487. Museo Civico, Brescia. Ivory diptych. Extremely broad, stiff, planar handling; ornament inscribed rather than molded.

66 ORTHODOX BAPTISTERY, RAVENNA. c.458. Interior. Octagonal plan. Floor level originally lower. Huge font for immersion rites. Walls with arcading, richly colored revetment; mosaics in the dome, lunettes, triangular fields between arches; formerly painted stucco figures (prophets, scenes of salvation), marble incrustation.

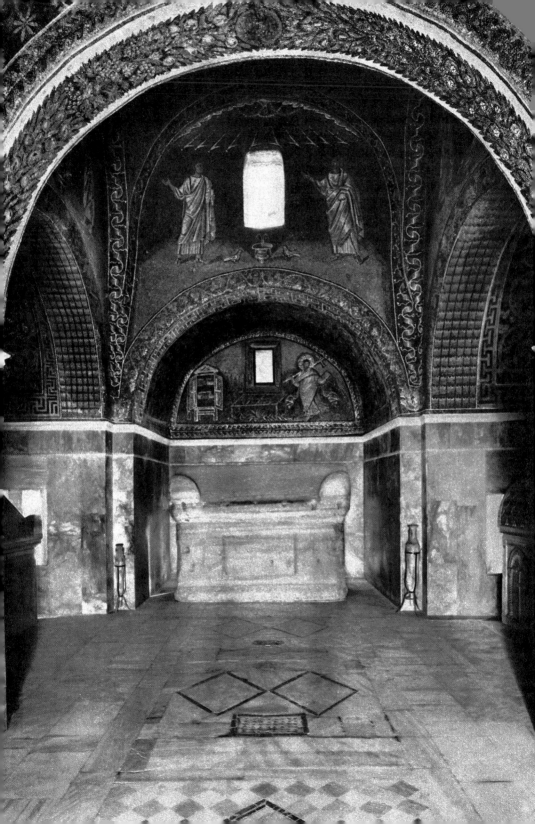

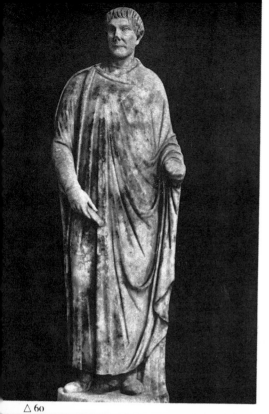
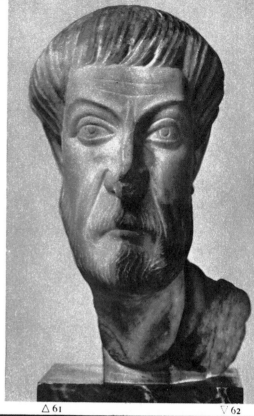

△ 60 △ 61 ▽ 62

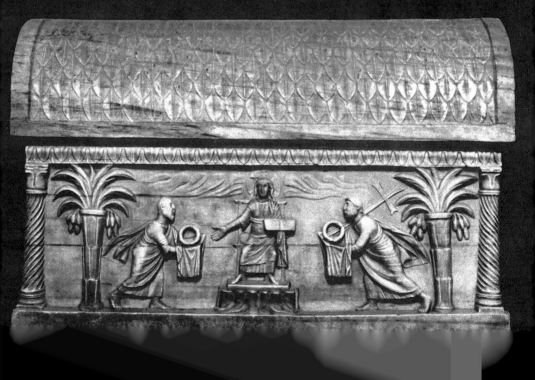

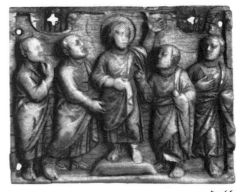

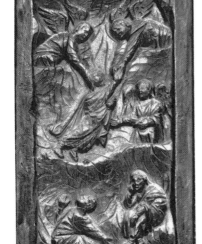

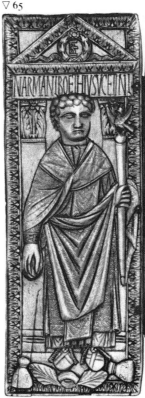

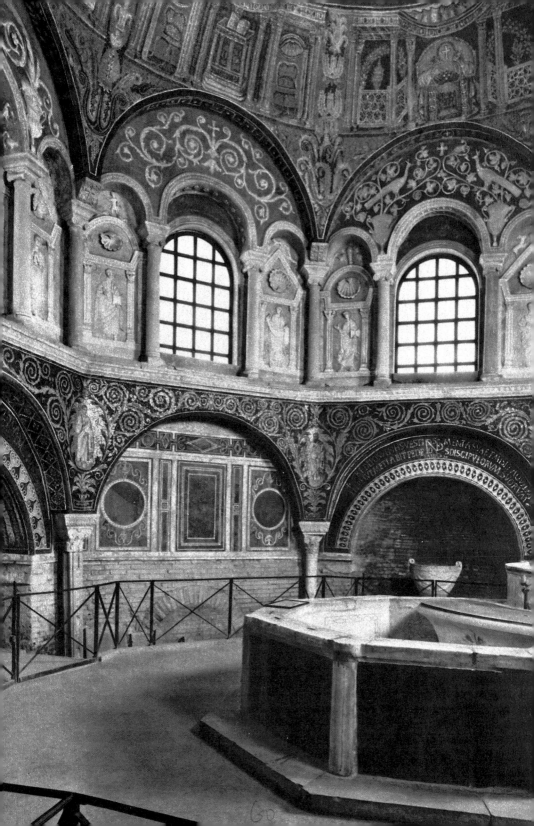

Ravenna's magnificent mosaic art began with the still classically inspired mausoleum of Galla Placidia (59). But while the apostles are still represented with the rounded forms and relaxed movement of antique philosophers, the image of the Good Shepherd—beardless, in the Roman tradition—is transfixed in a formularized pose within an ornamental pattern, with the natural landscape setting indicated by step-like recessions (56). Almost contemporary with the mausoleum, the Orthodox Baptistery (66) is also filled with mosaics well adapted to the architecture, notable for a balanced relationship of figures, scenes, and ornament, and intellectually unified by thematic connections. In their elegant stylization, their classical idealization, and the resplendent tonal accord of their robes of blue, gold, and white, the apostles in the cupola (67) are especially close to Eastern court art. Elongated and almost weightless, they seem to hover in front of the unreal atmosphere created by the blue ground. That the stylistic revolution reached Ravenna can be seen in the dome of the Arian Baptistery, which dates from fifty years later. The theme and composition are related, but strongly simplified. The broad figures, more graphically than sculpturally articulated, are transfixed in rhythmic uniformity. The mosaics of S. Apollinare Nuovo (the former palace church of Theodoric), which date from not much later, reflect the beginnings of the great synthesis that was to initiate the classicism of Justinianic art: The scenes from the life of Christ (68, 69) contain few figures and no narrative detail. The severe, often symmetrical compositions frequently place Christ in the center and often isolate him in tense contrast to other figures; furthermore, the somber color is dominated by his purple robe against the gold of the ground. The figures in the foreground, summarily articulated and outlined, combine to form a depthless relief, whose often dramatic intensity of expression captures the eye of the observer. This spiritual monumentality. marks the transmutation of Early Christian to Byzantine art.

67 ORTHODOX BAPTISTERY, RAVENNA. Cupola. Baptism of Christ, procession of the apostles proffering martyr's crowns; four thrones and altars in imaginary apses. Style is close to Eastern courtly classicism.

68 S. APOLLINARE NUOVO, RAVENNA. Nave. Mosaic: Christ separates the sheep from the goats. Before 526. Three-aisled basilica consecrated as the palace church of Theodoric in 504. Three zones of mosaics in the nave. Above: 26 scenes from the life of Christ (north side: mostly miracles; south side: Passion, without the Crucifixion). Middle: prophets and patriarchs. Below: the port of Classis, palace of Theodoric; procession of martyrs toward Mary or Christ (557–70). The Christ scenes produced under Byzantine renaissance influence have summarily conceived figures that are nevertheless generous and still classically substantial.

69 S. APOLLINARE NUOVO, RAVENNA. Nave mosaic: Christ before Pilate.

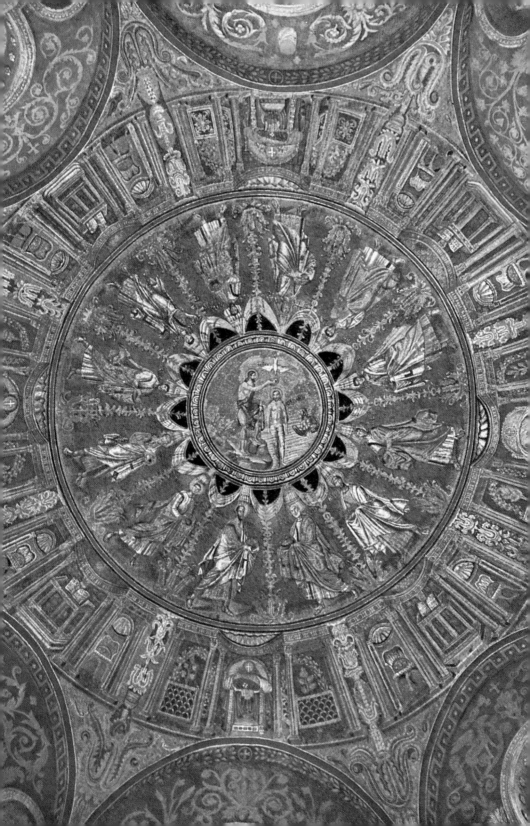

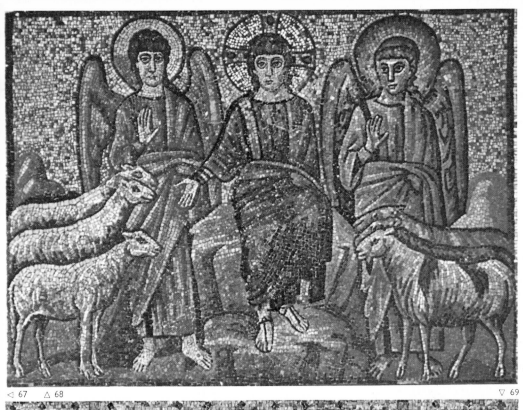

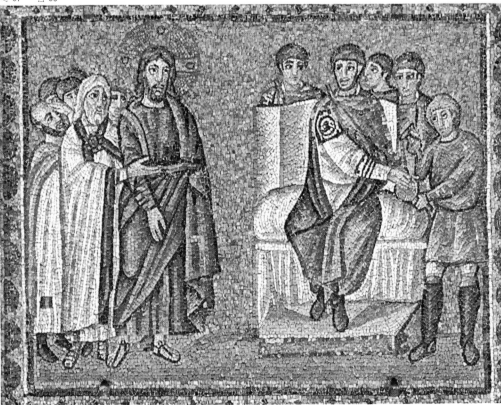

BYZANTINE ART

INTRODUCTION

For more than a millennium, from the Late Antique to the threshold of the modern era, the Byzantine Empire held sway in the lands of the eastern Mediterranean. Its importance for the history and cultural evolution of the West cannot be overestimated. For centuries, Byzantium was the sole European state, an advance post on the borders of Asia. In its unremitting struggle for existence against the peoples of the East, the destiny of the West was more than once decided. The culture and art of the West owed their very foundation as well as a wealth of inspiration to the Byzantine example. Only Byzantium uninterruptedly carried on the tradition of the Christianized Late Antique. Roman law, codified in Byzantium, retained its validity throughout the Middle Ages and is still taught today. Lying in lands of Greek culture and speech, Byzantium became the custodian of the Greek tradition as well. Literally a treasure house of antiquity, Byzantium preserved the works of philosophers and poets and all the branches of classical learning, which would otherwise have been irrevocably lost. From the early Middle Ages to the Italian Renaissance new waves of Byzantine influence continually fertilized the art and spiritual life of the West. The Slavic peoples of the Balkans and Russia received Christianity and the basis of their culture and art from Byzantium. Once a world capital and worldwide in its influence, Byzantium preserves even today its power as an ideal: for it was there for the first time that the synthesis of Rome, Hellas, and Christianity was achieved that is at the root of European culture. In many respects Byzantium was the schoolmistress of Europe.

The Byzantine Empire was forged between the 4th and 6th centuries out of the collapsing Roman Empire. Only the Eastern half of the empire was able to withstand the crises of the era of tribal migrations and to consolidate itself as a new state that could perpetuate Roman political and social traditions. Even when, in the early 7th century, a fundamentally transformed Greek and Christian state stood complete, Byzantium remained nominally a Roman empire, whose citizens called themselves nothing other than *Rhomaioi*—Romans. The ideological center of this tradition-conscious development was the new capital on the Bosporus, which Constantine had intentionally founded in 324–30 as a second Rome. This "Rome of the Christian world" was the legitimate heir of Imperial Rome, a conception that during the Middle Ages lost none of its fascination for either East or West. Byzantium remained forever faithful to the Roman claim to universal rule, which was reinforced by the political implications of the Christian idea of worldly dominion.

On only one occasion, under the great Emperor Justinian I (527–65) was the Roman Imperium restored under the aegis of the New Rome with the reconquest of the western Mediterranean (North Africa, Italy, and Spain). But Justinian's cultural creations did achieve lasting importance—his codification of Roman law in the *corpus iuris civilis* and the mighty churches constructed throughout the empire, among them the greatest church of Christendom, Hagia Sophia in Constantinople. (In this book, Hagia, the feminine form, and Hagios, the masculine form of the Greek word meaning Saint, or Holy, are abbreviated H.) The sudden collapse of Justinian's empire marks the end of the Late Antique. Although important bridgeheads of Byzantine culture in the West long persisted in the exarchate of Ravenna and in southern Italy, the empire was now finally concentrated in the lands of the eastern Mediterranean, with its core in Asia Minor and the Greek coast. There followed an uninterrupted sequence of defensive wars to the north and east, which, however, could not stave off a gradual constriction of the empire's boundaries. The conquests by the Slavs and Avars on the Balkan mainland meant that powerful enemies stood in threatening proximity to the capital. The Sassanid Persian Empire within a few years conquered Syria, Palestine, and the granary, Egypt; while the organization of the state, late Roman in character, finally disintegrated in bloody civil wars.

Salvation was brought by Heraclius I (610–41), who gave the Byzantine state its final shape. His throughgoing administrative reforms—including the splitting up of the empire into military zones, or "themes," and the settlement of soldiers on small hereditary farms on condition of military service—assured the empire the necessary permanent and potent defensive ability. It proved its worth at once in the extraordinary victories of the emperor, in which both the Avars and the Persian Empire were eradicated. Yet within a decade all the oriental provinces from Armenia to Egypt went under in the flood of the Arab invasions. The sieges of Constantinople (673–78 and 717–18) threatened its very life; the eventual Byzantine victory saved the empire and barred the path of the Arabs to Europe, but the bitter defensive wars against the Arabs and the Bulgarian Empire (founded in the 7th century) would last for many centuries.

During the 8th and 9th centuries a grave internal and religious conflict shook the empire, the Iconoclastic Controversy, which jeopardized its existence and the continuity of Byzantine culture. Leo III's decree of 726 forbidding the worship of images resulted in the virtually wholesale destruction of religious images and the fanatical persecution of the image worshippers (iconodules). The victory of orthodoxy and the restoration of the cult of images in 843 represented a victory for Greek character and cultural inheritance, and it reinforced the two hierarchical powers, the church and the imperium. It initiated a great political and cultural efflorescence, the so-called Middle Byzantine period of the 9th, 10th, and early 11th centuries. A succession of exceptional emperors, mostly from the Macedonian dynasty, maintained for the first time a consistent policy of expansion with dazzling success against Arabs, Bulgars, and Russians, and after the destruction of the Bulgarian Empire by Basil II (963–1025) Byzantium reached its greatest extent—from the Caucasus and the Euphrates to the Danube and Adriatic. The conversion of the Slavs to Christianity in the 9th and 10th centuries brought the whole of Eastern Europe under the ecclesiastical authority of the

patriarch of Constantinople and opened up the most important sphere of influence of Byzantine culture. This accession of power to the Orthodox church reinforced its independence against the claim to universality of the Roman papacy; the ultimate schism of 1054 only brought recognition to the long-standing and effective separation of the churches of East and West.

In the 11th century, with the dissolution of the system of "themes" and the enfeeblement of the central imperial power, the decline of the empire began. Extensive territory was lost to the Seljuks, after a disastrous defeat at Manzikert, in 1071. It is true that the emperors of the Comnenian dynasty succeeded in establishing Byzantine supremacy in the East in the late 11th and 12th centuries, but new dangers threatened from the West—from the powerful Normans and the Italian maritime republics, especially Venice, which had been granted privileges in 1082. But it was notably the Crusades that touched off a running conflict, in which the cultural opposition of East and West was expressed most violently. In the latter part of the 12th century the Serbs and Bulgars extended their empires, and Asia Minor fell to the Seljuks, leaving the impotent remnant of Byzantium an easy prey for Western aggression. Under Venice's lead the Fourth Crusade was diverted to Byzantium, Constantinople was taken, and a Latin empire was set up on the Bosporus (1204–61). The restoration of Byzantine rule began in Nicaea, where a legitimate successor state was consolidated. Subtle statesmanship on the part of emperors in exile won back Byzantine holdings in Greece and Asia Minor; and Byzantium's international recognition as a great power was re-established after the reconquest of Constantinople in 1261 by Michael VIII Palaeologus. But the inner decay of the empire could not be arrested: The state was impoverished, militarily enfeebled, and rent by civil war. The Serbs were able to erect a great empire near Byzantium and, most gravely, the Ottoman Turks overran the whole of Asia Minor at the beginning of the 14th century. Once the Turks had occupied the Balkans, after their victory at Kossovo in 1389, Byzantium was reduced to the capital and the despotate of Morea on the Peloponnesus. The ecumenical policies of the last emperors resulted not in the hoped-for assistance from the West but instead in a divorce of the Russian Orthodox church from the Greek. For the last fifty years of its existence Byzantium was merely a vassal of the Turks, and it disappeared completely with the fall of Constantinople in 1453.

The Byzantine Empire had its beginning and end in Constantinople, which for a millennium was its heart. The political and cultural pre-eminence of the capital was so complete that it can be said to have determined the history of the empire. Though initially the ancient Hellenic cities and later Salonika made important contributions to artistic development, from the 6th century onward criteria and models were supplied by the capital alone: Byzantine art is first and foremost the art of Constantinople. At the juncture of two continents, established on land and sea at the intersection of worldwide trade routes, Constantinople was virtually predestined to assume a world importance. As permanent residence of the emperors and seat of the patriarchs it was the heart of a centralized state structure and of the Orthodox church, a privileged center of trade and military base. It was the focus of the most extravagant court ceremonial and of the most savage civil wars. Constantinople was at all times the most populous and by far the most splendid city in Europe, filled with

numerous churches, but also with ancient statues and other ever-present tokens of the classical past. We can gain only a scant idea of the huge and luxuriously decorated imperial palaces from descriptions and from the magnificent floor mosaics that survive from the 5th century. Constantinople was above all else a spiritual and artistic center. The university steeped in the classical tradition and the equally important patriarchal school brought forth in an almost steady stream a vigorous, humanistically educated elite and prominent theologians and scholars of all branches of classical knowledge. Art and craftsmanship were concentrated in the capital in a huge number of workshops and scriptoria. The luxury crafts —mosaic, enamel, mosaic icons, silk weaving, goldsmithery—long had a monopoly there. Every work produced in Constantinople was distinguished by a higher measure of artistry and technical refinement and by an extreme subtlety of taste that could only have been produced in the soil of a highly sophisticated, venerable, and continuous culture. It was its supreme perfection that made Byzantine art for the West so desirable and inspiring, and yet so inimitable.

Byzantine art forms a unity in both form and content. It was the most consistent and comprehensive artistic "school" of the Middle Ages. Its pictorial programs and individual themes matured to such a level of conceptual clarity that, sanctioned by ecclesiastical authority and so transmitted, they remained viable for centuries. Their esthetic principles were the accurate reflection of content and the preservation and renewal of classical tradition. Never subjected to an inflexible regimentation, Byzantine art depended upon certain ideological and formal conventions that set limits to artistic freedom, but were elastic enough to permit a lively development of forms and styles.

Byzantine art was first and foremost a religious art, but it was neither a popular art nor a monkish one, both of which characteristics it developed late and only in a rather limited way.

It bears the decisive impress of the religious and humanistic outlook and taste of the highly educated court elite, of the aristocracy and higher clergy, who were its most important patrons. The determining influence came from imperial art, which was equally crucial for the West. The emperor was generally depicted in his religious function—with all the insignia of his terrestrial power, but exalted by the severity and immobility of the representation into the sacred sphere, as was appropriate to the representative of God on earth. Each of these imperial portraits is a political document, a symbol of the God-given legitimacy of emperor and realm. Imperial patronage had a similarly politico-religious import: as a demonstration of orthodoxy and consciousness of tradition, of might, and cultural superiority. The most important churches and many of the large monasteries were imperial foundations; the leading workshops of all branches of art were in the service of emperor and court. Imperial decrees began and ended the Iconoclastic Controversy and thus affected the destiny of Byzantine culture, and a succession of learned men on the throne decisively fostered the revival of the classical inheritance. Thus it was an art primarily inspired by imperial commissions that gave each period its spiritual and artistic profile. The very names of the periods when Byzantine art flourished are bound up with rulers and dynasties—Justinianic, Macedonian, Comnenian, and Palaeologan.

As in the history of the state, the first centuries of Byzantine art saw a transition from Early Christian and Late Antique, and from the multiplicity of styles cultivated in the old Hellenic cities, and in Rome, Syria, and Palestine, to the homogeneous art of Constantinople, which effectively fused and perpetuated all these currents. The art produced between the 6th and the 9th centuries is chiefly significant for having prepared the ideas, the themes, the formal principles, and the standards which after the Iconoclastic Controversy would be refined into the consistent system of Middle Byzantine art. The great Justinianic period produced for the first time an imperial art that revived classical pictorial illusionism, without sacrificing the powerful spiritual abstractions of the Early Christian period. The post-Justinianic period developed two key vessels of Byzantine, indeed of Orthodox art: the domed cruciform church, an ideal type produced by theological symbolism, and the icon, a panel painting that anticipated the Western altarpiece in form but which was conceived and which functioned as a cult image. Revered to the point of idolatry, the icon sparked the Iconoclastic Controversy.

In the raging dispute over the representational sacred image, its defenders developed a doctrine of images that was to affect subsequent art and religious thought in Byzantium. This doctrine was based on the central christological tenet of the incarnation of God as Christ, which, it was argued, authorized his depiction, and on the Neoplatonic concept of the identity of the image with the manifested idea, not materially, but through its nature. Since the depiction participated in the sanctity of the idea, it evoked reverence that was transferred to the idea, if the images of the divine and holy personages and events were correctly painted, agreeing in detail with authentic sources (the Holy Writ and the Apocrypha). The consequence of this doctrine of images was a purified iconography that determined the authentic and distinctive manner in which holy personages and events should be depicted. It also had a decisive effect on the programs and esthetic of Byzantine art, which reached its purest expression in the Middle Byzantine period.

The decorative programs of Middle Byzantine churches were the most consistent of the Middle Ages, for the hierarchical spaces of the domed cruciform church offered an ideal opportunity for manifold symbolic references. The highest, lightest, and architecturally purest zones stood for Heaven. They were reserved for the depiction of the eternal and transcendental: In the cupola appeared the monumental figure of Christ Pantocrator (the All-Powerful) or occasionally the eschatological themes of Ascension and Pentecost; in the apse, the Madonna as symbol of the Incarnation. The second zone—squinches, tunnel vaults of the crossing, and upper areas of wall—received a cycle based on scenes from the life of Christ and the death of Mary that had most important implications for salvation and resurrection. It also corresponded to the calendar of the Christian year, for the event of each feastday was represented. And each holy place—for example, Bethlehem or Golgotha— had its symbolic place. In the third, most terrestrial zone, the community of saints was distributed, with the strictest attention to rank, over niches, arches, and pillars—from the church fathers in the chancel, to the martyrs in the naos (the core and sanctuary), and the holy women in the narthex (in Eastern churches, a transverse vestibule). This rigorous symbolic system was enriched from the 12th century on (frequently in the narthex), but

only by scenes that were easily related to it—scenes from the life of Christ, Mary, and certain saints; a few typologically significant scenes from the Old Testament; the Last Judgment; and later, religious allegories. In this manner, church and imagery were realized as a unity, as a symbol of God's manifestation in the cosmos and through revelation. Visual symbolism was, however, intensified to magical presence by the special manner of depiction: Architectural space, especially that of the cupola and vaulting, became pictorial space as the symbolic figures faced one another and communicated across it. The depictions thus offered no illusionistic projection into depth; space was not behind but rather in front of the figures. But this pictorial space was in no way self-enclosed; through slight dislocations in symmetry, perspective, and figural proportion, each form and scene was adjusted to the line of sight of the observer, and would seem "correct" to him. The observer was spiritually and optically included in the "ionic space" created by the church's decoration. This symbolically and esthetically unified work of art was the unique and most splendid product of Byzantine culture.

The decorative system achieved its full glory through the use of wall mosaics, whose preciousness and gem-like refulgence echoed the eternal and transcendental qualities of the sacred imagery. Remarkably refined and complex technical procedures produced mosaics that to a high degree could become saturated with and reflect light, radiating intense color and surface vitality and endowing forms with monumentality because of their clarity of outline and modeling. Of all the pictorial arts, the mosaic decoration of churches reached the ultimate refinement of form and content and all the other arts were indebted to it; yet these, too, developed their own noticeable characteristics, conditioned by their varying function and tradition. Wall painting, which frequently substituted for mosaic, attempted to imitate its tonal values and firm construction, but tended either toward graphic simplification or toward versatility, associated with greater freedom in narrative detail. Enamelwork, with its lucent, colored pastes glowing between gold cloisons or fillets, came nearest to the costly sheen of mosaic; frequently, for example, on reliquaries and book covers, it was enriched with gems and embossed gold and silver. The monumentatity and the saturated color of mosaic and also enamel's delicate, filigree quality had a strong influence on book illumination, which reached an apogee in the Middle Byzantine period. In turn, book illumination richly stimulated the other visual arts, above all through its extensive repertoire of iconographic and compositional types, and as transmitter of classical models. After the Iconoclastic Controversy, book illuminators turned again to the great reserve of books from the Late Antique-Early Christian period. Generations of copyists preserved the extensive pictorial cycles from the Bible, Apocrypha, and the Saints' Calendar (Menologion), and also from classical writings, both literary and scientific. Selection and recombination produced new pictorial types and programmatic cycles that accompanied the most varied texts as a visual commentary.

While Byzantine book illumination played a recurrent role in inspiring Western art, the icon, because of its function as cult image, depended on Eastern orthodoxy for its full development. Byzantium cast the types, determined their sacred significance, and developed through them formal criteria that also held good for all other forms of representation. The

icon survived Byzantium—in the Balkans as a popular art; in Russia, too, but in a more exclusive context. Its themes were those used in church decoration, chiefly Mary, Christ, festal pictures, and certain saints and their lives. The late Byzantine period saw the development of the iconostasis, or screen hung with rows of icons that separated the sanctuary from the nave. Many of the ivories that were executed in the 10th and 11th centuries with extreme technical refinement were private icons. Even this flat, delicate relief—with hardly a trace of Greek plasticity—took its cue from painting. Byzantine art is planar decoration: Its images and its esthetic principles display themselves particularly in painting.

The exceptional homogeneity of Byzantine art—as compared with the stylistic diversity in the West—resided in the binding and hence enduring power of certain formal principles which, though modified and differently interpreted through stylistic fortuities and development, were never forsaken. The acceptance of the doctrine of images resulted in rigid pictorial methods designed to make the image a mirror for the eternal and suprarational aspects of the subject, while setting up an immediate relationship with the observer. The result was frontality, which ensured on the one hand the anchoring of the figure to the picture surface without any attempt to achieve spatial depth, and on the other the rigid internal organization of the figure, resting on the solid framework of outline and lines of modeling. In scenic compositions this hieratic and monumental frontality was replaced by a three-quarter view, which was sufficient to represent the interactions of the event and to present them legibly to the observer. The enlargement and isolation of the chief actor, the dramatic contrast of two figures or groups, and an intense and vivid repertoire of gestures brought out the essence of each event and intensified the lyrical or dramatic content to such a point that the observer was caught up in the role of participant. This magic compulsion was made possible because Byzantine art retained the classical, integral view of man and the larger part of the formal practices by which classical antiquity depicted the human figure naturally and in its natural surroundings. After the Iconoclastic Controversy the human figure quickly became the most important kind of subject matter and formal problem, and the tendency to spiritual abstraction never went to the extremes of anti-organic dissolution that it did in the West. Instead, a sure understanding of the human figure in action remained alive—despite anatomic incorrectness—and a definite feeling for proportion and harmony as well, which was evident quite as much in the individual figures as in the overall composition and the full or hushed color harmonies. Whether they employ static, monumental symmetry, or highly complex, mobile designs, Byzantine compositional schemata are largely of classical origin, but flavored with inimitable subtleties—slight distortions of symmetry or rhythm, compositional breaks, repetition of contours, effects of color and light—that combine to make the Byzantine product so lively and ingenious and to take on the aspect of sublime, intellectualized beauty.

These formal devices and esthetic effects demonstrate the continuity of Byzantine art; in the last analysis they are traceable to pictorial rules drawn up in the Late Antique period. Out of this process of reverting to classical forms and then modifying, interpreting, and refining them comes the continuity of tradition from the Late Antique to the end of Byzantine art. Byzantine "renaissances" succeeded one another like waves, and like waves they were

linked to one another; they arose, culminated, subsided, and were diluted with less classical streams. Each of these renaissances shaped its own image of antiquity, giving prominence to certain ideas and forms of classical illusionism and ignoring others. In certain works approximation to the classical is astonishingly close, but none of them go to the root of classical art—to direct observation of nature. Nevertheless, the imitation of classical models signified a creative revival, and it was this that imbued Byzantine art with its impressive and vital continuity. Thanks to this constancy-in-change Byzantine art kept alive for a millennium the dignity and the intellectual clarity of antiquity, for as Vöge has said, "the Byzantines were graybeards, but they were Greeks."

ART IN THE AGE OF JUSTINIAN

The period of Justinian (527–65) saw one of the great turning points in the history of art. Constantinople was the melting pot where all the artistic skills and traditions of the empire were fused into an imperial art that, magnificently realized in the capital, set its stamp on all other artistic centers. By synthesizing classical, Christian late classical, and Oriental art, the Justinianic period provided a foundation for subsequent Byzantine developments.

H. Sophia (Church of Divine Wisdom) in Constantinople was Justinian's architectural masterpiece. For a millennium it was the spiritual center of the empire, at once the patriarchal cathedral and palace church. Adjoining the *sacrum palatium* and connected to it by porticoes, the stage for resplendent imperial ceremonies and important acts of state, it was the physical expression of the close ties between church and theocratic imperium. This massive building, which was proclaimed a marvel even at the time of its construction, was founded by Justinian and built in little more than five years (532–37) by his fertile mathematician-architects, Anthemius of Tralles and Isidorus of Miletus. Huge and powerful, bare of ornament, and sparing of architectural detail, the great church towers over the city on its four mighty piers (78).

In starkest contrast, the interior presents a truly spatial architecture, harmonious and majestic (70, 74). The immensely wide, shallow dome over the four vast piers of the central square dominates the whole building. Attached to each end of the nave are half-domed areas, between whose canted piers are niches, or exedrae, opened up in arcades that bow outward, while the sustaining arches to the sides are filled in with basilically articulated walls. The directional emphasis thus given is gathered by the containing vaults and exedrae, and by the horizontals of the arcades and cornices, which conduct all impulses into depth back toward the center. This broad, light, and consummately harmonious area is surrounded by independent adjacent areas in two stories (aisles, galleries, narthex), whose complex construction acts as a counterthrust to that of the mighty dome. However, in the central space all the elements of construction are concealed: Even the powerful arches and piers supporting the dome are optically reduced to slight surfaces and indicative lines that run up to the slender pendentives (the spherical dome supports), without impinging on the cupola itself. All the laws of gravity appear to have been overcome: The cupola, drenched in heavenly light by the forty windows at its base, seems to swing, in Procopius's words, "as if hung by a golden chain from heaven"; the walls seem to have lost their substance—dissolved into light arcades, behind which a diffuse, tenebrous space acts as foil. The vaulting and walls come to resemble shining, taut membranes through their sheathing of gold mosaics, precious marble tablets, and intarsia, and through delicate lacy marble, which likewise transforms the capitals into insubstantial patches of light and shade (75). The impression of unearthly majesty was originally enhanced by the exceptionally precious church furnishings—altar and ambo (pulpit) of gold and precious stones, silver-ornamented cupboards, gold-embroidered stuffs on the ciborium (vaulted canopy).

Accepted as a perfect work of art, H. Sophia also holds a crucial place in architectural history. Roman techniques of vaulting and Greek ideas of proportion, Early Christian

basilical construction, and ideas of central planning absorbed from the domed basilicas of Asia Minor are combined in a hierarchical system of subordinate and superimposed spatial compartments, gliding arcades, and overlapped curtain walls that produced something fundamentally new. This edifice not only influenced the character of all the buildings of this period but presaged the whole of medieval construction.

The artistic similarity of buildings of the age of Justinian stems from the fact that identical constructional principles were applied to the most diverse traditional types of ground plan and that these principles guided the building of provincial churches as well as palaces. In the church of the Holy Apostles in Constantinople (536–50), five large domed areas were arranged in the form of a cross and girt on all sides with subsidiary areas in two stories (71). The crystalline balance of this spatial body was given in the church of St. John at Ephesus by the addition of a sixth domed unit, a clear directional emphasis. This type of plan was still used in the 11th century, at S. Marco, Venice, and in the 12th century in France (St-Front, Périgueux). H. Sergios and Bakchos in Constantinople (c. 527–32) is an octagon surrounded by ambulatory and galleries (72, 76). The broad umbrella dome rests on eight piered arcades, between which run colonnades that are stretched and bowed out into niches in the diagonals of the church. The calm, static proportions of this harmonious central area are stressed by the powerful cornices that circulate in it, breaking forward over the piers. S. Vitale in Ravenna (c. 526–46/48) exhibits a stylistically novel organization of space by slight but decisive variations on this prototype (73, 77, 79). One different feature is the dynamic contrast between the regular central plan and the strongly emphasized longitudinal pull toward the altar. New above all else is the emphasis on verticals: the tall piers that rise up without the interruption of a cornice to support the dome; the dome itself raised on a drum; the slender arcading of the niches. It is precisely these un-Byzantine stylistic details that contain the seeds of the Western development toward Romanesque and Gothic.

The pictorial arts, too, experienced a phase of classical maturity in the age of Justinian. Antiquity, especially the Greek past, again attracted attention. Not unjustly, this period of intense retrospection has been described as a renaissance. But it is important to realize that this *renovatio* did not rest on a sedulous classicism, on faithful imitation; rather, the classical ideal became the integrative element of a new vocabulary, into which the anti-classical tendency to spiritual abstraction no less effectively flowed. Herein lies the key to the notable and long standing influence of Justinianic art—that it synthesized the traditional contradictions of postclassical art, and thus determined in principle the esthetic character of Byzantine art.

Monumentality is inherent in the art of Justinian's reign; it derives from the concentration upon bold basic forms and from the dynamic tension under which these grandly conceived elements are related to one another. The weighty plastic volumes and the poised statuesqueness of antiquity were disciplined by the severe system of contour and descriptive lines that bind the forms fast to the picture surface and subject the whole to a firm, clearly calibrated organization. (Particularly brilliant examples are the mosaics in the apse of S. Vitale, and of SS. Cosma e Damiano, Rome.) In faces, too, realism and vitality are obscured by the interplay of modeling lines. In the imperial portraits of S. Vitale (80) the

dynamic balance of abstract and plastic pictorial values, of corporeal presence and spirituality is yet further accentuated: The forward movement of the procession is restricted by the hieratic surface ordering of the picture, which marks out the imperial pair as the center of the picture as they are of the ceremonial. The color scheme, typical of the period, is also informed by great splendor and harmony. In the chancel of S. Vitale (83) rich gradations of color echo in solemn chords of gold, purple, green, and white, and their exquisiteness is given its full value by the subtle fall of light and the perfect differentiation of the decorative pattern.

Ravenna offers compensation for the lost monumental painting of the capital, yet actually the churches of Justinian were aniconic—pictureless; the great synthesis appears to have taken place primarily in imperial court art.

The renaissance of Justinian's reign was already heralded in early 6th-century works of ivory—most notably, in their sure feeling for clear pictorial organization and for plastic values (85). An exquisite relief of an archangel of the same time (but almost Classic Greek in feeling) (86) affirms the spontaneous *renovatio* of classical prototypes. A stronger in-

70 H. Sophia, Istanbul. Original construction 532–37. Plan. 4th-century Constantinian church on this site rebuilt c.410, destroyed in Nike uprising. Justinian had it rebuilt by Anthemius of Tralles and Isidorus of Miletus. Consecrated 537. Consecration of present building following collapse of dome 562. After 1453 chief mosque of Turks, who added buttresses and minarets, razed atrium. Now museum. Interior length 80.9 meters, breadth 69.7 meters, diameter of dome 33 meters. The longitudinal nave centers in a domed square; half-domed areas attached to each end (NW-SE) of domed square, each with three exedrae. Arcading between piers supporting dome (NE and SW). The compact main area is surrounded by many, largely separate ancillary areas, but together they form a virtual square, with the apse projecting beyond.

71 Church of the Holy Apostles, Istanbul. c.536–50. Reconstituted plan. Built under Justinian by Anthemius. Replaced by mosque

70

71

fluence from antiquity—to which it owes its brilliant technique and its complex, fluid spatial composition—is unmistakable in the masterly representation of the rider on the Barberini diptych (*84*), a relief nearly in the round. Yet even here the precisely observed details are subsumed in the noble conception of the whole, and in a timeless remoteness, both typical of the art of Justinian's reign. Similar characteristics also distinguish a somewhat later masterpiece of ivory carving, the throne of Maximian in Ravenna (*87*), especially the five figures on the front, whose broad, sculptural execution points back to classical statues of philosophers. Similar to them are the scenes from the Gospels on the back, but the agitated and minutely treated realistic scenes from the life of Joseph on the sides seem to betray an older workshop.

A period of classical revival naturally brought a golden age for book production, the source and transmitter of the classical heritage. Many splendid works survive from the 6th century, attesting to a great and diversified production throughout the empire. In the Milan Iliad of about 500, Hellenistic battle pictures were copied. The Dioscorides Herbal of 512, now in Vienna, contains two court portraits and a largely authentic classical herbarium.

after 1453. Regular cruciform building of five equal domed areas, basilical articulation between piers, shallow mantle of galleried ancillary areas surrounding nave. In principle, adaptation of H. Sophia's central domed bay to cruciform plan. Central high altar. Rotunda of the mausoleum of Constantine in east.

72 Sts. Sergius and Bacchus, Istanbul. c.527–32. Plan. Founders: Justinian and Theodora. Architect probably Anthemius of Tralles. After 1453 mosque (outer vestibule, atrium destroyed). Now museum. Within, a square enveloping an octagon, with a broad, deep apse. The walls between the pillars are only bowed out into niches in diagonals.

73 S. Vitale, Ravenna. Plan. Begun under Archbishop Ecclesius probably 526, carried out chiefly under Victor (538–45), consecrated 547 by Maximian. Central niched octagon with octagonal ambulatory and galleries. Emphatically deepened, distinct chancel.

72

73

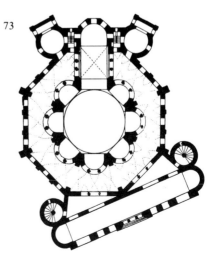

These codices originated in Constantinople, but the richly illustrated Cotton Genesis fragment in London (6th century) perhaps derives from Alexandria.

Three precious manuscripts written in silver on purple parchment—the Vienna Genesis and the Gospel fragments in Paris and Rossano—could equally well have stemmed from Constantinople, Asia Minor, or Antioch. Typologically the oldest of them, the Vienna Genesis (81) preserves much of the illusionism of its Hellenistic models. Genre-like, the scenes are often arranged in continuous sequence (note the bridge). The lively, softly modeled figures are loosely slotted into the atmospheric landscape background; foreshortening and the use of shadows and perspective were still familiar to the artist. Similar in its details, the Codex Rossaniensis (82) marks a decisive step toward the Middle Ages. The strict distribution of forms across the surface renounces depth. Dramatic contrasts are created through isolation and clustering of the figures, through vivid gestures and juxtapositions of color, and linear interrelationships. It is no longer illusionism but the religiously based transcendental message that stamps the formal appearance of these pictures.

74 H. SOPHIA, ISTANBUL. Interior toward southeast from northwest gallery. Synthesis of longitudinal and centralized planning with powerfully dominant central dome, supported by four sturdy but optically unburdened piers, buttressed by adjacent vaulting (half-domes, exedrae, and subsidiary vaults), drumless dome on pendentives, raised by about 6 meters after collapse in 557. Forty windows at its base. Basilical curtain walls between piers of lateral axis: five arcades in lower story, seven in upper, two rows of clerestory windows. Exedrae with arcades also in two stories; only apse fully open. Circulating cornice unifying space.

75 H. SOPHIA, ISTANBUL. Arcade decoration. Wall and capitals flat and thin, optically dissolved by delicate, colored, finely articulated ornamental fields. Lacelike contrast of light and shadow.

76 STS. SERGIUS AND BACCHUS, ISTANBUL. Interior toward northeast. Hierarchical system of overlapping parts already fully realized in this first Justinianic building: primary membering by heavy pillared arcades of octagon; the secondary arcades and colonnades act formally and technically as curtain walls, which are kept flat or bowed out into niches. They turn the walls into a translucent grille (thus containing the germ of Gothic wall structure). Circulating, broken architrave and cornice provide strong horizontal binding. Impression of dominant horizontality arising out of ampleness of central space, massiveness of piers, stocky columns below, and, above all, drumless umbrella dome.

77 S. VITALE, RAVENNA. Interior toward east. Despite the breadth, the light, vertical construction and the slim, sheer proportions predominate. Tall, uninterrupted piers take the vertical impetus over the drum into the cupola. The niches, with slender columns, are subordinate to the arcades of the octagon. Overlapping directional accents: dynamic contrast between central space and deep, high, and open chancel, which is set off by arcades from abulatory and gallery; apse also focal point of light.

78 H. SOPHIA, ISTANBUL. View from southwest. Broad, weighty arrangement of massive, powerful, almost unadorned blocks. Exterior character differing from interior. Buttresses Turkish.

79 S. VITALE, RAVENNA. View from south. Clear-cut units vertically staggered, clearly marked off by pilaster strips and large windows in relieving arches, corresponding to internal dispositions.

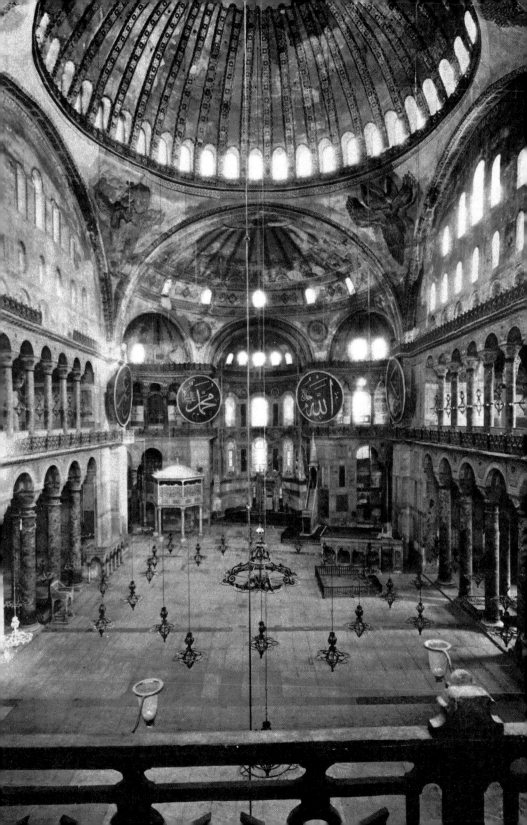

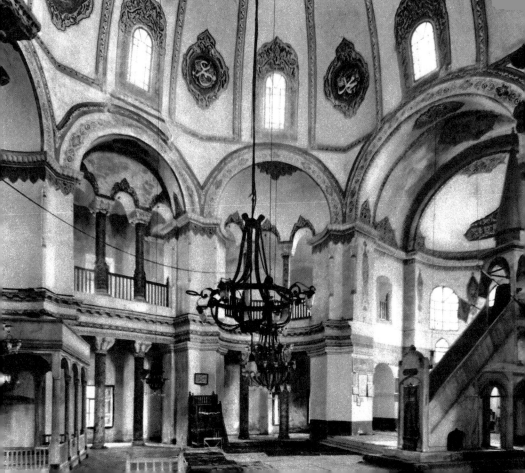

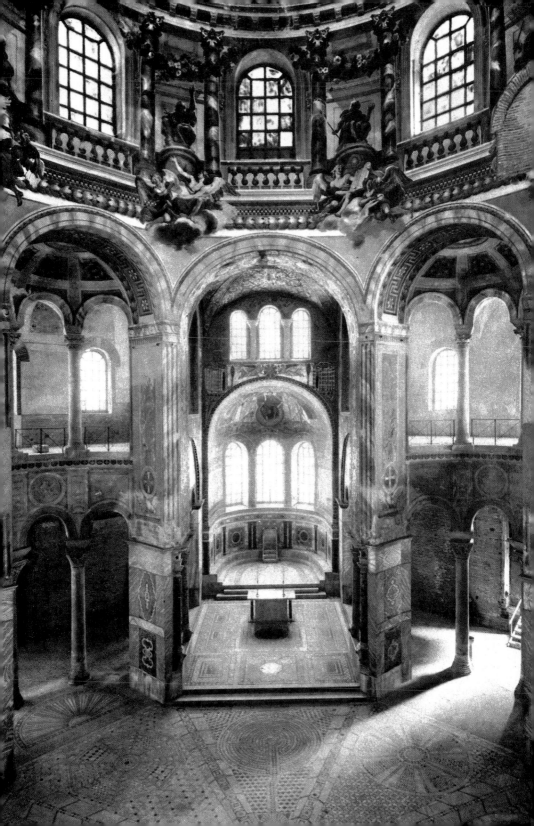

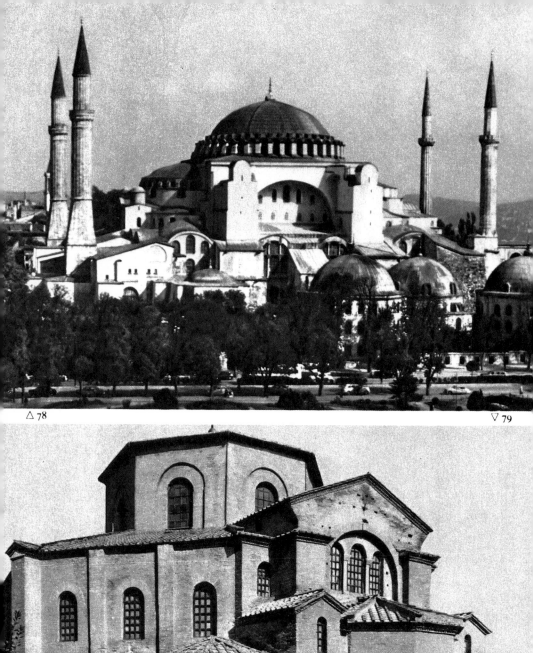

△ 78

▽ 79

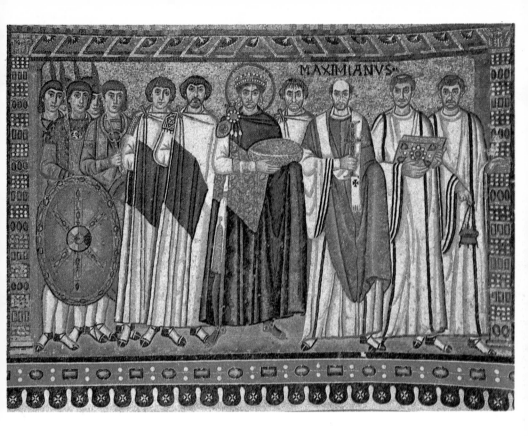

MAXIMIANVS

80 JUSTINIAN WITH CORTEGE. Before 547. S. Vitale, Ravenna. Apse, northwest wall. Mosaic. Justinian, dressed with pomp, in purple chlamys and diadem, advances in a procession to offer golden presentation bowl; Archbishop Maximian and two deacons with liturgical vessels before him, patricians and bodyguard behind. On facing southwest wall, the Empress Theodora in ceremonial robes, proffering a gold chalice (with the same gesture as that of the Three Kings embroidered in gold on her purple pallium), train of court ladies in costly brocades. Theodora emphasized by a shell-niche. An official leads her from a fountained atrium to the church. Imperial couple and closest retainers executed from portrait models from Constantinople, and they are noticeably finer and more individualized. Earliest representation of Justinian to appear in the sanctuary, as donor to the heavenly sovereign, expressive of the new sanctification of the theocratic empire. New and typically medieval is the picture's ambiguity. Symmetry, frontality, and hieratic concentration on the coloristically and formally emphasized and unobstructed figure of the emperor elevates the scene into a timeless and sacred realm; depiction is thus converted into symbolic representation. Yet the slight displacement of absolute symmetry and overlapping effect create the illusion of a procession advancing in ceremonial order. There is a similar ambivalence between the detailed structure, the individualized features, and the strict uniformity of modeling and contour. Court art of the capital is reflected in the stately monumentality and technical and esthetic refinement.

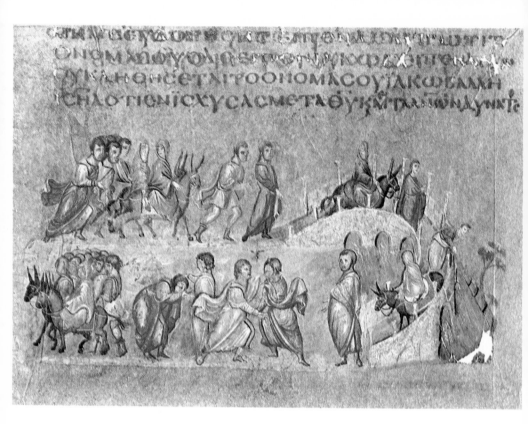

81 JACOB'S CROSSING OF THE JABBOK, HIS WRESTLING WITH THE ANGEL AND NAMING AS ISRAEL. Vienna Genesis. About middle 6th century. Austrian National Library, Vienna. Purple parchment. Silver uncial decorative script. 31.8 × 25.8 cm. 48 (of an original 192?) miniatures survive, one on the lower half of every page illustrating the Fall, scenes from the lives of Noah, Abraham, Jacob, and Joseph. Earliest of three stylistically related luxury codices. Origin, whether Antioch or Constantinople, disputed. Strong survival of Hellenistic tradition from era of first illustrations of Genesis. Lively narrative enriched by genre details, dramatic accents. Fluid movement of the decorative figures through bold foreshortening and contrapposto. Painterly impressionism used to achieve soft corporeality. Very richly shaded color ranging from the strongest to the palest tones. Partly illusionistic landscape settings or atmospherically colored ground, but generally shallow settings. Supple composition, often two rows linked by path or bridge. Some use of hieratic frontality and hierarchical relationships.

82 CHRIST AND BARABBAS BEFORE PILATE. Codex Rossanensis. Second half of 6th century. Museo del Arcivescovado, Rossano. Purple parchment. Silver uncials. 30.7 × 26 cm. Gospels of Matthew and Mark survive in 14 full-page miniatures, including scenes from the life of Christ, ornament, the earliest picture of an evangelist (Mark inspired by the Holy Ghost). Most scenes are in upper half; beneath, four prophets with long rolls of commentary. Both pictures of Pilate are full-page depictions: strong, dramatically highlighted surface compositions in place of free narration and spatial illusion. Vivid gestures and contours. Generously conceived compositions, based on strong local coloring.

ΔωΝ ΔΕ ΠΙΛΑΤΟϹ ΟΤΙ ΕΚ ΤΗϹ ΕΞΟΥϹΙΑϹ ΗΡωΔΟΥ ΕϹΤΙΝ ΑΝΕΠΕΜΨΕΝ ΑΥΤΟ
ΟϹ ΗΡωΔΗΝ ΟΝΤΑ ΚΑΕ ΑΥΤΟΝ ΕΝ ΙΕΡΟϹΟΛΥΜΟΙϹ ΕΝ ΤΑΥΤΑΙϹ ΤΑΙϹ ΗΜΕΡΑΙϹ

ΒΑΡΑΒ
ΒΧϹ

ΙωϹΗΦ ΧΙϹΕϹ ΝΚΑΙ ΚΚΙ ΚΕ ΦΗ Ν ΙΗ Μ ΙΜ ΤΟ ΝΚΕ ΑΚΜΝΙ ΚΝΚ Ε ΛΤΑ ΑΧ
ΤΟΙϹ ΑΡΧΙΕΡΕϹ ΙΝ ΚΑΙ ΧΙΜ ΙΝ ΜΑΡ ΤΟΝ ΜΑΡ ΚΑ ΥΛ ΑΥϹ ΑΛ ΟΚΝΜΑ Ν ΛΥΚΑΩΜΙΝ
ΕϹΚΙΟΝ ΕΝΑΧΕΚΛΝΟ

83 S. VITALE, RAVENNA. Interior. Southwest wall and vault of the chancel. Self-contained mosaic ensemble covering all the walls and vaulting, after a theological program centered on the Eucharist. In the lunettes: sacrifices of Abel and Melchisedek (SW), Abraham's hospitality and the sacrifice of Isaac (NE); above, scenes from the life of Moses, prophets, evangelists. In the vault of the apse: Christ in Paradise, enthroned on the globe, angels presenting St. Vitalis and Archbishop Ecclesius to him. In the chancel vaulting: acanthus scrolls enlivened with creatures; in its crown, four angels carry a medallion with the Agnus Dei. In the entrance arch: busts of Christ and the apostles. Rich ornamental borders emphasize the architectural framework. The figures in the apse are in the mature Justinianic style, striking a balance between classical solidity and rigid organization. The lunettes in a somewhat earlier style: over-elongated, unstable, split up, expressed as narrative.

84 BARBERINI DIPTYCH. Five-part imperial diptych. Beginning of 6th century. Louvre, Paris. Ivory. 34.1 × 26.6 cm. Constantinople. Possibly depicting Anastasius (c.500) or Justinian (c.527) in triumph. High, space-evoking relief. Classical in its full mastery of clear, pictorial organization and of lively movement in complex foreshortening. Full *renovatio*.

85 ANASTASIUS I (491–518). Left wing of consular diptych. 517. Cabinet des Médailles, Paris. Ivory. 36 × 13 cm. Executed with a group of similar diptychs in Constantinople. A traditional type has gained in fresh plasticity, solidity, refinement.

86 ARCHANGEL MICHAEL. Wing of a diptych. c.520. British Museum, London. Ivory. 43 × 14.3 cm. Court atelier, Constantinople. Superb recreation of a classical Greek prototype: firm, limber modeling of the body, subtle relief folds, delicately detailed architecture. Testimony to the strong stylistic sense and exquisite technique of the period.

87 THRONE OF ARCHBISHOP MAXIMIAN (545–53). Archepiscopal Museum, Ravenna. Ivory. 150 × 60.5 cm. Provenance disputed—Constantinople or Ravenna. Front: below the seat are John the Baptist and four evangelists and, above, Maximian's monogram. On the chairback (both faces): twelve scenes from the life of Christ (youth, miracles, apocryphal Marian episodes). Sides: ten scenes from the story of Joseph in Egypt. Certain panels lost. Various artists and styles. The five single figures by the chief artist in the classically schooled court style exhibit statuesque monumentality, plastic volumes with vigorously systematized internal modeling, naturalistic heads. Scenes on the chairback are related but are in shallow relief with softly rounded forms, occasional grooved folds. Lyrical atmosphere. The Joseph panels are related to late 5th-century ivories from Alexandria in their realistic narration, box-like space thronged with lively figures. Abrupt, angular plasticity.

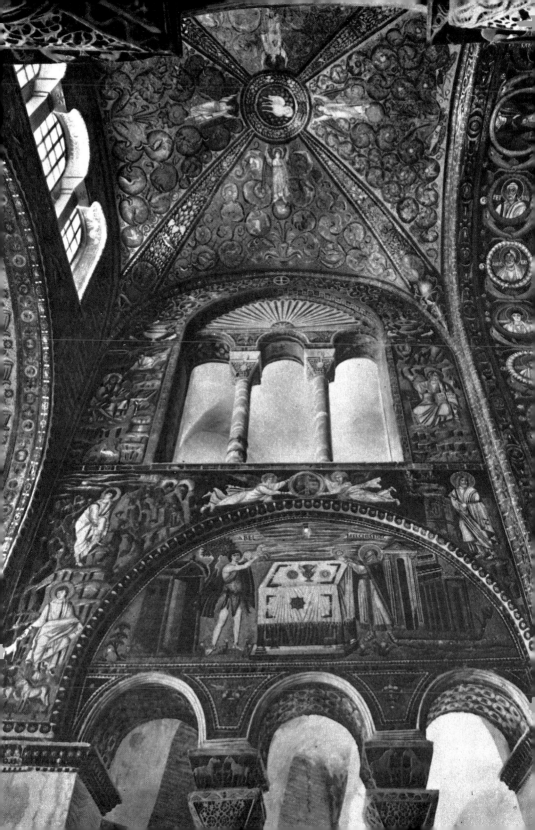

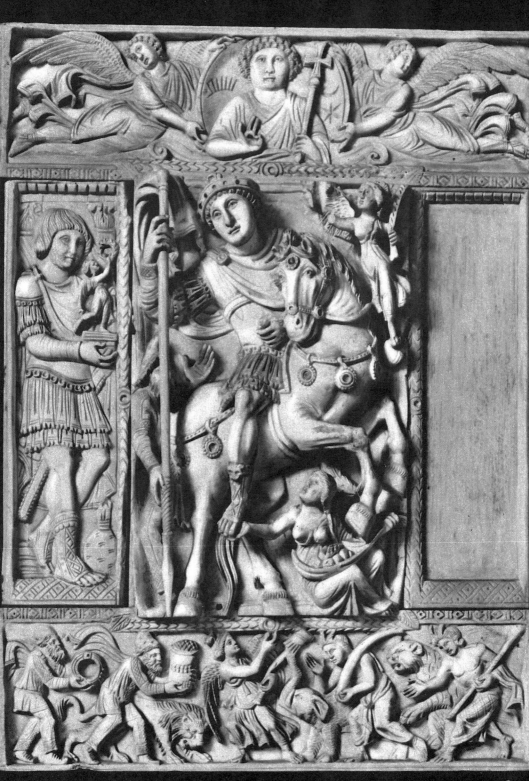

84

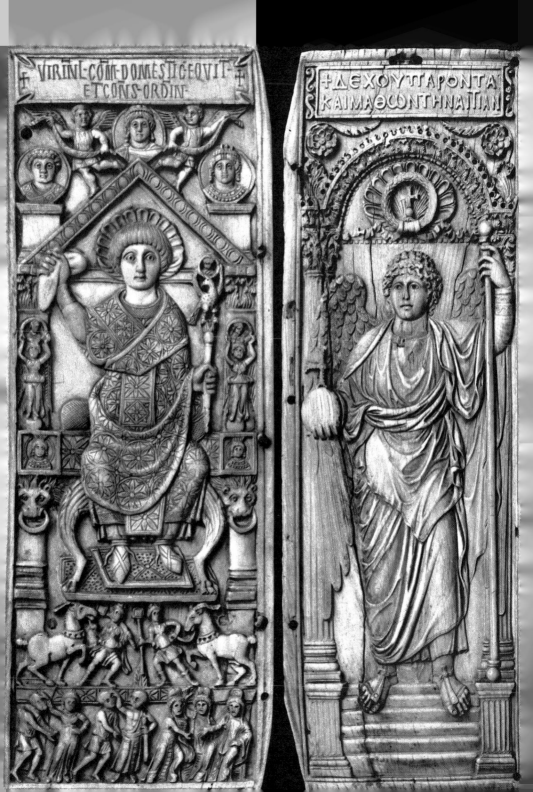

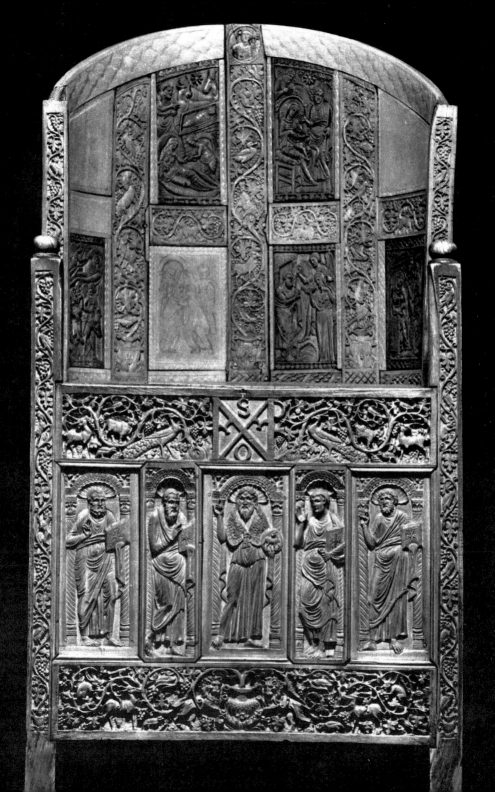

THE 6TH TO 8TH CENTURIES

In the architecture of the post-Justinianic period a step was taken toward a solution that would be fully realized in the late 9th century—the domed cruciform church. The evidently conscious Byzantine search for an ideal architectural type cannot be explained simply as an autonomous stylistic development; it was, rather, a response to the need to give clearer visual expression to the concept of the church as a symbol of the order of the cosmos. Churches of the 6th to 8th centuries are unique in their solidity, in their assertion of each part, and in the ambiguity of their internal relationships. They dispense with the spatial illusionism and the rational clarity of Justinianic churches. This evolution in the direction of the Middle Ages was prefigured in the domed basilicas of the 5th century and in the "overlapping" principle of Justinianic construction. The church of H. Irene in Constantinople (88), begun in 532, with other churches of the 6th century, points the way. Within the basilical plan the dome is dominant. The basilical articulation is subordinated to the mighty piers, becoming, in effect, a curtain wall in the nave, and a secondary feature at the west end.

The church of the Koimesis at Nicaea, of the 7th century, brought a decisive concentration upon the domed area (89). In this building, the body of the nave has been thrust back into the outer range of piers, and their massive strength thus achieves full expression. H. Sophia at Salonika brings the type and style of these churches to their most monumental form (90, 97). It is governed by the concept of dome over cross, the latter being marked out by the broad barrel vaults carried by the piers of the dome. All the adjacent areas are subordinate; they act optically as a diffuse foil of space and light but also provide directional impulses, which set up tensions against the main central area; for example, the narthex with its strong lateral current and the three apses—the lateral ones aligning longitudinally with the side aisles, the high central one with the nave. An important step for the future was taken with the penetration of the piers by small passages in both stories, which visually lightened their massive bulk, an effect strengthened by the broad encircling cornice, which divides the surface of the piers into sections. The reduction of the piers from within was carried forward consistently in the course of the 8th and 9th centuries: in the Kalenderhane Cami in Constantinople, of about 850, passages have already been expanded into small cross-vaulted spaces (91, 98). Marble revetment and cornices accentuate the ambivalence between massiveness and surface interest typical of this style.

The period between Justinian and the Iconoclastic Controversy was also of great importance for the figurative arts. A new esthetic order, which was deeply intertwined with the religious needs of the time, came to maturity. The veneration of religious pictures, rapidly increasing in both public and private life, resulted in a new type of image—the isolated and usually frontal portrait of a saint—executed in an abstract style that made visible form the transparent vehicle of the immaterial and numinous in such a way that picture became icon. Simultaneously, the artists of this time refined their formal vocabulary in order adequately

to reflect all the phenomena of the visible and immaterial world. This sensitivity to the expressive potential of every artistic form makes it understandable that the classical heritage was carefully cultivated. About the middle of the 7th century, the time when the iconic style came to full maturity, classical imagery was adopted with a comprehension revealed in few of the earlier or later renaissances. Thus, in Constantinople, and radiating out from there, two radically opposed styles existed side by side, and both made possible the revival of figural art after the Iconoclastic Controversy.

Monumental painting offers splendid examples of these two styles. From the second half of the 6th century a decisive tendency toward a planar, bodiless, and slack linear style is detectible (at the monastery of St. Katherine in Sinai; in Ravenna, the procession of the martyrs at S. Apollinare Nuovo, and at S. Apollinare in Classe, the apse; in Rome, at S. Lorenzo). Moreover, the large pictorial cycles were steadily replaced by individual, usually votive pictures, which were distributed around the church without a thought for the decorative whole. By about the middle of the 7th century (in Salonika, at H. Demetrios [*100*]; in Rome, at S. Agnese) the abstract style had evolved new pictorial values: A firm linear framework, parceling the figures out almost geometrically, tethers them to a strict but boldly conceived surface pattern that takes no account of volume or space. This simplification results in a monumentality that affords the picture new spiritual dimensions. The holy figures face the observer in immobilized frontality and elevated tranquility. The representation is exalted into a transcendental cult image.

The Hellenistic style, which Greek artists brought to Rome, is represented in S. Maria Antiqua in the Forum. In these frescoes (dating from the mid-7th century to the beginning of the 8th century)—most of which also are votive pictures—the figures, reminiscent of Augustan prototypes, are delineated by modeling with light and shade. They have a full, supple corporeality and move freely in space. This impressionistic technique was also employed in the wall paintings of Castelseprio, near Milan (*101*). The sketchlike background, the airy landscape, the easy movement of the figures, and the rapid, evocative brushstrokes all come very close to Pompeiian painting, while the occasional chubbiness of figure and sharp highlights reveal the Byzantine point of departure.

The few icons surviving from this period betray a similar stylistic divergence. On the one hand, there are holy personages with an abstract, magical presence (Sts. Sergius and Bacchus, at Kiev); on the other, as in the Marianic icons of Sinai (*102*), next to the severely frontal saints, there are a pliant, sculptural Madonna and an angel, whose spontaneity expresses ethereal being. In the Marianic icon in S. Maria Nova in Rome (*103*) the severe facial features are based on a richly interrelated system of curves; but the icon owes its delicate and sensitive appearance to its golden tonality, to the exquisite transitions between pink, olive, and light blue, and to the ingenious indications of light, all of which derive from classical tradition.

In book illumination the tendencies to abstraction and the intensification of expressiveness were announced in the purple codices, particularly that of Rossano, although on the basis of a more conservative classical tradition. The Syrian Rabula Gospels of 586 (*99*) also display much classical illusionism—coloristic perspective and modeling, foreshortening,

and a rich palette—but translated into a dramatic and expressive style, in which the line assumes an organizing and communicative force. From the developments of the 7th and 8th centuries, one can guess that both the extremely abstract and the Hellenistic styles were represented in manuscripts.

The variety and, to some extent, the extreme polarities of this period come strikingly to the fore in the case of silverwork. A number of silver dishes and vessels with mythological themes are evidence of an unruptured Hellenistic tradition (93). The figures with their corporeal solidity and flowing movements are confidently realized. Liturgical vessels, too, are indebted to this tradition in the most diverse ways (95). A conscious classicism was also cultivated in the court workshop of the Emperor Heraclius (first quarter of the 7th century): The nine dishes from Cyprus decorated with episodes from the story of David (92) are among others in following the pattern of the art of the earlier Theodosian dynasty in composition, in their supple full-bodied relief, their pliant modeling and accurate rendering of facial features. A total contrast is provided by works such as the patens from Stuma (94) and Riha in Syria—one rigidified into graphic abstraction and monotonous severity, the other, lacking, it is true, technical elegance, yet reaching heights of expressiveness in movement and feature. All these pieces of silver were made (some at the same time, as their hallmarks show) in Constantinople. This evidence is all the more precious, as no works of wall painting or book illumination, and only (possibly) a few icons from Constantinople survived the Iconoclastic Controversy. It demonstrates the importance of the capital as the origin and source of influence for a prolific art style that was rarely given such extreme expression.

The visual arts, so highly developed in the 6th and 7th centuries, were almost extinguished in the Iconoclastic Controversy (726–843). All figural Christian images were systematically destroyed and their production forbidden. Artistic activity did not dry up altogether, however: Written sources record the decoration of churches with representations of plants and animals, and secular scenes, and a very active imperial art. But virtually nothing of this art survives except a few silks (96) executed in all probability at this time. Their combination of classical and oriental patterns appears to have been characteristic of the period. Many other inferences point to an increasingly arid, abstract, and linear hardening of form. On the other hand, immediate Byzantine influence on the Carolingian renaissance in Western Europe encourages the supposition that there was an unbroken cultivation of the classical tradition in the empire. The wall paintings in Castelseprio will tend to affirm this, if their dating at around 800 can be upheld.

88 H. Irene, Istanbul. Interior toward south-east. Begun 532; radically altered after fire of 564 and earthquake of 740. First build-ing: evolution of the domed basilica toward greater importance of the domed space in front of apse, but west arm still basilical. Galleries probably demarcated by arcades and screening walls. Rebuilding: probable opening up of the galleries, so that tunnel vaulting and broad piers extending to the outer wall visible, typical of contemporary style. Shallow transverse dome instead of barrel vault over west arm.

89 Koimesis Church, Nicaea. c.700. Plan. Important precursor of the domed cruci-form church. Concentration on domed area. Basilical elements minimized—no west arm, arcades between pillars thrust out-ward, producing Greek cross. Aisles con-stricted to small passages.

90 H. Sophia, Salonika. 8th century. Plan. Most significant of the transitional build-ings. Central domed area clearly cross-shaped, for flanking nave arcades have been shifted to the outer line of the enclosing two-storied shell of lower rooms that pro-vide a mantle of light for the core of the church. Compact apsidal grouping. Extra bay in front of apse asserts the long axis of the church. Important for future develop-ments are the narrow passages penetrating the exceedingly massive piers of the dome.

91 Kalenderhane Cami (Akataleptos Mon-astery), Istanbul. c.850. Plan. Further systematization: the central domed cross-ing especially is more emphatically marked. The mass of the piers is eaten away by inner rooms, with which the lateral apses are aligned. Subsidiary areas form a squared ambulatory.

92 The Marriage of David. 610–29. Classical Museum, Nicosia. Silver dish. Diameter 27 cm. From the great treasure from Cyrene, Cyprus (nine David dishes, ewers, jewelry, etc.). The dish is a missorium, originating in the court atelier of Heraclius; reflects in-fluence of the conscious *renovatio* of courtly classicism under Theodosius I.

93 Hercules and the Nemean Lion. End of 6th century. Cabinet des Médailles, Paris. Silver dish. Diameter 60 cm. Made in Con-stantinople. Typical of the post-Justinianic accentuation of the classical tradition is the ample and delicately modeled relief.

94 Communion of the Apostles. 565–78. Archeological Museum, Istanbul. Silver paten. Diameter 37 cm. Found in Stuma, Syria. Made in Constantinople. In spite of partial, almost inflated plasticity, an ex-tremely shallow relief. This liturgical vessel conveys a spiritual effect through the strict rhythm of similar shapes.

95 Jeweled Cross between Two Angels. Second half of 6th century. Hermitage, Leningrad. Silver dish. Diameter 18 cm. Found near Poltava. The classicizing tradi-tion of the early Justinianic era has evolved here into a doll-like delicacy and stylized preciousness (note the crinkled hems).

96 Chariot Drawn by Team of Four. 8th century. Musée de Cluny, Paris. Silk. Height 75 cm. According to tradition taken from the grave of Charlemagne with a second piece now in Aachen Cathedral treasury. Perhaps from Constantinople. Late Antique circus scene combined with Persian ibex motif, orientalizing frame.

97 H. Sophia, Salonika. Interior toward east. Monumental design with broad dome on drum. More spacious and less compact than other transitional buildings, but just as square and massive. The thickness of the walls can be deduced from the breadth of the surfaces, especially of the piers, barrel vault, and arch before the apse. Only a partial optical lightening of the piers in spite of openings cut through them, since the cornice emphasizes their breadth. The cornice also connects upper section of piers with the galleries, and divides up the wall: ambivalence of relationships between space and wall, horizontals and verticals.

98 Kalenderhane Cami (Akataleptos Mon-astery), Istanbul. Interior toward north-east. Despite greater opening up of the piers, still emphatically continuous wall surfaces. Marble revetment splits the walls up into segments, and makes them opti-cally insubstantial but not transparent as in Justinianic churches.

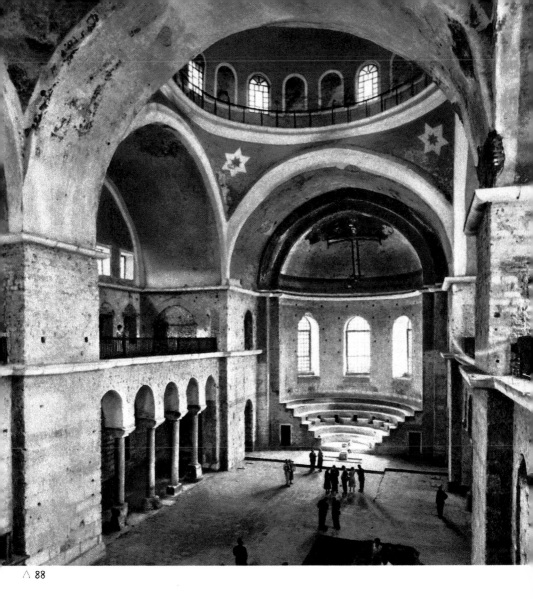

∧ 88

89

90

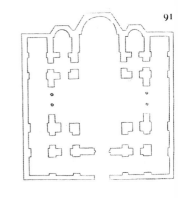

91

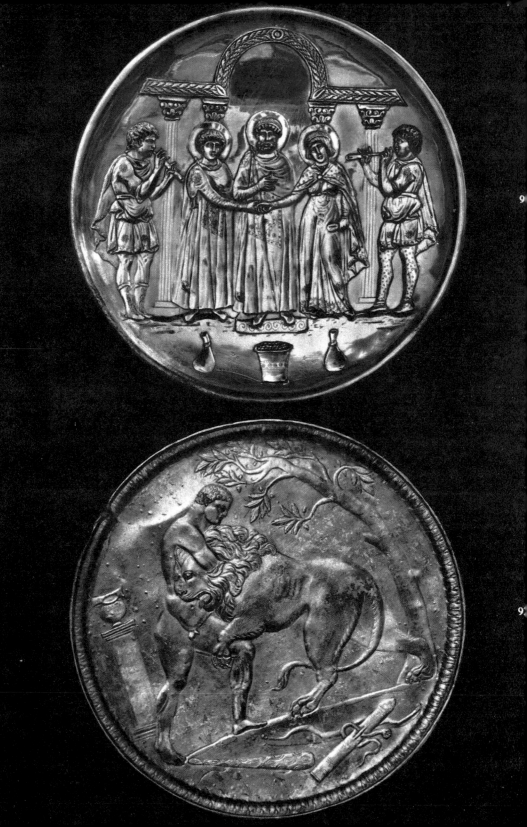

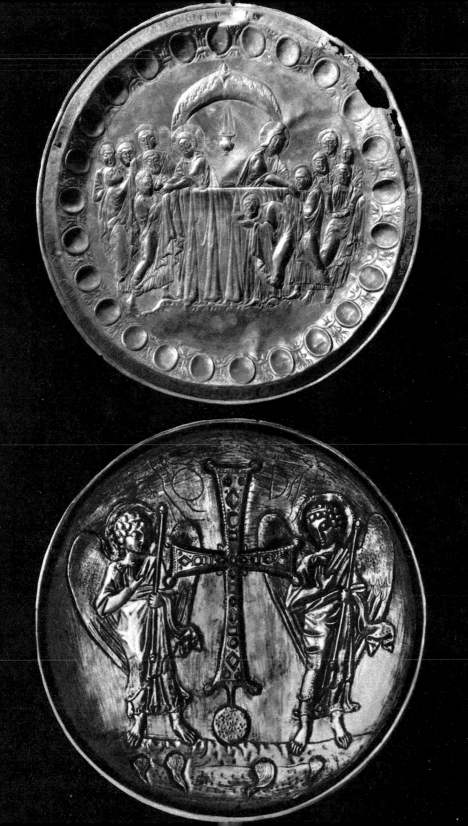

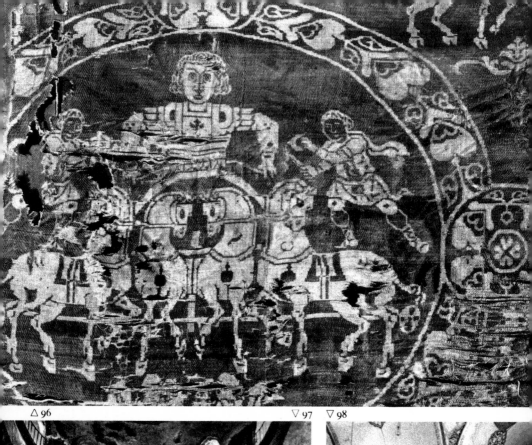

△ 96

▽ 97 ▽ 98

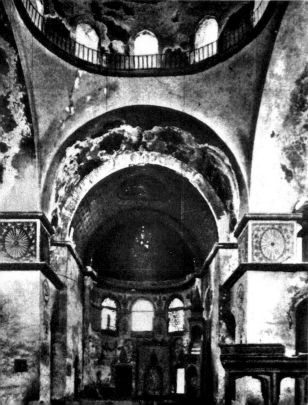

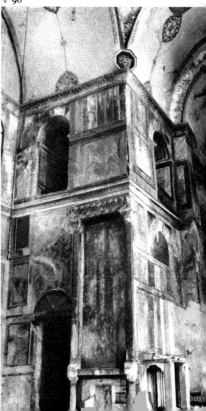

99 THE ASCENSION. Rabula Gospels. 586. Biblioteca Laurenziana, Florence. 33.6 × 26.8 cm. Written in Syriac by the monk Rabula in Zagba (northern Mesopotamia). Besides small scenes from the Old and New Testaments and arches of the Canon, seven full-page miniatures, including Crucifixion, Ascension, and Pentecost—the latter clearly in classical, illusionistic tradition. Inspiration for the Codex Rossanensis. Tendency to extremely expressive realism and delight in narrative perhaps Syrian.

ΓΚΤΙCΤΑCΘΕΟΡΕICTΟΥΠΑΡΕΝ ΛΟ ΖΟΥΛΟΜ ΕΚ ΟCΘΕΝΟΕΝ ΙΑΡΤΥ ΟCΔΗΜΗΤΡΙΟΥ
ΤΑΚΑΡΒΑΡΟΝΚΛΥΔΟΝΑΒΑΡΒΑΡΟΝCΤΟΛΥ ΜΕΤΑΤΡΕΠΟΝΤΟC ΡΟΥ ΛΕΝΟΥ ̀

100 ST. DEMETRIUS WITH DONORS. c.650.
H. Demetrios, Salonika. Pier mosaic at
entrance to transept. Church contains ear-

lier private votive mosaics from the late
6th and early 7th centuries. Provincial in
style, the figures are extremely flat, bodiless,

98

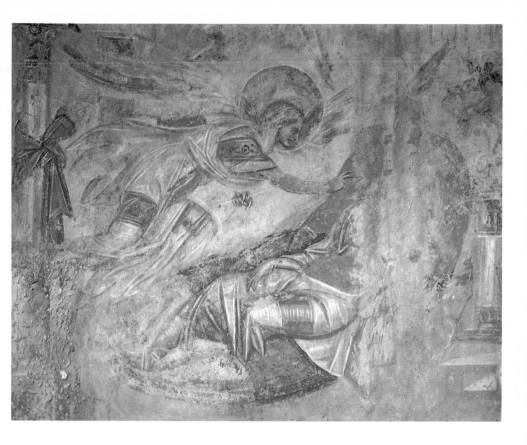

linear, unstable; backgrounds partially in classical tradition. This mosaic is one of a group of official ex votos executed after the fire of 630, on the piers, in mature iconic style of Constantinople: sure, sturdy linear organization; abstraction gives a metaphysical transparency.

101 JOSEPH'S DREAM. 8th century (?). S. Maria di Castelseprio, near Milan. Discovered 1944. Dating disputed (7th to 10th century). Part of small wall-painting cycle dealing with youth of Christ, of high quality. Illusionistic character: organic movement of the figures, extended landscape, delicate color, idealization. Probably painted by Greeks.

102 MADONNA AND CHILD ENTHRONED WITH SS. THEODORE AND GEORGE AND TWO ANGELS. Icon. Beginning of 7th century (?). St. Katherine's Monastery, Sinai. Encaustic. 68.5 × 48 cm. From Constantinople (?). Strongly instilled with the classical spirit, which, however, has been diluted and originally interpreted: saints in the foreground frontally posed, intensely austere and reduced in corporeality, the Madonna and child glance away in lifelike fashion; the angels are classically and impressionistically in swift movement. Stylistic differentiation in figure representation denoting degrees of reality.

103 MADONNA AND CHILD. 7th century. St. Maria Nova de Urbe, Rome. Encaustic. Mary's head c.55 cm. high. Fragment of an enthroned (?) Madonna, perhaps the highly venerated cult picture from S. Maria Antiqua. Uncovered 1949. The harmonic severity of the construction of the face tempered by a delicate distribution of color and light indicating classical extraction. It exudes both the immediacy of life and sacred transcendence.

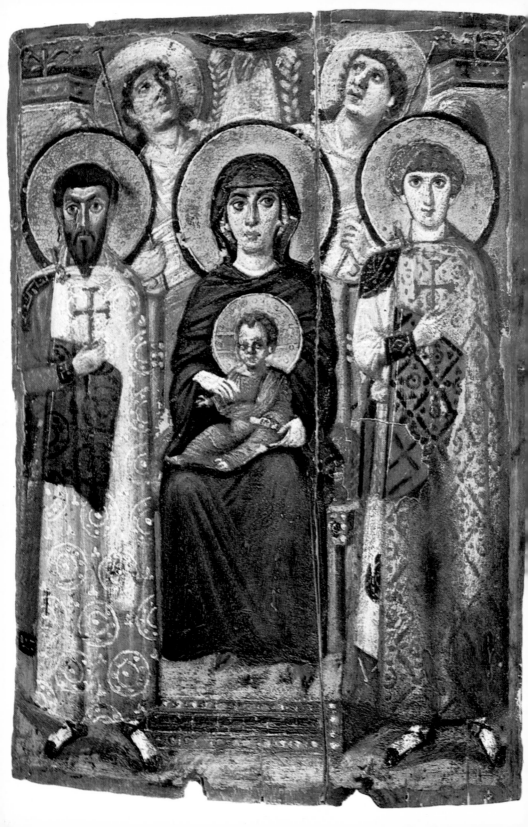

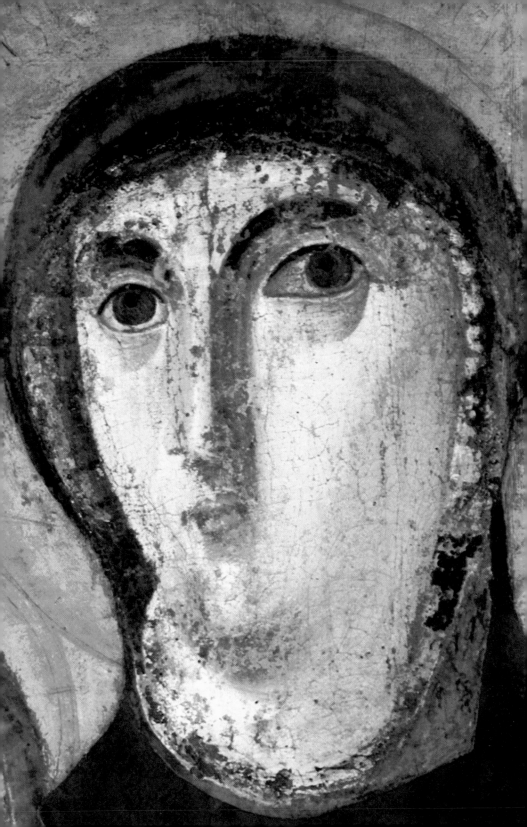

MIDDLE BYZANTINE ARCHITECTURE

Mature Byzantine religious architecture increasingly concentrated upon the development of the domed cruciform church. From the 6th century on, churches were almost exclusively of this kind, and once the type was fully worked out in the second half of the 9th century, motifs and stylistic characteristics changed, but not the type itself. Even subsequently developed special types were merely variations on the basic theme, which also became a starting point for church architecture in the Slavic lands. The domed cruciform church owes its remarkable durability to the coincidence in it of form and idea: The theologocal conception of the church with its wealth of symbolic relationships found an exact correspondence in the actual building, all of whose parts had a fixed place in the ideal church of the theologians, so that none could be omitted or drastically altered. The same was true from an architectural standpoint: Each part stood in such intimate relationship to the next and to the whole that none could be detached—esthetically and literally.

The fully developed domed cruciform church (*106, 108*) consists of three parts arranged along one axis: vestibule (narthex), core (naos), and three apses. The narthex is generally low-ceilinged, divided into bays with cruciform vaults. The naos is a square central area, covered by the dome; the four arms projecting from the crossing are of equal length and barrel-vaulted. For steep arches with piers or columns support the dome and at the same time mark off the arms of the cross from the center. Slender pendentives mark the transition between the square below and the circle of the cupola above, which is, however, also usually raised high on a drum. The exterior corners between the arms of the cross have lower cruciform or small domical vaults, and are opened up by slender arches on all three sides. While the lowest part of the church is a unified, hall-like spatial cube, it blends above into a complex system of vaults, which are hierarchically piled up to the still, central semicircle of the dome. The structural qualities and proportions of the space thus created can only be read from its boundaries—the vaulting and walls. Everything massive, corporeal, and material has been drained away into the thin shells of the walls and the slender columns or pillars under the dome, which scarcely seem to function as supports. This complete dematerialization is accentuated by the light that enters from subdivided windows in the drum, lunettes, and apse, and by the colored, reflective sheathing of marble on the walls and of mosaic on the vaults. Technically, too, the reduction of mass is taken to great lengths: The burden of the dome's thrust and weight is shared by the supports and, through graduated buttressing, by all the vaulting out to the external wall. This complicated system of load distribution made it feasible to have each individual member extremely light and to dispense with reinforcement.

The dominant accent in the main body of the church is the centralized and staggered vertical leading up to the cupola. The wide, lofty central apse, which is often deepened by a preceding bay, provides a second directional accent. The modest ancillary apses (prothesis and diaconicon) are connected to the eastern corners of the naos and are also open to the main apse. This east end, the holy of holies of the Orthodox rite, was set off from the nave by marble barriers (templons), and it was out of these that the high picture screen, the iconostasis, developed in the 13th century.

The exterior appearance of the domed cruciform church (109) reflected in its sculptured clear-cut structure the shape of the interior. The succession of interior spaces (narthex—naos—apses) is quite as distinctly marked as is the hierarchic massing, which culminates in the high drummed dome. This clear, polished structure has its maximum effect at the east, in the angular bodies of the apses and the piled straight lines, diagonals, and curves of the eaves of the roofs. No supplementary accents are provided by façades or towers.

The earliest fully realized domed cruciform church was probably the Nea (New Church) of the emperor Basil I (consecrated 881), now destroyed. Other churches of this first phase built in the 9th and 10th centuries in Constantinople—the North Church (104) of Fenari Isa Cami (Panachrantos Church); Eski Imaret Cami (Pantepoptes Church)—possessed a mantle of subsidiary areas which corresponded to the aisles of the older transitional buildings; like the old aisles, they were connected with the central space by narrow arcades (in later churches they were given autonomy as passages or chapels, and finally were discarded altogether). While these early churches were low, broad, and massive, in the 10th and 11th centuries a strong trend to dematerialization resulted in churches with extremely slender proportions—Kilise Cami (Church of St. Theodore) (105); Budrum Cami (Myrelaion Monastery), etc. The already thin walls were frequently further reduced by niches. On the outside, a rich, delicately stratified relief was produced by stepped blind arcades, niches, and pilasters. In the 11th and 12th centuries, through an adjustment of proportions, the domed cruciform church achieved its classic form. Examples are the double church of the monastery of the Pantocrator, in Constantinople; the Panaghia Chalkeon, in Salonika; the Kapnikarea, in Athens; and the church of the Virgin, at Hosios Lukas, in Boeotia (106, 108). Even these churches are relatively modest in plan—diameter of dome varies from 3.5 to 7 meters—but very harmonious and light, for columns instead of piers open up the lower spaces.

One significant variation of the domed cruciform church was diffused through Greece in the 11th century—at Hosios Lukas, the Katholikon (106, 110); at Nea Moni on Chios; at the church at Daphni near Athens (107, 111); and elsewhere. In these churches the dome was extended over the arms of the cross, and the four supports were eliminated. Squinches (deep cone-shaped niches) make the transition from the relatively broad central square thus obtained to the rim of the dome; the eight wide arches of the squinches and the tunnel vaults make the dome seem a kind of light umbrella. The arms of the cross are displaced outward into the adjoining aisles. At the Katholikon at Hosios Lukas, an encircling gallery story enriches the mantle of subsidiary areas. The width of the light cupola and the apparently thin structure of the walls, which have been opened up into light arcades, reinforce the impression of balanced monumentality peculiar to this church—which is also notable for its well-preserved marble and mosaic decoration.

104 FENARI ISA CAMI (PANACHRANTOS CHURCH), ISTANBUL. North church. Beginning of 10th century. Plan. Early domed cruciform church, massive piers and walls. Side aisles separate ancillary areas.

105 KILISE CAMI (CHURCH OF H. THEODOROS), ISTANBUL. 10th century. Outer narthex, 13th century. Plan. Mature domed cruciform church. First surviving building with columns instead of piers. Very slender and light, a dominant vertical impulse given by steep ribbed dome.

106 HOSIOS LUKAS (Boeotia, Greece). Right, Katholikon, early 11th century. Left, Church of the Virgin (Theotokos), 11th century. Plan. Main church (with lower church): variant of the domed cruciform type, domed area extended over inner arms of cross, so that supports fall away; outer parts assimilated into mantle of independent subsidiary spaces. Theotokos a classic domed cruciform church.

107 MONASTERY CHURCH, DAPHNI (near Eleusis, Grece). Late 11th century. Plan. Imperial foundation. Cistercian monastery in 13th century. Gothic vestibule and monastery. Related to Katholikon at Hosios Lukas, but the relationship between areas is simplified and systematized.

108 CHURCH OF THE VIRGIN (THEOTOKOS), HOSIOS LUKAS. Interior toward east. Classical sense of proportion and measured clarity of space. One of the oldest surviving templons (trabeated colonnades) on which, above plinths, icons were shown.

109 KATHOLIKON (left) AND CHURCH OF THE VIRGIN (right), HOSIOS LUKAS. View from east. Enclosing blocks, revealing perfectly the structure of the interior: widened cubes with projecting dome, tautly graduated, sharply outlined east end. Decorative placement of the stone.

110 KATHOLIKON, HOSIOS LUKAS. Interior toward east. Broad and very high central area. Squinches (conical niches) mediate between the square and the circle. The dome is poised over the eight arches of the squinches and arms. Encircling gallery. Chancel fully opened up, subsidiary dome over choir. Wall dissolved into delicate arcades; marble revetment.

111 MONASTERY CHURCH, DAPHNI. Interior toward east. Simpler version of Hosios Lukas Katholikon: no galleries, the arms of the cross also fully opened up. Narrow openings or niches instead of transparent arcaded screen. Emphatic verticality.

112 LEO VI BEFORE CHRIST. End of 9th century. H. Sophia, Istanbul. Narthex, lunette over Doorway of the King. Mosaic. Probably inspired by a sermon of the emperor, here in *proskynesis* before the Almighty Christ (as Divine Wisdom). Mary and Gabriel in medallions (reference to the Incarnation) simultaneously intercede for the emperor and realm. Monumental despite lack of proportion due to technical inexperience of mosaicists. Massed weight of bodies, fussily modeled parts gathered together by linear contours. Heavy, subdued coloring.

113 TWO APOSTLES (from an Ascension). End of 9th century. H. Sophia, Salonika. Dome mosaic. Stemming from pre-iconoclastic style, figures are elongated, weightless, inorganic. Double curved lines obscure bodies and drapery. Abstract hillocky landscape.

114 THE TRANSFIGURATION. Chludov Psalter. c.860. Historical Museum, Moscow. Colored brush-drawing. Earliest of the so-called Margin Psalters, deriving from the circle of the Patriarch Photios in Constantinople. Several hundred scenes round the margins of the text. Lively classicizing figures. Fluid, abstract draftsmanship. Vivid imagery.

115 THE CRUCIFIXION. Chludov Psalter. The illustrations are a commentary on the text and are frequently polemical—e.g., Iconoclasts are depicted whitewashing an icon of Christ, in association with the Crucifixion.

116 BOOK COVER. 9th century. Biblioteca Marciana, Venice. Cloisonné, pearls, and precious stones. 26×17.5 cm. Crucifix, apostles, angels in medallions. Back: Maria Orans. Typical of early enamels are large segments, coarse outlines, pearl border.

117 APOSTLE PAUL. Homilies of St. John Chrysostom. End of 9th century. National Library, Athens. 38×25 cm. Monumentality, precise articulation, modeling with color of Justinianic inspiration.

104

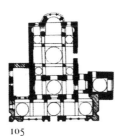

105

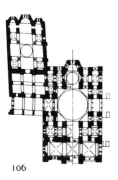

106

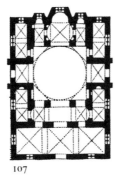

107

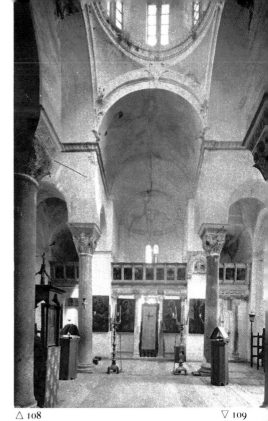

△ 108 ▽ 109

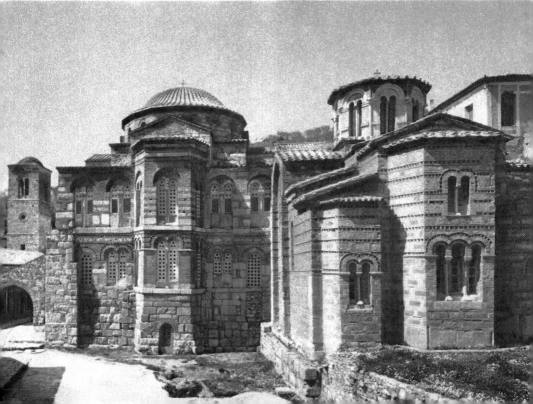

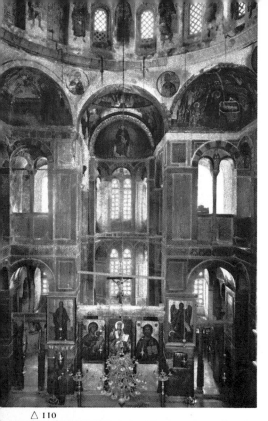

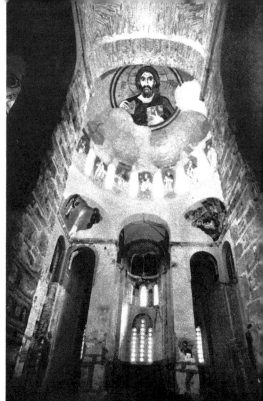

△ 110 △ 111 ▽ 112 ▷

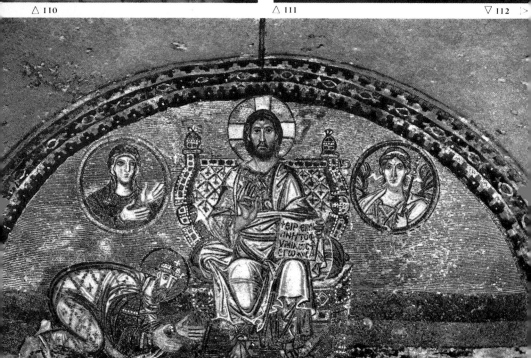

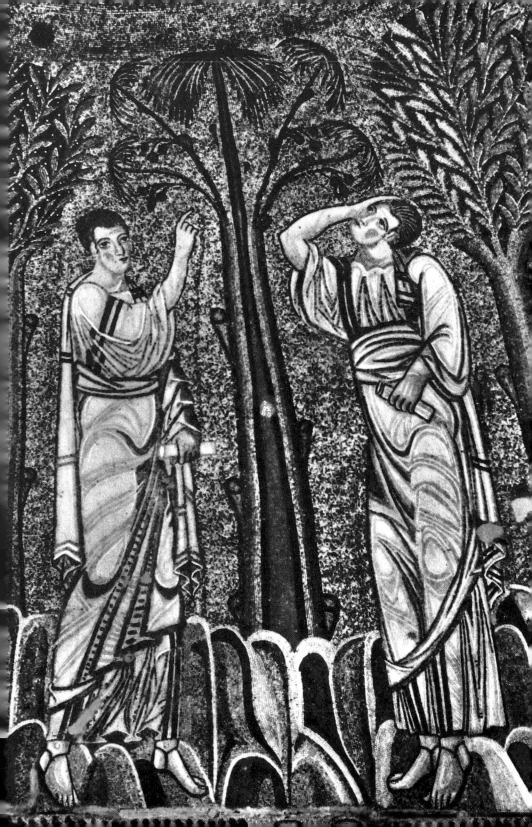

△ 114

△ 115

▽ 116

▽ 117

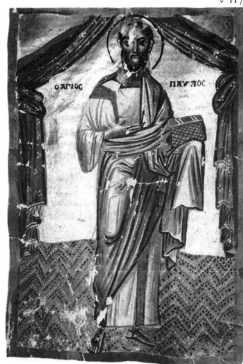

THE 9TH CENTURY

The ban on images, which lasted for more than a century, all but severed the tradition of figural representation in art. There are many indications that, at the same time, the link with classical models was loosened and that the tendency to reduce forms to lines and planes was further strengthened in the secular figural art of the iconoclastic period.

Christian figural art, apart from a few works of official propaganda, made only a tentative reappearance after the victory of the iconodules (image-worshippers). Evidently at first the linear tradition of the 7th and 8th centuries continued. Even at the end of the 9th century the mosaics of the church of H. Sophia in Salonika—especially the slender apostles of the Ascension (*113*)—display this abstract linear style: The multiplication of lines willfully distorts and blurs limbs and drapery; expressive gestures, like the "punched-out" trees and hills, are starkly etched onto the gold ground.

In the latter part of the 9th century, under the first Macedonian emperors, Basil I (867–86) and Leo VI (886–912), there was a rapid revival which culminated in the brilliant art of the so-called Middle Period. In the 9th century, an intensive effort was made to recreate a picturesque illusionism and to recapture the beauty of figural representation. The figure was again treated in the round—even if it remained disproportionate and only tenuously situated in space and its surroundings—and a painterly modeling with color became the most important method of achieving this. There were many attempts to draw the picture together as a scenic and compositional (or at any rate coloristic) whole. Again it was to the classical past that the art of the late 9th century turned, borrowing models, details, and techniques in order to realize its own pictorial vision. Its greatest inspiration was the art of the 6th century, especially that of the age of Justinian, which had fused the classical heritage and a style of spiritual abstraction into a new unity. Both of these elements were reworked, with varying emphasis, in the art of the 9th century, and their presence points to further developments—the mature Macedonian Renaissance of the 10th century and the transcendental imagery of Middle Byzantine art. Ecclesiastical decorative programs, the greatest and profoundest achievement of the Middle Period, also began to crystallize in the period after the Iconoclastic Controversy: Although historical scenes were still absent, frontal, isolated figures were preferred, standing before the gold ground with a firm outline and grave forcefulness. The most prominent monumental pictorial work of the 9th century is the mosaic over the main portal of H. Sophia in Constantinople. A political and religious profession of faith, it shows Leo VI making obeisance before Christ (*112*). In these broad, projecting figures the separate parts are clasped in and covered by parallel bands of color. The proportions are still heavy and unevenly worked out—this was probably occasioned by the lack of technical experience—but in the feeling for sculptural values, and for abundant relief restrained by contour, the path toward a new kind of imagery is evident.

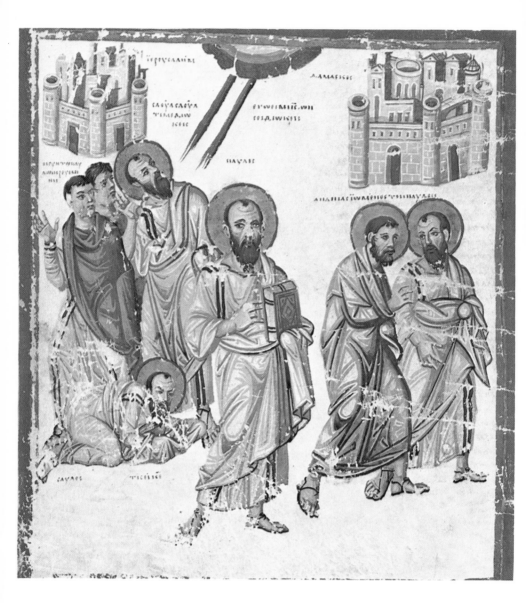

118 CONVERSION OF PAUL. Cosmography of Cosmas Indicopleustes. End of 9th century. Biblioteca Vaticana, Rome. c.33.5 × 33.5 cm. A description and chronicle of the world (important from the Byzantine outlook) was written and illustrated in the 6th century with diagrams of the Earth and Cosmos, scenes from both Testaments, etc. This 9th-century copy of the original codex brings together illustrations to the text that were originally separate (Conversion of Paul, Road to Damascus) into one framed picture grouped around a central portrait of St. Paul. There is no unified conception behind the picture and no spatial connection between the views of towns and figures. Robust construction of figures, summary modeling, and indication of drapery; few colors, chiefly light, with heavy drawing in black and white highlights.

These stylistic tendencies characterize every work of this period, but, especially in book illumination, they are significantly affected by the kind and style of the model used. Thus, for example, among the 46 full-page miniatures of the *Homilies of St. Gregory Nanzianzen*, done for Basil I in 880–86, there are frontal, iconic figures, broadly conceived compositions taken from monumental painting, and simple, multiple-strip narrations with small compact figures, whose vivid gestures, together with the views of towns and the powerful use of contrasting color, point back to early Byzantine works (*119*). *The Vision of Ezekiel* (*120*) is extraordinarily close to the Hellenistic prototype in its softly colored, extensive landscape and classicizing frame; yet the clumsy, inorganic figures with crumpled robes pressed against their bodies are typical of Byzantine art, which firmly declined to make direct observations of nature and borrowed details from antiquity. In the *Cosmography of Cosmas Indicopleustes* (*118*), an attempt was made to assemble all the phases of a continuous narrative in one picture, but neither a firm comprehensive pictorial composition nor spatial unity was achieved. The figures have solidity but are inorganically subdivided, and the composition, too, remains fragmentary. Its penetrating immediacy derives from the isolation and contrast of motifs. In the Chludov Psalter of 858–68, the earliest of the so-called Margin Psalters produced in Constantinople (*114, 115*), the linear structure of limbs and drapery is denoted in a painterly wash technique that recaptures much of the spontaneity of classical movement. Its tense expressiveness is reminiscent of the Rabula Gospels. The earliest surviving works in enamel, which now begin to proliferate, also strive for an immediate painterly effect. Relatively large, lucent particles of color on a green ground glitter in the delicate gold mesh; the broad pearl frames that isolate the enamel fields heighten the slightly shrill effect of material preciousness (*116*).

119 RAISING OF LAZARUS AND ENTRY INTO JERUSALEM. Homilies of St. Gregory Nanzianzen. 880–86. Bibliothèque Nationale, Paris. 41 × 30.5 cm. Executed for Basil I in his court workshop. 46 miniatures, including scenes from both Testaments, from chronicles, lives of the saints, etc. Type of pictorial presentation varies according to the model used: several strips with one or more scenes, the main and the secondary scenes relatively unified; closed compositions patterned on murals; icon-like figures and rows of figures. Stylistic variations similarly determined by the models. Typi-cal for this first phase of the Macedonian Renaissance—classical borrowing of details (not compositions), classicizing figural types and architecture not spatially related, figures ample, ill-proportioned with large heads and hands. Unnaturally angular drapery.

120 THE VISION OF EZEKIEL. Homilies of St. Gregory Nanzianzen. Hellenistic landscape in richly classical oval frame, delicately coloristic evocation of light. Scenes cleverly inserted in composition. Figures closer to the classical ideal. Typically "wet," crumpled drapery. (See also *119*.)

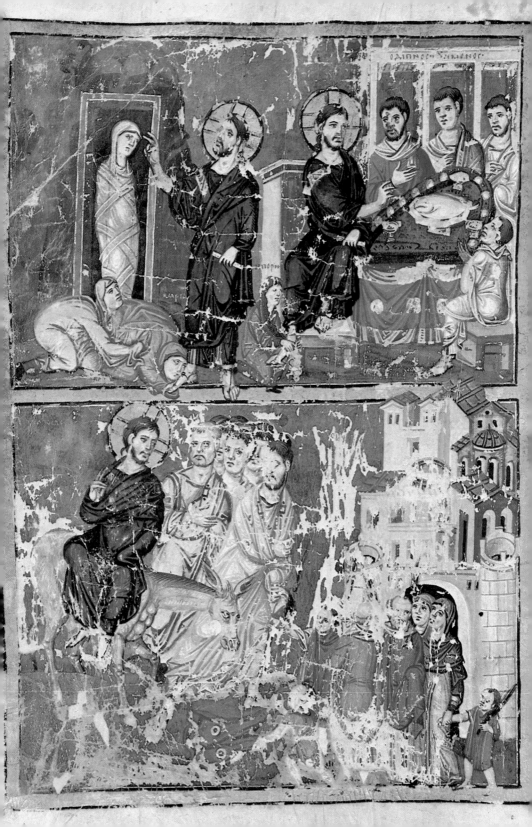

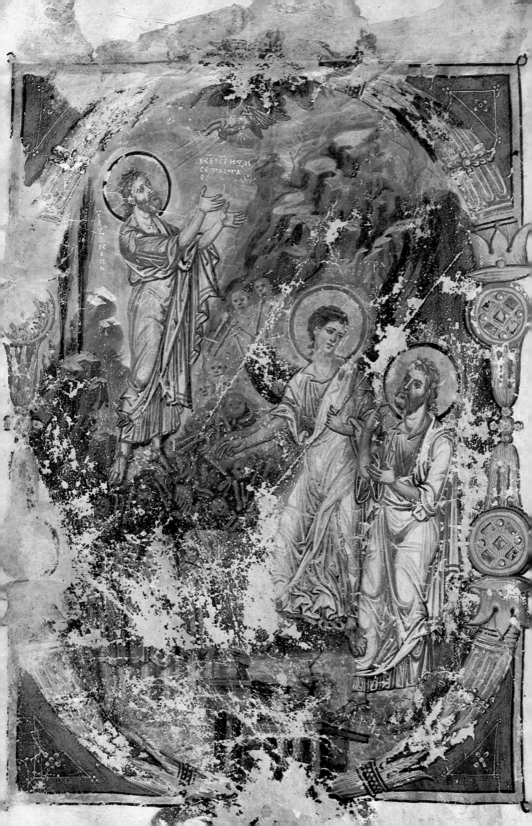

THE MACEDONIAN RENAISSANCE

THE 10TH CENTURY

One of the most brilliant epochs of intellectual life and art in Byzantium occurred during the reign of the first Macedonian emperors in the late 9th and 10th centuries. The Macedonian Renaissance is particularly notable for its great revival of art and learning. In this century, in which the Byzantine Empire of the Middle Ages reached its greatest extent, power, and influence and the old Roman imperial idea seemed to have been realized anew, a vigorous humanistic movement evoked fresh interest in the achievements of Byzantium as well as classical antiquity. This interest in the past seems to have been concentrated in the university (which had been reorganized after the Iconoclastic Controversy), where all the classical branches of learning were taught. It received powerful encouragement from such important and cultivated men as the patriarch Photius and an emperor who was both scholar and artist, Constantine VII Porphyrogenitus (913–59). At the emperor's instigation, great encyclopedias of classical learning of all description were compiled; in his scriptoria works of classical literature, historiography, and science were collected, copied, and preserved for posterity. The emperor's own writings reveal his encyclopedic and antiquarian interests; his Book of Ceremonies is an incomparable source of information on courtly ceremonial and its history.

Book illumination was pre-eminent in the artistic *renovatio* of this golden age of Byzantine art. The resplendent and lavishly embellished manuscripts, the luxury product of a highly cultivated taste and consummate craftsmanship, are deeply permeated by the classical spirit. Not only the texts but also the illustrations of classical writings were brought into new editions and made accessible. A few of these classical copies of the 10th century (whose "Pompeiian" technique can sometimes make one forget the centuries-long hiatus between classical antiquity and 10th-century Byzantium) have survived, while the existence of countless others is attested by later quotations of individual pictures. This revival of classical formulas took place in all spheres of book illustration, Christian no less than secular. The models were chiefly manuscripts of the late classical and Early Christian period and of the 6th and 7th centuries—that is, dating from periods when the classical tradition was fully alive or being intensively strengthened. Probably only rarely were classical works themselves copied.

One of the most brilliant works of Byzantine book illumination, the Joshua Roll in the Vatican (*130*), is a particularly clear reflection of the classical heritage in Byzantine art. This 11-meter-long illustrated roll was doubtless unique when it was produced, probably to honor an imperial patron or recipient. A triumphal picture-story was extracted from the chronicle of Joshua: The idea of a triumph and the format of a pictorial frieze were taken from the bands of reliefs on classical columns of victory. The technique used was also singular: brush-drawing in light washes in four shades—brown, purple, blue, and white. In spite of the limited range of color, the scenes have a lively, dramatic action, real corporeality, and convincing spatial illusion. The wide, panoramic landscape, studded with hills, trees,

altars, and views of towns at an indeterminate distance, the idealized beauty and nobility of the figures and their graceful movements, the delicate technique, the ease with which light and shade are created, the foreshortening and placement of figures in space—all these things are very close to the classical world. Nevertheless, the 10th-century character of the manuscript is unmistakable: It is evident, for example, in the somewhat jarring addition of classical personifications of towns at the borders of individual scenes, in new, unclassical motifs, such as the courtly obeisance of the Gabaonites, and in the brittle angularity of much of the drapery.

Stylistic kinship and a similarly close relation to antiquity connect the Joshua Roll with some other well-known manuscripts, the Paris Psalter (*121, 122*) and the Bible of Leo the Patrician in the Vatican (*123*). Both are embellished with a splendor and wealth comparable

121 ISAIAH'S PRAYER. Paris Psalter. Mid-10th century. Bibliothèque Nationale, Paris. 36 × 26 cm. 14 miniatures from the lives of David, Moses, Jonah, and others. Certainly from the court atelier. Copies (each well known) from the 11th to the 14th century. A masterpiece of classical revival. Humanist spirit evident in the elevated, sensitive conception of beauty, as in the moralizing and allegorical accompanying figures. Each scene a panel-like enclosed composition. Figures and landscape motifs after Late Antique models. Plastic, statuesque figures and substantial pieces of architecture create space; anatomy and perspective only partially consistent. Impressionistically applied, brilliant but balanced color, for example, the figures of Isaiah, Night, and Dawn are only in blue and pink.

122 CROSSING OF THE RED SEA. Paris Psalter. Illustration from the Book of Moses. Transformation of strip composition into full-scale picture; renunciation of spatial unity in favor of monumental composition. Pictorial construction balanced by accents of color. Coloristic and plastic emphasis on single figures (here, Moses) produces spatial breadth. Dynamic contrast between full, muscular bodies and sharp, brittle folds of drapery. Classical personifications: Night, Desert, Abyss, Red Sea. Frame of gold and precious stones.

123 MOSES RECEIVING THE LAW. Bible of Leo the Patrician. Second quarter of 10th century. Biblioteca Vaticana, Rome. 41 × 27 cm. First of two volumes with 18 miniatures preserved (scenes from Genesis, lives of Moses, David, Job, Elijah, Judith, and others; and from the St. Nicholas legend; Mary receiving the book from Leo the Patrician, etc.). One of the masterpieces of the Macedonian Renaissance. Various artists and models, some identical with those connected with the Paris Psalter. Large, full-scale, multiple-scene strip pictures. Painterly style with fluid transitions: integration of the slender, supple figures with the architecture and landscape; aerial perspective; illusionistic compositions with glowing colors.

124 CONTAINER FOR RELIC OF THE TRUE CROSS. Middle panel of the cover. c.965. Cathedral Treasury. Limburg an der Lahn. Gold, cloisonne, chased silver, set with precious and semiprecious stones. Overall dimensions: 48 × 34 × 6 cm. In the center of the sliding cover: Christ, with Mary and John interceding (Deesis), archangels, twelve apostles, framed with precious stones and enamel busts of saints. Above and below (not shown), great rosettes of semiprecious stones. Rich border with inscription. Inside, a case with cross-shaped space for reliquary of the cross, decorated with angels, cherubim, seraphim. Reverse: chased silver gemmed cross. Masterpiece of gold work and enameling. Classical balance of design and figural style.

115

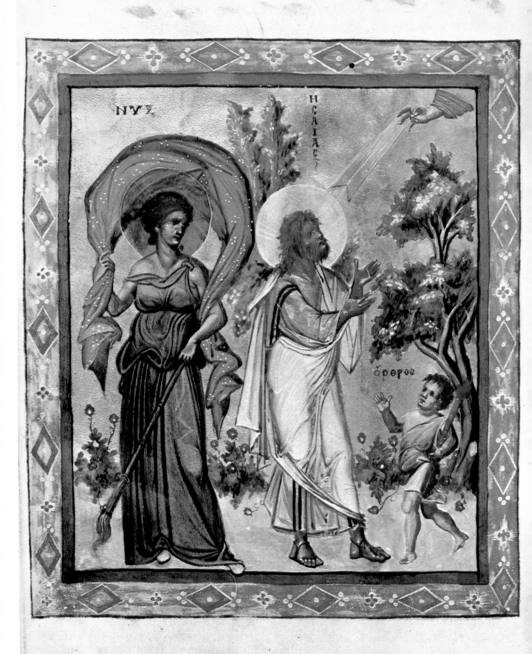

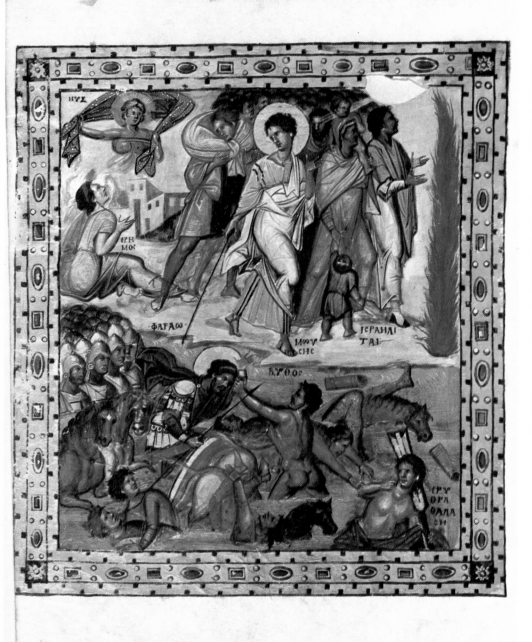

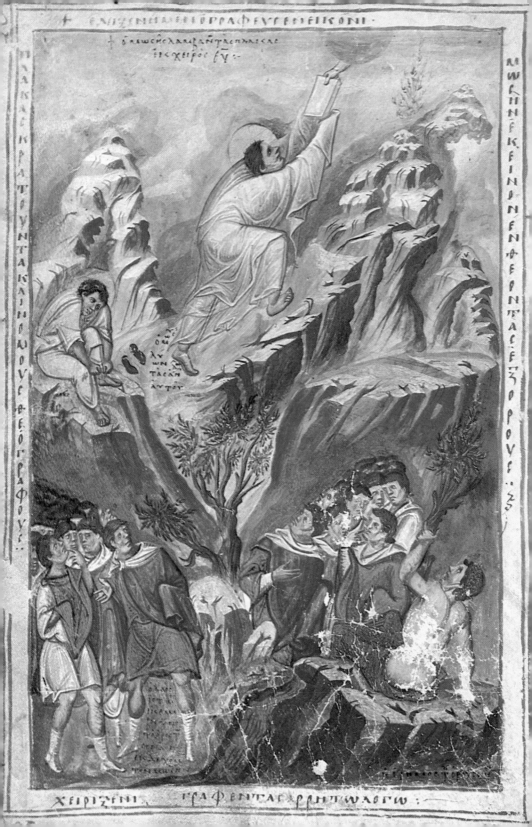

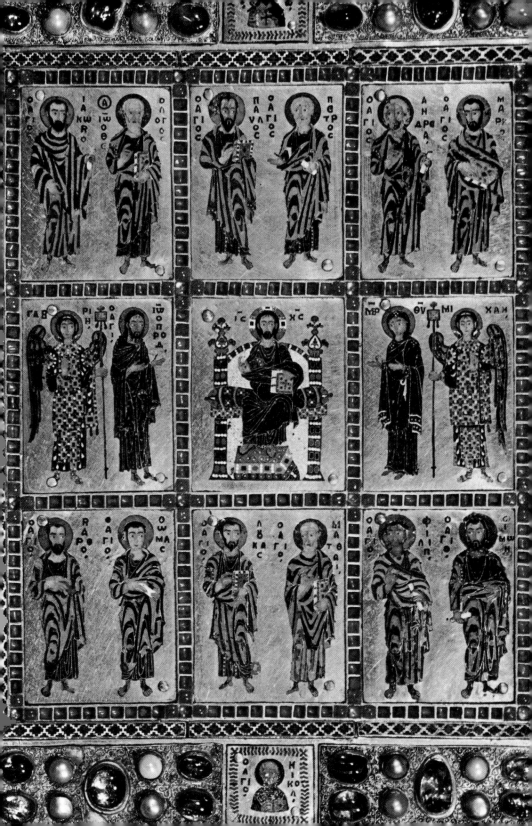

only to jeweler's work. Strong, glowing, and richly nuanced colors are boldly and dynamically juxtaposed, and the airy, atmospheric backgrounds coalesce out of subdued light blue and white. Color and light, with which the painter was particularly facile, are used to evoke sculptured forms that move freely in a spacious environment rich in landscape motifs. But an illusion of autonomous figures in space is only partially created. The individual emphasis given to the figures and scenery fragments the space, and the figures themselves seem more the product of assemblage than growth. Foreshortening and perspective thus lack a consistent setting.

The painters of the Paris Psalter evidently attempted to insert elements taken from the most diverse sources and of the most diverse form, into the virtually square pictorial field, sometimes jeopardizing consistency of form and even of content. Nevertheless, in some of the pictures a classical original was surely recaptured: the calm, blue Night in *Isaiah's Prayer* (*121*), Moses walking on the shore of the Red Sea (*122*), and many of the distinguished, delicate faces. The Bible of Leo, with its slender, strangely boneless and unstable figures

125 HARBAVILLE TRIPTYCH. Front. Mid-10th century. Louvre, Paris. Ivory. Center panel, 24 × 14 cm. Court workshop. Christ enthroned, with Mary and John interceding; saints beneath and on wings within and without. Back: large cross in Paradise setting. Miniature altar for private devotion (such devotional triptychs, sometimes with Gospel scenes, were much beloved in the 9th and 10th centuries). Rigidity tempered by classical conception of figures and folds; plastic forms in shallow space, painterly freedom in rendition of the heads. Stylistic tendency to elongation and accentuation of finely chiseled, elegantly flowing folds.

126 VEROLI CASKET. Two side reliefs. 10th century. Victoria and Albert Museum, London. Ivory. Overall dimensions of casket: 40.5 × 15.5 × 11.5 cm. Scenes from classical mythology: Sacrifice of Iphigenia (after Euripides), Bellerophon and Pegasus. (Not shown: Rape of Europa, Dionysus, bucolic scenes with putti, etc.) Masterpiece of the classical revival, transmitted through book illumination. Best of the "star" or "rosette" caskets (so called after the pattern on the borders). Typical of the 10th-century renaissance: painstaking copy of classical model, unclassical doll-like figures in exaggerated movement, restless surface pattern, angular hems on the garments.

127 LUKE THE EVANGELIST. New Testament. British Museum, London. First half of 10th century. 29.5 × 22.5 cm. One of three portraits of evangelists. Luke reflectively writing. Exact depiction of writing implements, but mere indication of interior. Painterly, impressionistic style; objects summarily modeled with color and scattered light. Delicate, precise, often calligraphic brush drawing.

128 MARK THE EVANGELIST. Gospels. Mt. Athos, Stauronikita Monastery. Mid-10th century. 28 × 21.5 cm. Superlative renaissance work after a very early model. All four evangelists posed in the manner of classical statues of philosophers in front of sumptuous theater architecture. "Pompeiian" landscapes are seen in the distance. Statuesqueness, spaciousness, bold modeling, splendid color.

129 DEATH OF THE VIRGIN. First half of 10th century. Bayerische Staatsbibliothek, Munich. Ivory on the cover of the Gospels of Otto III, once the center of a triptych. 14.5 × 11 cm. Sorrowing apostles stand around the deathbed; Christ holds Mary's soul in the form of a child. Belongs to the so-called painterly group of 10th-century ivories, which display space-creating architecture, undercut relief, passages of light and shadow, dense strands of drapery.

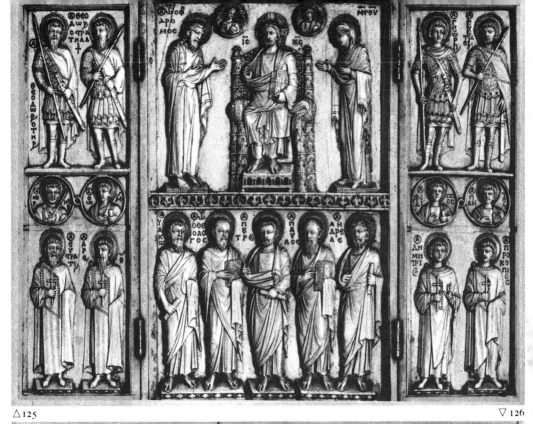

△ 125

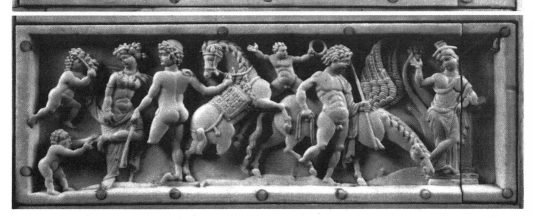

▽ 126

ⲟ ⲗⲟⲩⲕⲁⲥ

127

▷ 129

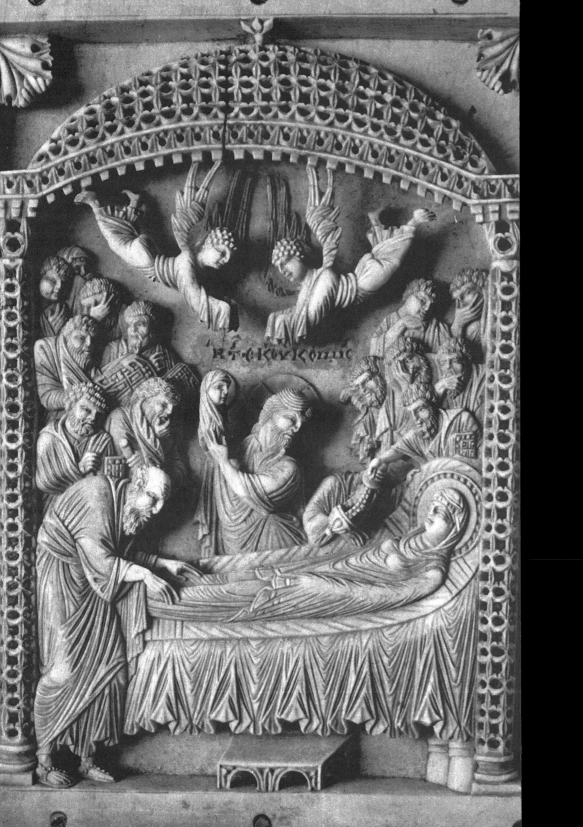

contained in more restricted space, is probably somewhat earlier and somewhat less classi-cizing than the more boldly sculptural and (in the rendering of the drapery) more metallic-ally brittle Paris Psalter. Still, the picture of Mt. Sinai (*123*), with the peaks towering above the haze of pink, white, and blue, the vehement Moses, rapt onlookers, and brilliant color, is certainly among the finest and certainly among the most classical works of the Mace-donian Renaissance (despite the clumsy handling of foreshortening in the figure of Moses).

That the artists and patrons of the period strove to achieve the most authentic *renovatio* of classical antiquity is borne out by several pictures of the evangelists in a manuscript in the Monastery of Stauronikita on Mt. Athos (*128*). These portraits, deriving from the earliest of the holy authors, reflect—in their full, statuesque corporeality and reflective remoteness, as well as in their general conception—classical portraits of philosophers. The architecture of the background betrays the origin of this humanist conception of the medita-tive thinker: the proscenium wall of Roman theaters, where statues of philosophers were once to be found.

But there is also a series of miniatures from this period that depicts the evangelists writing, in a state of inspiration (*127*). In these miniatures the figures are blurred with fine, rippling folds and coruscations of light. They mark a retreat from the world of actual appearance in order to give religious content a deeper resonance.

Ivory carving also flourished in the 10th-century revival. Several caskets with rosette borders, such as the Veroli casket (*126*), reproduce scenes from classical tragedies and mythology. Despite the closeness with which the figures and motifs imitate their proto-types, the puppet-like gestures and turbulent surface pattern indicate that there were limits to the Byzantine comprehension of the antique—limits particularly evident in the art of relief, which lacked a firm classical tradition of its own. Illusionism is more readily found in ivories with Christian themes, for example, a *Death of the Virgin*, in Munich (*129*). Both the canopy and the spacing of the figures one in front of another, the foremost ones being in very deep relief, create the impression of depth. The fine play of light and shadow over an active surface gives the relief a painterly quality that brings out the feeling in the expressive faces.

The products of another imperial workshop are imbued with a severer, more icon-like spirit. In the Romanus group of reliefs—for example, the Harbaville triptych (*125*)—the prototype of draped classical statuary has been whittled away to produce extremely slender figures, poised rather than standing. Their organic articulation is preserved, but the most powerful effects are those of contour and line, which, especially in the drapery, combine into elegantly constructed, self-justifying patterns. There are related stylistic features in one of the finest works of enameled gold, the great reliquary of the True Cross in Limburg (*124*). In the figures of the apostles and the evangelists its classical inheritance is manifest, parti-cularly in the broad, light and dark blue enamel modeling lines. The delicate mesh of gold lines does indeed faithfully delineate the figures of Christ, Mary, and John in the central panels, but at the same time it transports them into the realm of the abstract and immaterial. Here the decisive step into Middle Byzantine art is taken, as it was in contemporary book illumination.

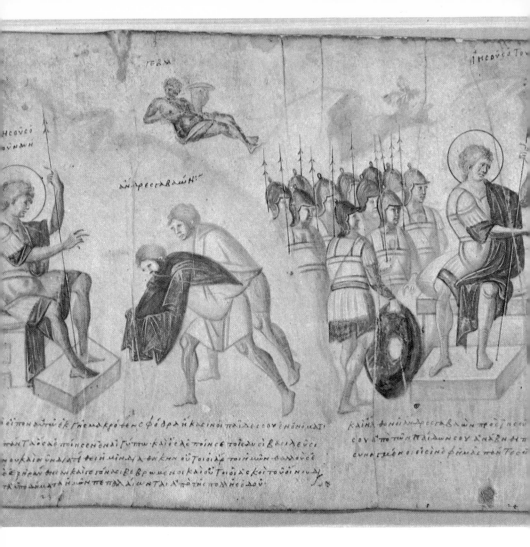

130 JOSHUA AND THE SPIES FROM GIBEON.
Joshua Roll. Mid-10th century. Biblioteca
Vaticana, Rome. Length 11 meters, height
45 cm. From the imperial scriptorium, prob-
ably for Constantine VII. Continual
frieze, text in the lower margin—excerpts
from the first twelve chapters of the Book
of Joshua. Triumphal pictorial program in
the manner of classical triumphal columns:
deliberate choice, deviating from literal
illustration of the Octateuch. Painted pic-
torial frieze from a period lacking monu-
mental sculpture. Present dating certain
(earlier dated 7th century), but not typical
of 10th century. Modeled on an Early Chris-

tian roll; probably the only 10th-century
contributions are modifications of style
and motif. Probably a uniquely free
combination of separate scenes from a
codex of the Octateuch into a roll, with
landscape motifs forming transitions and
occasionally vague personifications of an-
tique origin at the junctions. Possibly a 7th-
century stylistic model. Also unique tech-
nically: brush drawing in only four colors,
accomplished illusionistic technique, with
perspective, lighting, foreshortening, etc.,
largely mastered. Extensive landscape in
which the ample, supple, sculptural figures
are embedded.

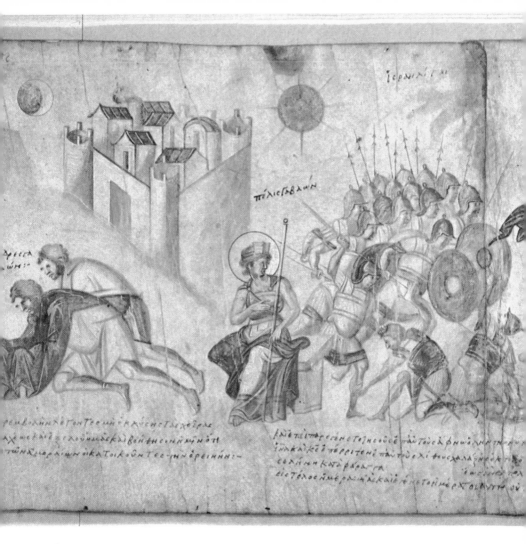

131 BAPTISM OF CHRIST. Menologion of Basil II. c.985. Biblioteca Vaticana, Rome. 36.4 × 28.4 cm. Ecclesiastical calendar (synaxarion) for the first half of the ecclesiastical year. 430 miniatures, one per side with appropriate text: scenes from the lives of the saints (chiefly martyrdoms), feasts of the Church, reliquary processions, etc. Executed in the court atelier by eight painters (singularly, all the miniatures are signed). However, individual style subordinated to the dominant style of the time and atelier. Variations are created by models used. Late Macedonian classicism in a new, rhythmically linear, self-contained kind of pictorial organization. Symmetry gives compositional balance: emphasis on the center, parallels, and contrasts. Schematization of space into a shallow stage, of figures into inflated and indented shells, and of lines into jagged, brittle systems. Drawing in gold (chrysography). Many classical motifs. Humanistic idealization matched with ascetic spiritualization.

132 MARTYRDOM OF ST. EUDOXIOS. Menologion of Basil II. Forceful movements transfixed on a compositional screen. Note sharpness of breaks in the folds of drapery. Graphic color composition, with each color modeled in a finely nuanced sequence of tones.

127

μοῦ· καὶ ἰλ·θὲ φωνὴ ἐκ τῶν οὐρανῶν λέγουσα·
ὅ ὗος ἅ ἡ ὁ ἴος μου ὁ ἀγαπητὸς ἐν ᾧ εὐδόκησα·

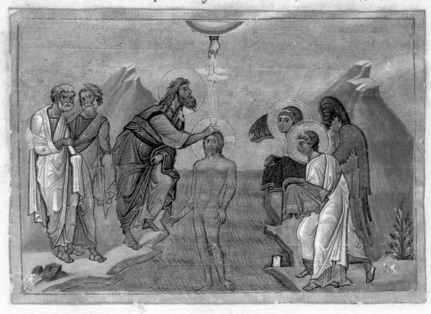

△ 131 ▽ 132

ρων ἐ γ λο ζιου ρ ω π υ λου· ιζ τῆς σ υ νο λι ασ αγ ω·

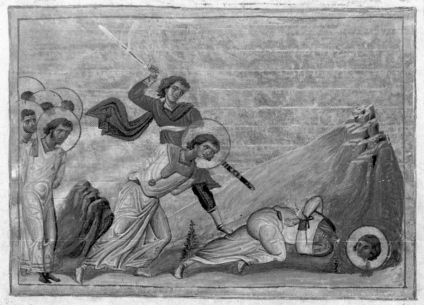

ὁ δά ζιος ὁ τ ου χ̅ μ̅ α̅ ρ̅ τ̅ ι̅ ο̅ ς̅· ἱ ο υ ερ χ̅υ̅ δ̅ π̅ π̅ τ ρ αγ α μ ου μαστ λ δω ε̅

MIDDLE BYZANTINE ART

THE 11TH CENTURY

The late 10th century was a watershed in the history of Byzantine art. It is true that the achievements of the Macedonian Renaissance were influential well into the 11th century. It is also true that as early as the third quarter of the 10th century new artistic ideas were beginning to win ground as the unconditional emphasis on classical revival dwindled: Rigorous stylization and spiritualization became perceptible in all spheres of art. Nevertheless, around 980 something radically new was created; esthetic principles were given expression which were to retain their validity into the 13th century and indeed were basically never to be foresaken. Around 980 the Byzantine Middle Ages began, their point of origin doubtless in the court atelier of Basil II.

New was, first of all, a strongly articulated style (137, 138, 139). It was in the first place linear: A rigorous, closed system of linear interrelationships in complex balance was employed to organize picture surface and to anchor each figure firmly to its place within the rhythmic and decorative pattern of the surface. The figures themselves were endowed with a precise linear structure; the florid drapery, rich in folds, crystallized to form highly expressive silhouettes. Just as the free and individual unfolding of the figure was sacrificed to this systematic organization, pictorial space forfeited its illusionistic depth. It rigidified into a stage—graduated like a relief, before the imaginary backdrop of gold. Landscape and architectural frames selected from a rich classical repertoire enclose the figures or stabilize their movements. Each portion of the picture follows a unified choreography aimed at total repose or dynamic effect (132). The compositional rhythm never moves beyond the borders of the pictorial field, but is concentrated upon the center, and takes the classical form of the triangle, frequently inverted. The coloring, too, is bound into this rigorously conceived picture: With the finest hatching, and through subtly graduated nuances of the basic tones, the colors unite to form a precious skin of metallic polish and thinness (131). The gold of the ground, which recurs in the highlights on the ridges of the drapery folds, is incorporated into the play of saturated color, which preserves its harmony despite the wealth of unusual admixtures. A new conception of man is evident in this new kind of picture: Obvious types replace individual portraits; spiritual and ascetic traits lend the humanist ideal a grave, occasionally gloomy severity. The distance between the enclosed world of the picture and the viewer increases, confronting him with a transcendental world, and through this exclusiveness creating a new, half-magical, half-spiritual relationship between him and the sacred image. This style is found fully formed in the Menologion of Basil II of about 985 (131, 132, 138). Its 430 miniatures, by eight painters, are—uniquely—all signed, but subtle criteria are needed to distinguish the different hands. In effect, the style of the workshop and of the time eradicated the individual styles, and variations between the miniatures were chiefly caused by differences in the models.

But the achievement of the court artists of Basil II was far greater than the development of a new style. They created that unity, repose, and self-containment within the picture

(what is more, within the *narrative* picture) which had been sought ever since the picture had begun to release itself from a decorative or narrative continuum. With an almost mathematically lucid economy of means they perfected Byzantine pictorial form. Closely associated with the systematized conception of pictorial surface and probably simultaneously evolved was the new conception of space in monumental painting. The ensemble of decorated areas in the church followed organizational principles as rigorous as those ordering the individual picture. Each figure and each scene had its place, and each was adapted to the special conditions of the vaulting, in order to maintain the integrity of the individual picture, as well as a formal unity, harmony, and optical correctness of the whole. And just as each picture was built from the background outward, so the pictures in the vaulted areas of the domes and niches of the church moved forward into actual space. Actual space became pictorial space (the stage, so to speak, for the scenes depicted) and what can be called "iconic space," into which the observer is physically, spiritually, and optically drawn. Individual pictures join to create a hierarchically organized pictorial unity, a perfect embodiment of the iconographic program.

The decoration of Hosios Lukas, in Boeotia, dating from the 11th century, is the earliest surviving example of this perfected spatial treatment. With its terse, heavy, geometrical, and visionary style, it is a monastic version of the Byzantine style (*134*). Nevertheless, it is based on the same complex techniques and the same pictorial conception as, for example, the mosaic decoration of Nea Moni on Chios of about fifty years later, which was the work of Constantinopolitan artists. Here we are confronted with a second characteristic of Middle Byzantine art: It was based on pictorial rules, compositional norms, and norms of linear organization that could be applied to distinctly different styles. On the one hand, the systematic pictorial schema of the Menologion was responsible for a certain classicizing monotony and lack of warmth; yet, on the other hand, it created a very durable pictorial structure, adaptable to any kind of change in style. (See, for example, *140*, the lectionary in the Dionysiu Monastery, which displays mannerist elongation and twisting of figures, gracefully affected movements, and shallow relief.) To this standardization of the pictorial ideal, and to this essentially constant pictorial organization, 11th-century art owes its unified character.

Hardly any other period was so fertile in production and stylistic imagination as the 11th century. Numerous ateliers cultivated their own traditions, modifying and borrowing according to their own inclination. Sumptuous books and precious mosaic decorations (*133*) were created together with simple "cheaper" decorations. The general tendency was toward an intensification of relationships within the picture. Thus pages were organized as decorative units—framed picture, marginal figures, ornamental borders, initials, elaborate letters, and text formed a well-proportioned whole (*140*). A taste for the small, delicate and calligraphic led, after the middle of the century, to the so-called *style-mignon*—a precious, very delicately colored script with little figures, rhythmically grouped in orderly lines (*135*). However flat, slender, and weightless these figures are, they still display a certain fluidity and assurance of movement in which classical tradition survives. By contrast, portraits of the evangelists long adhered to the philosopher-type of the 10th century, and thus retained greater weight and plasticity, and even a greater scale (*142*).

The last quarter of the 11th century brought the widest variety of stylistic variations: compositions either spare or filled with figures; forms manneristically elongated and compressed or sharply simplified; expressiveness and arid stereotyping; color that was brilliant or dull (*141, 143*). Linear modeling was rarely exaggerated to the point of disruption of form, which frequently occurred when Byzantine art was exported and imitated by local artists—as it was in extremely varied form in Kiev and at the church of H. Sophia, in Ohrid, Serbia. Around 1080 certain ateliers achieved a very harmonious and monumental style, in which previously brittle and jagged lines were smoothed out, and forms and contours were imbued with a lucid, gentle breadth and solidity (*146*). But by this time the classically inspired renaissance of about 1100 had begun.

133 CHRIST PANTOCRATOR BETWEEN CONSTANTINE IX MONOMACHUS AND ZOE. 1028–42. H. Sophia, Istanbul. Mosaic in south gallery. Originally depicted Zoe with first husband Romanus III. Probably all three heads destroyed on the banishment of Zoe in 1041; replaced after her third marriage of 1042, and emperors' names exchanged. Imperial votive picture in old tradition transformed into the formularized representation of a ceremony of donation. Imperial pair (with purse and bull of privileges) seem bodiless under the armor of gold, pearls, and precious stones of their ceremonial robes. Only the faces have a lifelike air, yet they, too, are flat and graphically schematized (note color on the cheeks). Christ beautifully modeled in blue on blue. Balance in the profuse, contrasting system of folds.

134 THE WASHING OF FEET. First half 11th century. Hosios Lukas Katholikon. Narthex, niche mosaic. Composition concentrated on the crux of the scene; accent and tension given by isolation of the chief actors, by framing group of figures, and by curve of the heads and gestures accentuated by pure gold background. Broad, heavy figures constructed from geometrical and sculptural elements. Rigorous, powerful linear structure knits the drapery into large compositional units, making a severe, rhythmically ordered whole. Strong relief created by strips of color modeled abruptly from light to dark with only five tones each. Dull color. Ascetic monumentality (in contrast to the optical refinements of court art) not deriving from provincial distortion, but from important monastic style that originated possibly in the capital. A weaker (local?) workshop evident in the naos.

135 FEEDING OF THE FIVE THOUSAND AND RESCUE OF PETER. Gospels. Bibliothèque Nationale, Paris. Third quarter of 11th century. 23.5 × 19 cm. From the monastery of St. John Studios in Constantinople. One of two surviving manuscripts with literal illustrations of the text and several hundred scenes added in rows as supplement. Style mignon—minute, wiry figures in fluid but legible succession of scenes, decorative pictorial calligraphy. Resembles precious enamelwork as a result of the gold lines and glowing, gemlike colors.

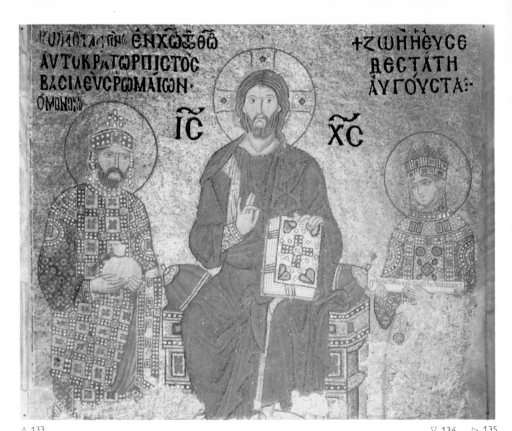

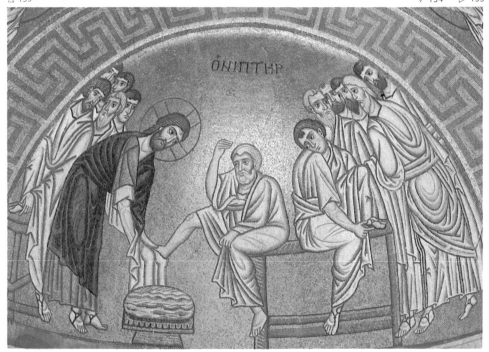

ἰδὼρ τὸ θαλάσσιον πλεῖν ἀναχαλικά· ζόμιλνον
ἐω τῶν μακάτων· ἢ γὰρ βλαπ πὸς ὄψ μ·

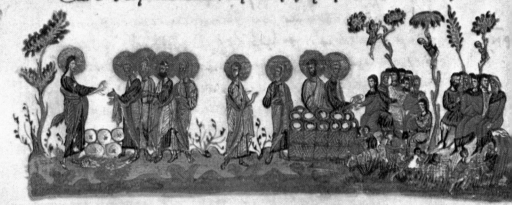

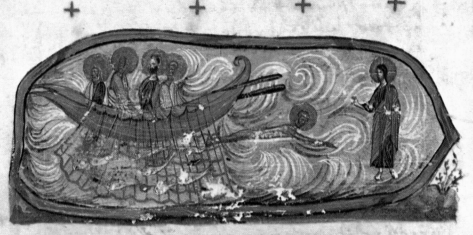

Τὲ γὰρ τὴν δὲ φυλακὴν τὴν νυκτὸς ἀπῆλθὸ
πρὸς αὐτοὺς ὁ ἷϲ περιπατῶν ἐπὶ τὴν θα
λάσσαν· ἰδόντες τόν αὐτὸν ἐπὶ τὴν
θάλασσαν περιπατοῦντα· εἶ εὐ ἐτα
χθησαν λέγον τὲς ὅτι φάντασμά ἐστιν·

136 BOOKCOVER. Christ, apostles, saints. 12th century. Biblioteca Marciana, Venice. Silver-gilt, enamel, precious stones. 35.5 × 25.5 cm. Reverse: Maria Orans and saints. Mannerist calligraphy of the gold fillets, ascetic physical types, opaque colors, and disproportionately broad frame characteristic of the late period of enamelwork.

137 BOOKCOVER. Archangel Michael. End of 10th or beginning of 11th century. Treasury of S. Marco, Venice. Silver-gilt and enamel. Restored. 48 × 36 cm. Testimony to the supreme technical mastery of Byzantine goldsmiths' work. Balance struck between noble form and luxurious material. The piece has the magical presence of an icon.

138 MISSION OF THE APOSTLES. Menologion of Basil II. Consistently symmetrical grouping of apostles and the triumphal arch-like architecture around the picture's center. Surface pattern in accord with the graduation and clustering of the masses in space. Very harmonious construction of the figures. Realization of the Middle Byzantine esthetic ideal.

139 MADONNA ENTHRONED BETWEEN CONSTANTINE AND JUSTINIAN. End of 10th century. H. Sophia, Istanbul. Mosaic lunette in south vestibule. Political image: Mary as protectress of the empire, city, and church—proffered by their founders. Stylistically similar to the Menologion (see above): richly complex pictorial organization; schematization of spatial stage, bodies, and features; nevertheless, full, vigorous modeling of the faces.

140 CHRIST IN GETHSEMANE. Lectionary. Dionysiu Monastery, Mt. Athos. c.1059. 39.6 × 29.5 cm. Certainly a product of the court scriptorium. Magnificent example of 11th-century manuscript illumination. Whole page treated as a decorative unit: harmonious placement of the scene and ornamental framing, initial- and marginal-figures (Christ addresses youths), gold uncial titles, and script of the text. Classically derived understanding of anatomy displayed. Modeling in delicate colors.

141 SCENES OF THE PASSION. Lectionary. Biblioteca Vaticana, Rome. End of 11th century.

34.8 × 27 cm. Systematized pictorial structure, late phase of the abstract linear style. Similar compositional schema employed in all scenes, contrapuntal lines and movements. Dynamic effects—tense tranquility, excited action. Elongated figures.

142 MARK THE EVANGELIST. Gospels. Austrian National Library, Vienna. Beginning of 11th century. 22.2 × 17.5 cm. Philosopher-type of the 10th century in new, lineally schematized picture. Balance of masses (figure and desk) within the picture. Expressive contours set off by pure gold ground. Figure composed of sculptural elements flattened out on the picture surface. Brittle, crystalline system of folds, rich in contrasts. Psychological tension results from contrasts between plane and line.

143 JOHN THE EVANGELIST. Gospels. Bibliothèque Nationale, Paris. End of 11th century. 22.2 × 15.5 cm. Picture field densely filled with fragmented forms of an ornamental character. No sense of space or organic relationships. Extreme flatness. Virtual independence of the linear pattern. Bright, brilliant color.

144 CANONICAL TABLE. Gospels. National Library, Athens. End of 10th century. 34 × 25 cm. The architectural structure—an arcade—conceived broadly, but in completely planar fashion. Tightly packed with stylized palmetto patterns. Ornamental contrast between pattern and ground, positive and negative. Gold superimposed on blue.

145 CANONICAL TABLE. Lectionary. Biblioteca Palatina, Parma. Third quarter of 11th century. 30.5 × 23.5 cm. Typical ornamental style of the 11th century with the elegant precision of the court atelier detectable. Carpet-like decoration with petal pattern. Carefully differentiated frame and content. Cool harmony of blue-green on gold.

146 EMPEROR NICEPHORUS III BOTANIATES WITH ST. JOHN CHRYSOSTOM AND THE ARCHANGEL MICHAEL. Homilies of St. John Crysostom. c.1078. Bibliothèque Nationale, Paris. 41.5 × 31.5 cm. New, grandiose monumentality, still based on a rhythmically harmonious linear style. Modeling with coloristic means.

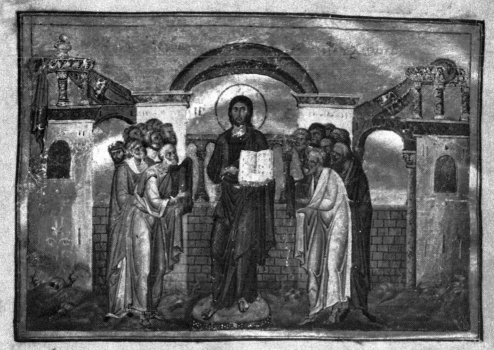

ἡμ[ῖν] ἰνδικτο[υ] μέορτα ζει ἰ τοῦ θ̅υ̅ δ̅λ̅ ψηοῖ ἀαπωοταρ̣αρ̣ μίων
παραμωουοαι διατογομ ζϲδἀζαρχ ἡ ὠ ἐραιτουχρομουαι

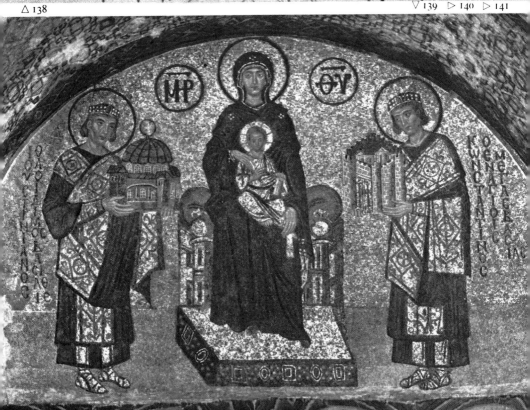

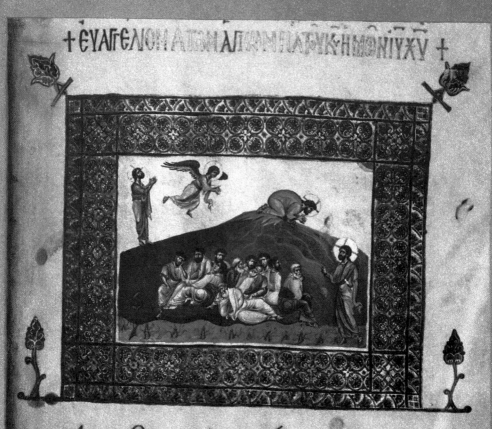

✦ ЄΚΤΟΥΚΑΤΑΙΩΑΝΝΗΝ †

ιωβμ ό κς τοῖς
βαπ τοῦ μαθη
ταῖς + μ ῶν δ δ
ζα σθη ὁ ιχ ὁς
του α π ου ιαιο

ιδ ὁ δοξα σ θη
ε τ αι π ω + ει ὁ
ιδ ὁ δοξα σ θη
ε μ αυ τ ω ι αι ο
ιδ ὁ δο ξα σ θω π

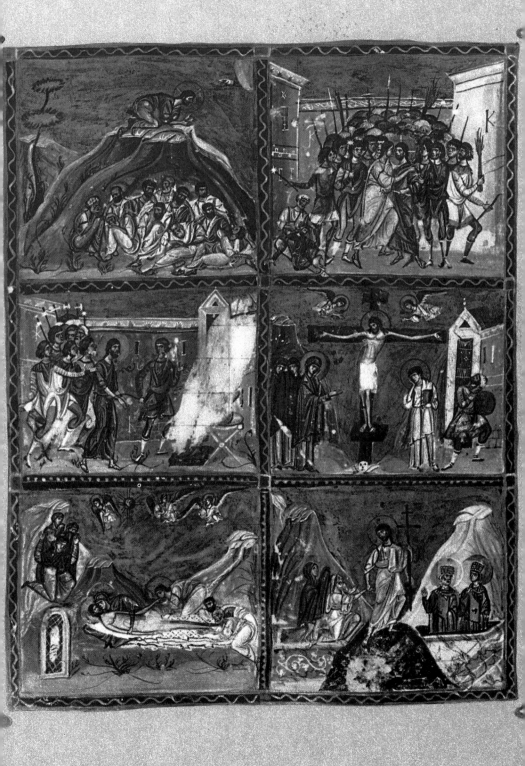

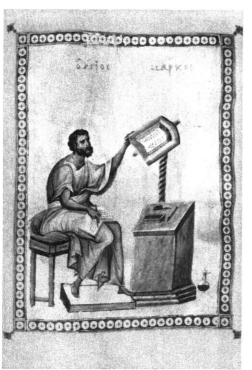

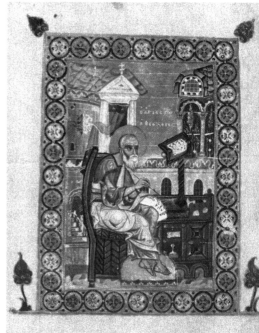

△ 142 ▽ 144 △ 143 ▽ 145 ▷ 14

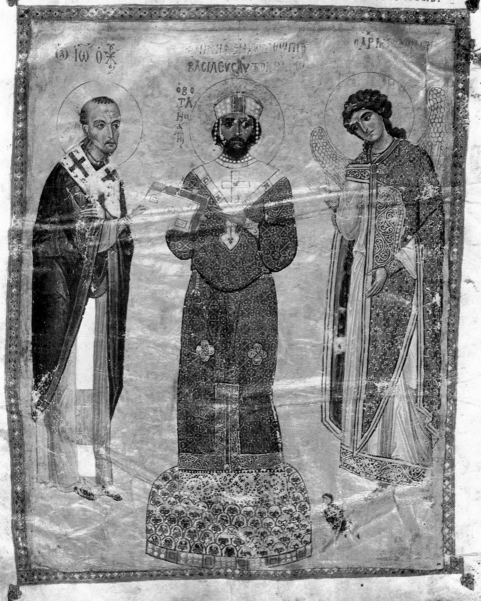

COMNENIAN ART

THE 12TH CENTURY

The renaissance movement of about 1100, which clearly predominated over the many stylistic tendencies persisting from the 11th century, should be seen as a reaction against their mannered abstract linearity. The so-called Comnenian Renaissance had its sources in classical Greek art. The statuesqueness and humanism of the art of the Greeks inspired their remote descendants to create an art of elevated dignity and monumentality. The mosaics executed by Constantinopolitan artists in the monastery church at Daphni near Athens are masterpieces of this style (*147, 149*). Each figure and each scene is imbued with spirituality and deeply human feeling. The pictorial structure preserves the clear, rhythmic organization of Middle Byzantine art, but without any geometric stiffness. Softly flowing rising and falling movements create a thick web of harmonious relationships that embrace buildings and landscapes as well as figures, and often the extended gold ground adds a note of tension or feeling. Space is constructed from background to foreground without any illusion of depth, but no longer in shallow layers—rather, with extensive relationships existing between foreground and background. Organically lively, loosely balanced figures stand and move with a natural, easy confidence, fitting harmoniously into the whole picture and individual scene. Rhythmic harmony also fills the soft billows and beautifully undulant lines of the drapery, and a gentle warm color turns light and dark tones into the illusion of light and shadow. In the somewhat later mosaics of the narthex (*149*), draperies are more agitated, the highlights and pools of shadow are more sharply contrasted, and the strict pictorial relief is broken up, as a new formal and psychological dynamism begins to erode measured balance.

Concurrent with and continuing after this classicizing style, there was another academic metropolitan style that remained extremely planar and linear. Even the mask-like plasticity of the faces in the imperial foundation mosaic in H. Sophia (*148*) was produced by sharp welded lines.

In the first half of the 12th century the imperial scriptorium may have played an authoritative part in furthering stylistic developments. An important group of manuscripts—the Jacob group (*154, 155*)—is notable for almost revolutionary color schemes (striking chords of ultramarine, cinnabar, and mat gold) and for an inner dynamism that disrupts classical balance. Contrasts are struck, parallel movements coalesce to produce emphatic action with an impetuous narrative tempo. The figures do indeed preserve much of the organic articulation inspired by the classical renaissance, but bodies are frequently cut by jagged lines, abrupt protuberances, and depressions. This dynamic effect derives chiefly from a novel illusionistic painting technique quite different from the 10th-century practice of modeling freely with a range of tones. Now only a few tones are sharply contrasted, disrupting the surface with their tensions; moreover, the highlights are focused in scrolls, ridges, and slivers, whose busy, form-flattening pattern accentuates the nervous vitality. Though the traditional paths were not really forsaken, a considerable degree of artistic

freedom—embracing iconography as well as technique—is perceptible in these miniatures for the first time.

The 12th century was the century of monumental art and comprehensive decorative programs *par excellence*. Although much of the art of the capital has been destroyed, we still have decorations produced by the Greeks (or at least more or less directly influenced by them) in Norman Sicily, Serbia, Russia, and around the Adriatic. In the cathedral of Cefalù, of 1148 (*150*), the classical restraint of the Daphni mosaics has disappeared. The drapery is exceedingly stylized and the figures communicate a certain tension. The sense of monumentality is produced by cascading, surging lines. The human warmth and ascetic distinction of the faces give them penetrating force. Only a little later, in the mosaics of the Capella Palatina in Palermo, this style is reduced to a web of simplified, thicker strands in flat, carpet-like compositions.

The variety of styles evident in the first half of the 12th century produced, in the second half, the highly important and complex art of the late Comnenian period. The frescoes in the church of H. Panteleimon in Nerezi (Serbia) of 1164 (*151, 153*) again reveal a pictorial organization consistently rich in interrelations. But now, every line and curve is fraught with sensitive life and tension. Each figure is the vehicle of one gesture, and these gesticulating figures are woven into lyrically intimate and realistic depictions of mood. The confident elegance of the draftsmanship and the refined syntheses of cold and warm colors betray the hand of an artist from the capital. Quite another mood—one of expressive and dramatic vitality—is struck in the mosaics of the cathedral of Monreale of about 1180 (*152*). This imposing decoration was, in form and content, consistently conceived. Compositional schemata bind the scenes on a whole wall into a single decorative pattern. The flow of movement and line is extended from one picture to another. The dynamic integration of the separate shapes into a formal whole is taken to its logical conclusion: The individual figures are subordinated to the ornamental ensemble. A web of agitated, abruptly contrasted and repeated lines and sparkling touches of light enmeshes and entangles the figures. Arabesque assumes a life of its own, contributing a dynamic effect and nervous piquancy. The complication of motifs, the bold compositional logic (with landscape and architecture rationally included), and the inflation of figures to gigantic proportions betray a vein of mannerist exhaustion in late Comnenian art. Its ultimate expression is perhaps in the angel in the chancel at Kurbinovo (*156*), concealed behind eleborately twisting and zigzag patterns.

147 ANASTASIS (THE HARROWING OF HELL).
▷ c.1100. Monastery church of Daphni near Athens. Mosaic in south transept. Part of a classic pictorial program enriched with Marian scenes. The fully elaborated Byzantine system of church decoration: figures and scenes meaningfully relegated to their situation in the church; actual space of domes and niches becomes pictorial space; scenes on the straight walls given a lucid, rhythmic articulation by means of dense interplay of lines and movements. Relief style modeled on ancient Greek art: statuesque solidity, monumentality, and classical motifs such as Hades who has assumed the pose of a classical river god.

148 MADONNA AND CHILD BETWEEN JOHN II COMNENUS AND IRENE. c.1118. H. Sophia, Istanbul. Mosaic in south gallery. More conservative character of the imperial votive and/or ceremonial picture evident. In type identical with the Zoe mosaic (133). Schematically flat with exact portrait detail (note the blonde plaits of Irene the Hungarian). Dry, dark delineation of folds. (In the mosaic of 1122 of Crown Prince Alexius nearby, the new form-evoking linearism is evident: Face modeled by circular whorls of color.)

149 PRESENTATION OF THE VIRGIN. Beginning of 12th century. Monastery church, Daphni. Mosaic in the vestibule. Loosening of measured balance of scenes in naos: lively movements, rapid narrative. Contrasting drapery patterns with fluttering seams, disrupted surface. New psychological tension.

150 APSE MOSAIC. 1148. Cefalù Cathedral, Sicily. Donation of the Norman king Roger II. Executed by Greek artists. Program of a Byzantine dome (Ascension and Second Coming of Christ) here transferred to the apse of a basilica. The monumental half-figure of the Pantocrator, which ordinarily would have fit into a semicircle (see 111) is adapted to a conch, which it dominates. (At Monreale, vastly enlarged, it fills the whole apse.) Conceived as a statue-figure but extended across the surface through a profusion of drapery. Both ascetic and humane.

151 THE LAMENTATION. 1164. Nerezi (Serbia). Fresco cycle donated by Alexius Comnenus, painted by Greeks. New human and realistic sense of drama. All movements of figures echoed in landscape forms. Proliferation of ornamental lines restrained by broad sweeping contours.

152 THE WASHING OF FEET. c.1180. Monreale Cathedral, Sicily. Mosaic in south transept. Foundation of William II as cathedral and monastery church. Basilica. Mosaics cover walls above a marble plinth. Great cycles of the Old and New Testaments, and of Sts. Peter and Paul; enlarged program in apse dome. Designed and executed by Byzantines, stylistic unity. Dynamic interweaving of all forms into a dense, agitated surface pattern rich in contrasts; often with airy, classicizing architecture behind figures.

153 ST. PANTELEIMON. 1164. Nerezi. Fresco on front wall of apse, in a finely ornamented, sculptural frame. Belongs with the well-preserved iconostasis. Iconic stiffness, mitigated by sensitivity and nobility of the saint, the elegance of the smooth, rhythmic shapes, and the cool coloring.

154 ASCENSION OF CHRIST. Frontispiece to a book of sermons in honor of Mary by the monk Jacob of Kokkinobaphos. Second quarter of 12th century. Biblioteca Vaticana, Rome (a second copy in Paris). 33 × 22.5 cm. From court scriptorium. Very extensive Marian cycle, with supplements from the Old and New Testaments referring to Incarnation and Redemption. Scene framed within a section of domed cruciform church.

155 THE VIRGIN GOING TO THE TEMPLE. Sermons of Jacob of Kokkinobaphos. Each episode in several phases, corresponding to the far-reaching rhetoric and free amplification of traditional iconography, including, for example, announcement of the event to the "just" in Hell. Disruption of classical idealized form: dynamism in narrative and composition, forcibly contrasted movements, deeply furrowed relief due to novel handling of modeling by abrupt contrasts of color. Vivid, brilliant coloring.

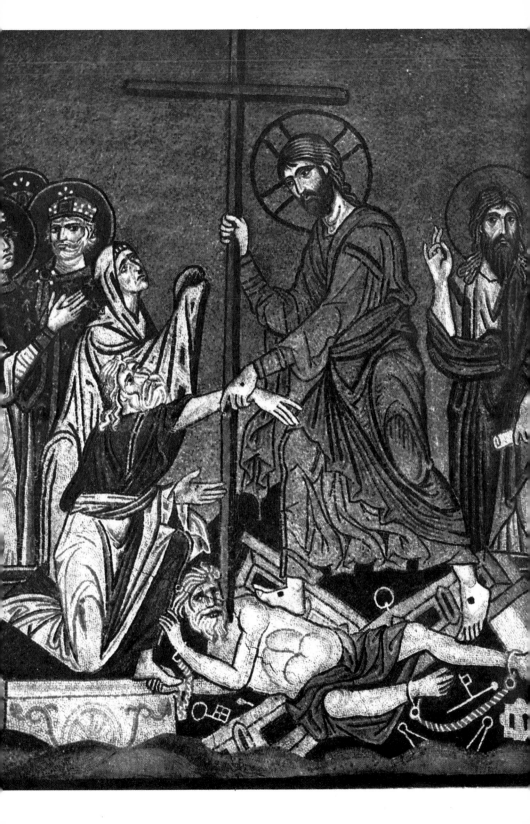

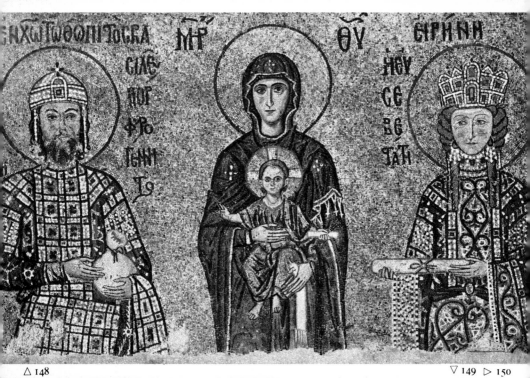

ЗΝΧΩΤΩΘΦΠΙΤΟΟΚΑ ΜΡ̅ ΘΥ̅ ΕΙΡΗΝΗ
ΟΙΛΕ ΗΕΥ
ΝΟΡ CE
ΦΡΟ ΒΕ
ΓΕΝΝ ΤΑΤΗ
ΙΩ

△ 148 ▽ 149 ▷ 150

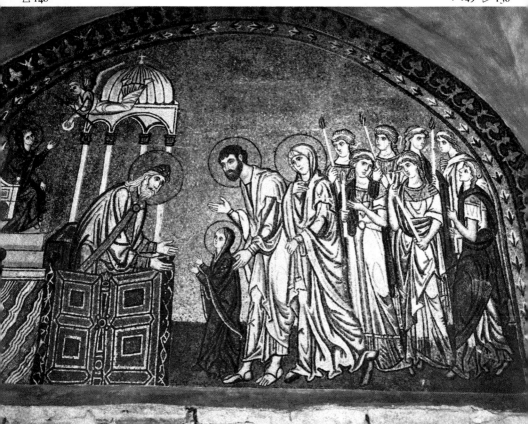

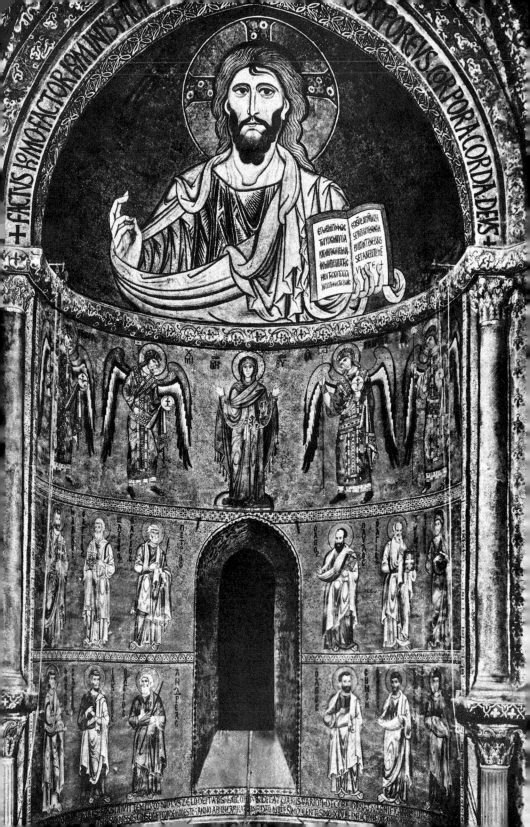

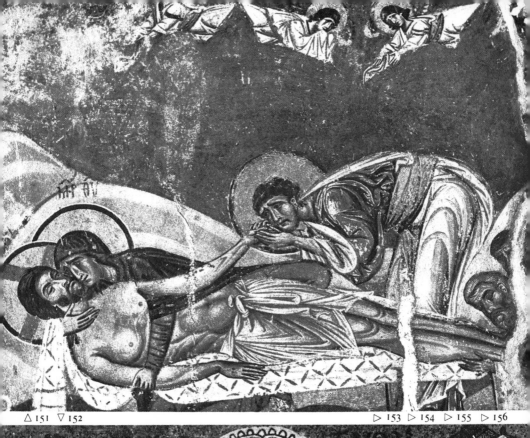

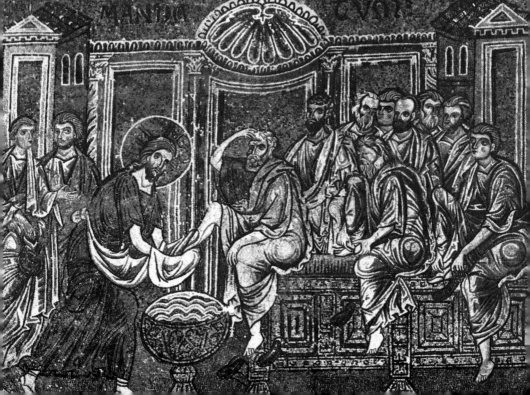

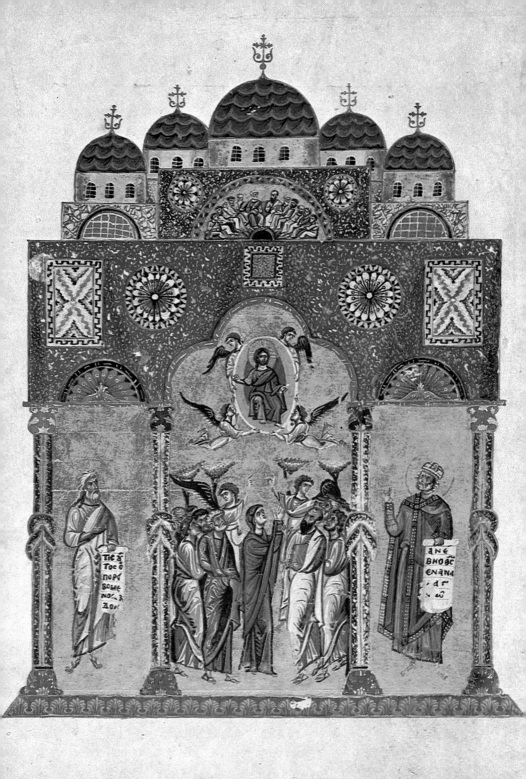

τὸν καθαρότατον τῆς γνώσεως τοῦ
καὶ ωρερ χρεοι. Κόσμησον τὰ τωματίων
ἄλλα. καὶ τὴν ἰωβρατίαν σκηνημὴ ὑπόδξαι

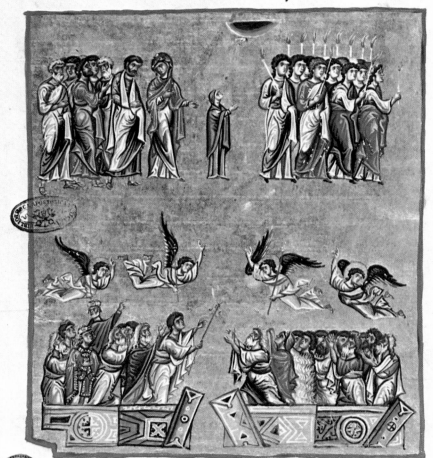

Σημεβρργτάρὦς τριβίζουσι λαμαρίς,
εἰς τὸν ἄλλα τὸν μ᾽ἱῴων ἑσαύγαι· σὴ

THE ART OF THE 13TH CENTURY

The period of Latin rule (1204–61) was by no means a dark age for Byzantine art, for out of the new political, social, and cultural situation grew an art of a wholly new style, and of such high caliber that this period must be counted one of the most significant in Byzantine history. The variety and extreme divergence of stylistic means and the frequent experimentation reflect the countless different factors that influenced the search for a new formal vocabulary. Foreign commissions and particularist culturo-political demands (for example, those of the markedly conservative Byzantine Greek court-in-exile at Nicaea) were as much responsible for the new orientation as contacts with the Slavic vernacular styles and Western models. Attachment to an unbroken tradition was largely dissolved, and the personal initiative of individual artists was stronger than previously. (Signatures become more prevalent.) Craft traditions suffered many disruptions, particularly mosaic and enamel. Mural painting, icons, and book illumination become the dominant forms of expression, and, as a luxury art *par excellence*, the mosaic icon, formed of minute particles of molten metal and color, flourished as never before. The most important contributions to the creation of the new style were made by Constantinopolitan artists working in Serbia and Macedonia alongside important native painters.

Toward the end of the 12th century a stylistic change emanated from Constantinople. Compositions and the formation of figures were simplified, and a new luministic emphasis and a painterly approach to the picture surface became widespread. Wall paintings in Serbia at Studenica (*159*), and in Bulgaria and Russia, display the characteristics of this polished, subdued style. About 1230 this development took a decisive new direction: Plastic volumes, physical weight and corporeality, and the concomitant spatial values made their return. At first the surface of the full-bodied figures was traversed by a system of broadly curving lines. Pictorial space remained relatively shallow, its extent inferable from the volume of the figures and the massive, block-like architectural backdrops. Moreover, compositions were still informed by the principle of rhythmic organization of the picture surface. But there was a heightening of spiritual values, detectable in a profundity of expression. Individual features were given a new tranquility, fresh naturalness, or driving energy. This moment is perhaps best exemplified by certain Constantinopolitan manuscripts that derive from 10th-century models, and by a variety of wall paintings by Greek and local artists in Serbia and Bulgaria—at Boiana (*158*), Sopočani (*160*), Mileševo (*161*), Morača, and elsewhere. From the capital survive two large icons of Mary, now in Washington (*169*). The subtle compositional balance, the fluid articulation of the delicate gold drawings, the lyrical composure of the noble faces, and the brilliant technique all declare the high level of artistry reached in the capital even under foreign rule. It was from works of this description that the *maniera greca* of Italian Duecento painting developed.

156 ANGEL. 1191. Church at Kurbinovo on Lake Prespa (Macedonia). Fresco in chancel. Extreme form of Late Comnenian mannerism—frozen, hard forms, sharp lines; ornamental complexity as an end in itself.

What was only a tendency in the first half of the century became a fully mature style around 1260, reaching classical perfection in the work of the main master of Sopočani, who must have come from Constantinople. The Death of the Virgin (*162*), and the closely related Deesis mosaic in H. Sophia (*157*), rank among the very finest and most significant works of Byzantine art. They also mark the climax of what was probably the most thoroughgoing of all the Byzantine renaissances. For the first time the loosening of the bonds of tradition had the effect of increasing the distance from the classical heritage, so that retrospection became a new encounter, a creative dialogue with the pictorial means and esthetic principles of classical antiquity. Understood from within, and not merely selectively copied in its externals, the art of antiquity became the most vital impulse and the yardstick of the new Palaeologan art. The figures at Sopočani have full, three-dimensional plasticity, and they stand and move in what appears as continuous deep space. All the classical devices are employed to achieve this optical illusion of space—foreshortening and the grouping of figures behind one another, broad, hilly, and terraced landscapes extending into depth, space-displacing piles of architecture, but, above all, atmospheric perspective achieved through the play of color and light. Shadows reappear, as does the illusion of light streaming in and gently modeling figures. Draperies and movements are flowing and supple and induce a wonderfully harmonious rhythm through the whole picture. The intensity and profundity of the expressions is in accord with the beautiful, idealized forms. The external becomes the mirror of the soul; the human and the transcendental flow into one another (*168*).

On the basis of these superlative performances the step to true Palaeologan art was taken shortly after 1261, in Constantinople, which very soon reasserted itself as the center of influence. The return of many artists to the capital, and the pooling of the diverse experiences that they had had abroad, hastened the development of the new style and impregnated it with a wide variety of characteristics (*163, 164, 167*). The surviving manuscripts, icons, and mosaic icons of the capital display a tendency toward the intensification of stresses within the picture, through the extension of space, through luministic effects, through an increase in the stiffness and brittleness of drapery, or, particularly, through the swollen dimensions of the bodies. Outside the capital, in the Macedonian district—especially at Sv. Kliment in Ohrid (*166*)—this tendency to excessive bulkiness and heaviness turned into an extremely powerful, stony monumentality: Here, East and West (one thinks of Giotto's work at Padua) run closely parallel, both in time and temper.

157 CHRIST from the Deesis. c.1260. H. Sophia, Istanbul. Mosaic in south gallery. Only the upper parts of Christ, Mary, and John preserved. Perhaps the first commission of the Palaeologues after the reconquest of Constantinople. Masterpiece of the classicism of c.1260. Virtuosity of mosaic technique: plasticity within an easy painterliness; finest gradation of colors, cold and warm tones interlocked; use of minute stones. Illusionistic cast shadows. Singular intensity of expression. Differentiation of form and emotion among the three heads.

158 ST. EUSTRATIOS. 1259. Tomb church of the Bulgarian Boyars, Boiana, near Sofia. Detail from a fresco. The possibly Greek painter had great skill as a portraitist; a truthful as well as idealized, compelling image. The frescoes here are still flatly conceived, with slender figures.

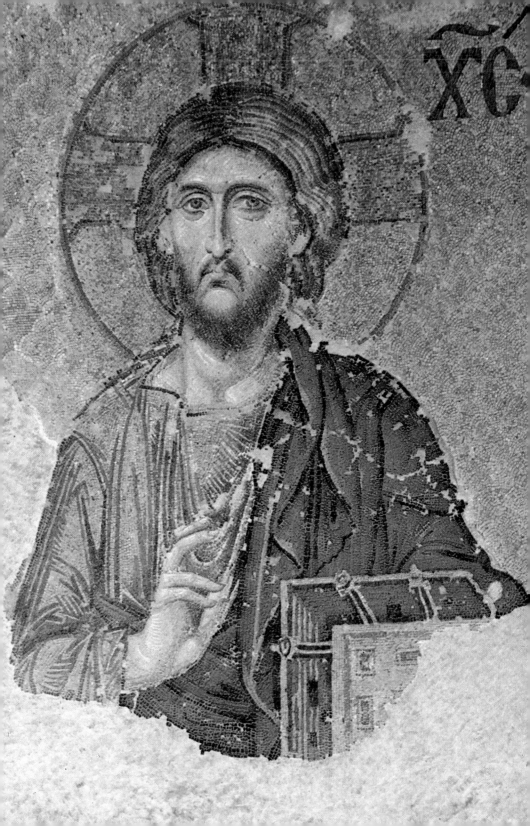

159 CHRIST (detail from Crucifixion). 1208–9. Church of the Virgin (Nemanja), Studenica, Serbia. The earliest wall paintings, partially painted over in the 13th century (including parts of the Crucifixion). Crucifix in the large format and subdued form of the early 13th century.

160 PATRIARCH. c.1260. Monastery church, Sopočani, Serbia. The ensemble painted by two workshops, a stylistically earlier and a later; Greeks working beside Serbians in both. The stylistically later one, probably led by Constantinopolitan artists, executed the four patriarchs on the eastern piers. Full, painterly plasticity, classic statuesqueness and ideality.

161 ANGEL AT THE SEPULCHER. c.1236. Monastery church, Mileševo, Serbia. Naos. The homogeneous fresco decoration is a masterpiece of the stylistic period that preceded the later 13th-century classical renaissance. The monumentally conceived figures have increased in volume; more intensive interrelationship of gaze and gestures. Gold ground in imitation of mosaic. Most likely by a Serbian painter: a welcome freshness, types occasionally not Byzantine.

162 DEATH OF THE VIRGIN. c.1260–65. Sopočani. Naos, west wall. Mary on her deathbed with sorrowing apostles; Christ in a choir of angels holds her soul in the shape of a swaddled child; on the balcony, lamenting women. Above, angels on clouds approach Christ and the apostles. Masterpiece by the main artist, probably a Constantinopolitan painter; one of the most outstanding works of Byzantine art. Classic in spirit with all the qualities of the early Palaeologan renaissance: illusionistic composition of great breadth; effects of light achieved by fragmentation and reflections of color. Cast shadows. Full-bodied, monumental, and statuesque forms, which are at the same time long-limbed and elegant, with rhythmically flowing movements of body and contour.

163 MARK THE EVANGELIST. Gospels. Bibliothèque Nationale, Paris. Before 1261. 31.8 × 25 cm. Very substantial figure, modeled in a painterly fashion. Based on a 10th-century model. Anticlassical in the brittle delineation of folds and in formal and psychological tension.

164 THE FORTY MARTYRS OF SEBASTE. Last third of 13th century. Dumbarton Oaks Collection, Washington. Mosaic icon. 22 × 16 cm. Martyrs exposed to their death by freezing supplied pretext for showing nudes in complex postures in ivories as early as 10th century. In this technically accomplished icon, there are greater repose, more classical facial types and effects of light than usual in such scenes.

165 SCENES FROM THE LIFE OF MOSES. c.1280. S. Marco, Venice. Narthex, north end. Mosaic lunette: Feeding of the Children of Israel. The mosaics of the narthex copied from a 6th-century manuscript (the Cotton Genesis)—very faithfully in the Genesis dome, the others more freely, with classicizing figures. The last dome and lunette take up the new Palaeologan style and display a unified spatial setting with scenes loosely distributed over wide landscape.

166 BIRTH OF THE VIRGIN. c.1300. Sv. Kliment, Ohrid, Serbia. The extensive mural cycle is an early work of the painters Michael Astrapas and Eutychios, who decorated churches for more than twenty years for King Milutin. The ample, heavy style of the time is here taken to an extreme: massive block-like figures and buildings, prismatic modeling, hard drawing.

167 BIRTH OF CHRIST. Gospels. Bibliothèque Nationale, Paris. Before 1261. Latin and Greek text in two columns. Substantial figures in a wide landscape.

168 CRUCIFIXION. Third quarter of 13th century. National Museum, Ohrid. Icon from Sv. Kliment. Reverse. 97 × 66 cm. Classic maturity. Specifically new in an icon is the expression of human feelings.

169 MADONNA AND CHILD ENTHRONED. c.1250. Mellon Collection, National Gallery of Art, Washington. 84 × 53 cm. Masterpiece of Constantinopolitan work. Wonderfully balanced, sculptural figure, situated in space on a typically Palaeologan pseudo-perspectival round throne. Luxurious, delicate modeling in gold.

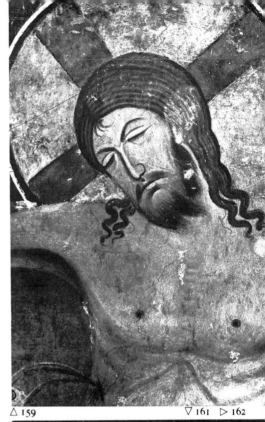

△ 158 ▽ 160 △ 159 ▽ 161 ▷ 162

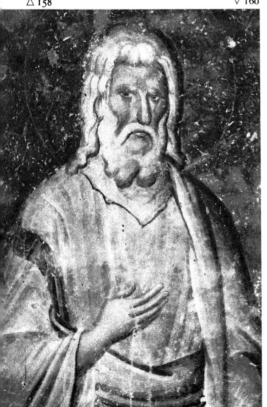

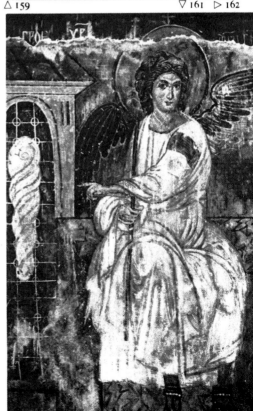

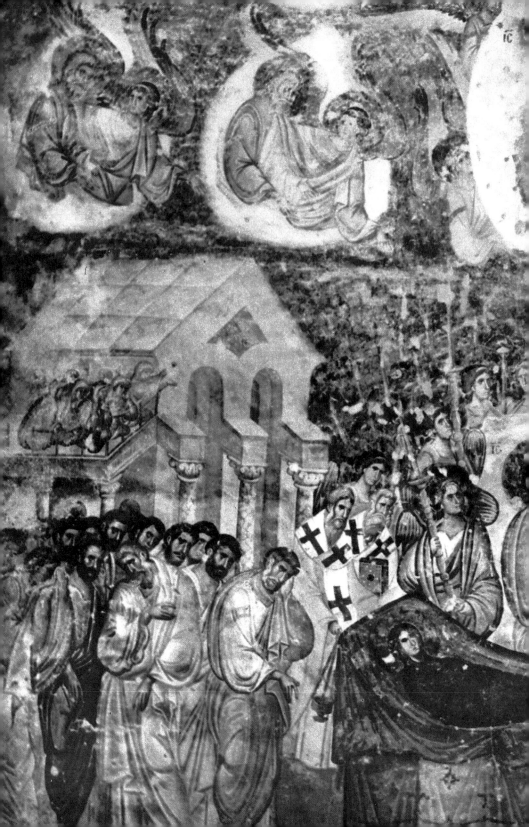

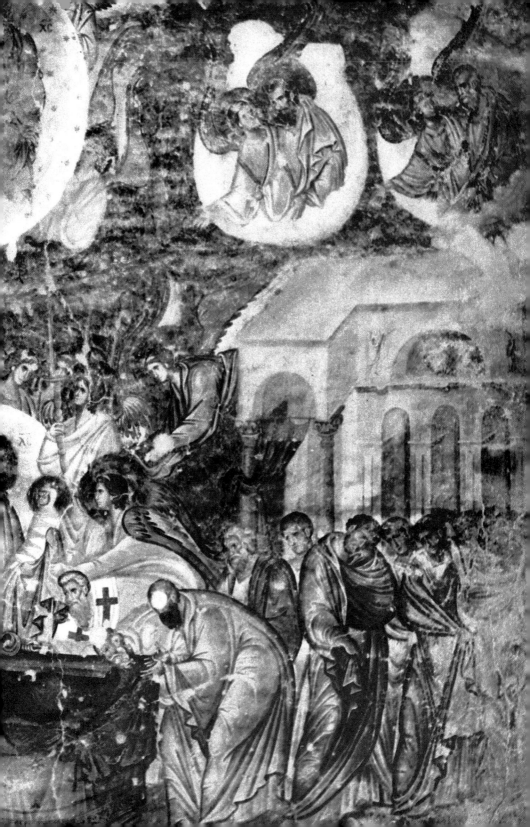

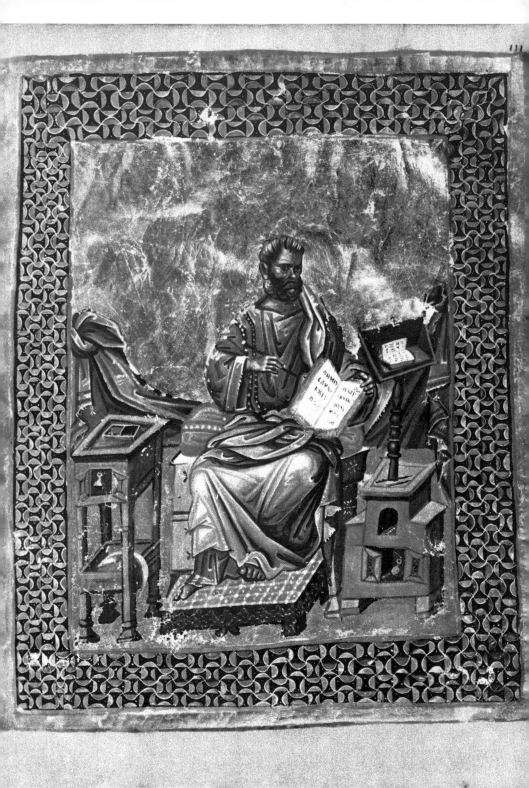

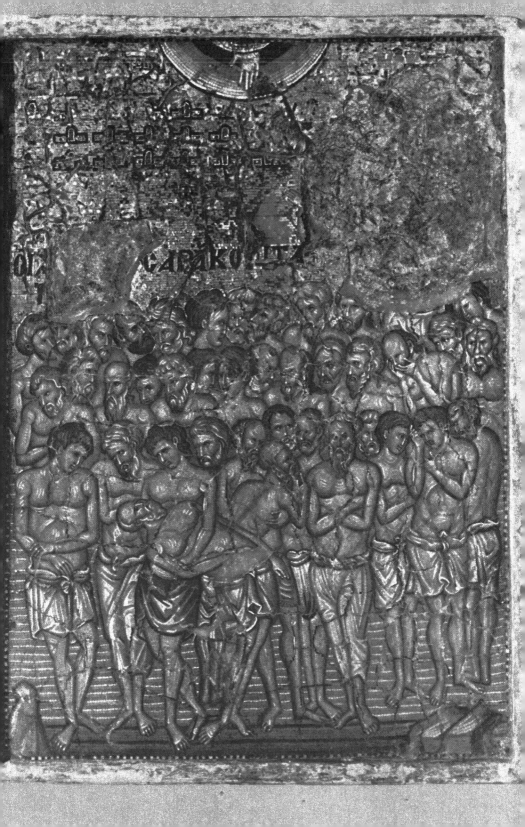

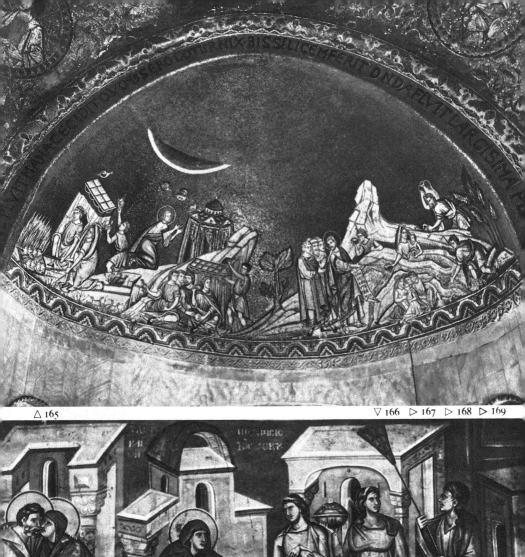

△ 165 ▽ 166 ▷ 167 ▷ 168 ▷ 169

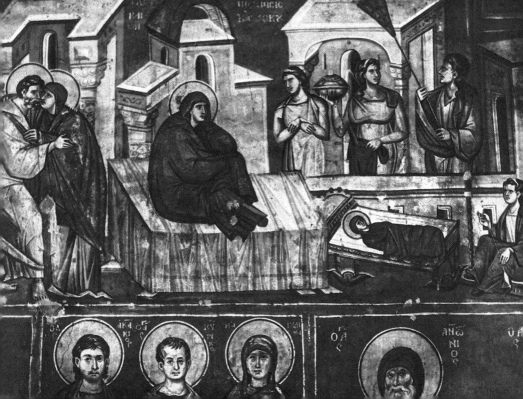

προσέταξεμ αὐτῶ ὁ ἄγγε
λος κυ. καὶ παρέλαβε
τὴ γ̅υ̅αῖκα αὐτοῦ. καὶ οὐ
κ ἐγίνωσκεν αὐτὴν, ἕως οὗ ἔτεκεν τὸν υἱὸν αὐτῆς
τὸμ πρωτότοκον·
δ̅ ἐκάλεσεν τὸ ὄνομα αὐτ̅υ̅·

precepit ei angelus do
mini. Et accepit con
iugem suam et non co
gnoscebat eam donec
pepit filium suum
primogenitum. et uo
cauit nomen eius ihm

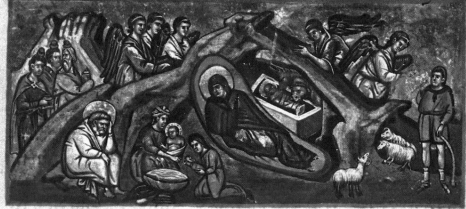

Τοῦ δὲ ι̅υ̅ χ̅υ̅ γεννηθέν
τος ἐμ βηθλεὲμ τῆς
ιουδαίας. ἐν ἡμέραις
ἡρώδου τοῦ βασιλέω.
ἰδοὺ μάγοι ἀπὸ ἀνατο
λῶμ παρεγένομ το εἰς
ἱεροσόλυμα. λέγοντ τι
ποῦ ἐστιμ ὁ τεχθεὶς
βασιλεὺς τῶμ ιουδαy

um ergo natus est
ihus in Bethleẽ
iude in diebus herodi
regis. ecce magi ab
oriente uenerunt
Jeroso ~~li~~ mam
dicen ~~tes~~ tes
vbi est qui natus
est Rex iudeorum.

✝ ἡ ἁϊστηνη χ̅υ̅ τ̅ χ̅υ̅ πηη

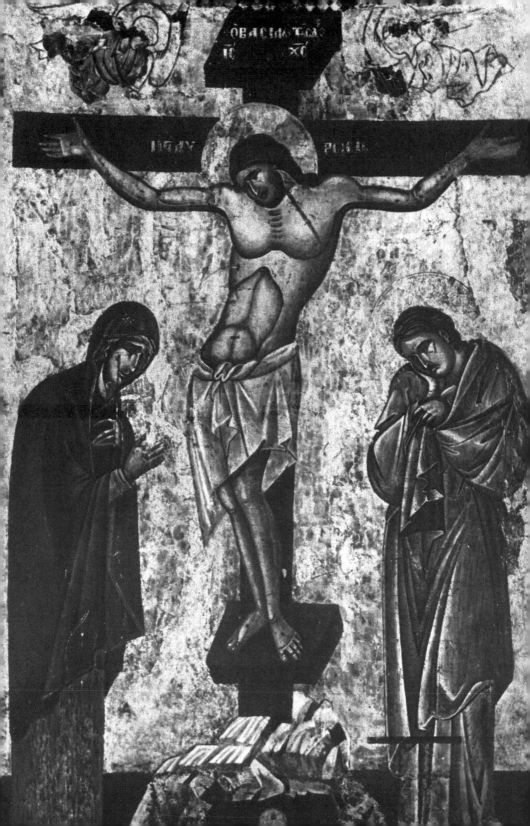

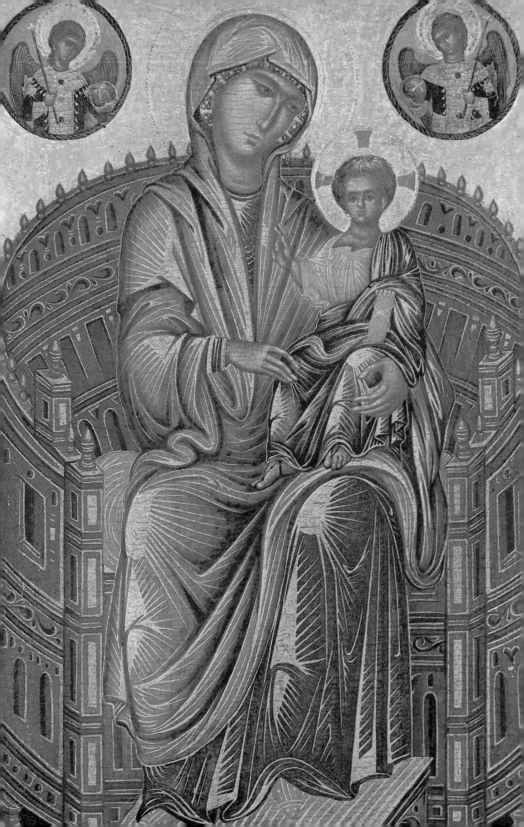

PALAEOLOGAN ART

About 1300, with Constantinople again the artistic center, a brilliant style came to maturity—one that was as independent in its artistic character as it was complex in its manifestations. This high Palaeologan art, with its heyday in the first quarter of the 14th century, stands out as one of the most spectacular and momentous epochs of Byzantine art. Its most important monument survives in Constantinople itself—the mosaics and frescoes of Kahrie Cami, the church of the Chora Monastery, which were created about 1310–20 (*170, 171, 172, 174*). They were the donation of Theodorus Metochites (1260–1332), the Great Logothete (a post corresponding roughly to chancellor) under the emperor Andronicus II, who was above all else a great scholar, poet, and patron, and one of the immensely important humanists who, in the late Byzantine period, revived an interest in the philosophical, scientific, and literary heritage of classical antiquity. Without a doubt important impulses from this humanist elite made themselves felt in artistic development. They may have excited, or at least have encouraged, the extraordinary familiarity with classical prototypes and the proliferation of classical motifs and forms that went far beyond the traditional, largely 10th-century repertory of classical features. Technical subtleties, previously all but unknown, were now taken for granted, and justify the supposition that there was a critically exacting study of classical art, apparently concurrent with the antiquarian and critical endeavors of the scholars. The concept of a Palaeologan renaissance of the early 14th century is thus firmly based. But the art of this period is distinguished by its independence from tradition, its extremism, and its psychological tension, and the real key to its character can be said to lie in the general political and spiritual situation of the times: Byzantium was an empire severely threatened; confidence in its own viability and purpose was already weakened and uncertain at the time of Metochites.

Starting with its pictorial program, Kahrie Cami broke the rules of tradition. Although the customary sequence was followed in the naos (of the liturgical cycle only the Death of the Virgin survives), in both vestibules there are cycles from the life of the Virgin, the youth and miracles of Christ, which are filled with a wealth of subsidiary scenes never before found in monumental painting. These scenes cover all the saucer domes, vaulting arches, and lunettes above the marble pediment, into which are set large, icon-like fields of mosaic containing the twelve apostles. The genealogy of Christ and Mary, each composed of twenty-four patriarchs, fills the small fields between the ornamented ribs of the two pumpkin domes of the inner narthex. An attached church to the south, the Parekklesion, is dominated by two frescoes, a huge Anastasis (the Harrowing of Hell) in the apse (*174*) and a vast Last Judgment in front of it, which is linked to a dome by angels and by Old Testament scenes that are typologically associated with Mary (for example, Jacob's Ladder). The Death and Resurrection of Christ and the salvation of man had never before been illustrated with such epic vision and such passion for detail. Many singularities in the organization of scenes mark a break with tradition and predicate Italian and, behind them, Late Antique models. High Palaeologan art follows a quite novel pictorial logic and esthetic as well; it employs a grandiose, dramatically effective stylistic language with an unusually rich

vocabulary of forms (*170, 171*). It is an art of emphasis and contrast, and its tension-laden atmosphere has not a trace of classical restraint. The figures are not organically conceived, being either very thin or very heavy. They have small heads with either fine, delicate faces and characteristically projecting occiput, or abrupt, caricatured features. In the drapery, broad slack areas are contrasted with calligraphically dense and taut passages and sharp-edged folds frozen in the act of fluttering. Gestures and movements reproduce every nuance of feeling from lyrical simplicity to heroic pathos and explosive drama. All the figures are intimately related to one another in dramatic exchanges, often by glance or mimic gesture, and this is intensified into a spiritual and emotional field with each subject expressing its appropriate mood. Each scene becomes a pictorial drama that directly addresses the observer. The same dynamism is induced by spatial elements and the color. Space in the picture is appreciably broader and deeper than before, so that the figures move easily and unconstrictedly on the pictorial stage, though accurate perspective is not achieved. Fantastic pieces of open architecture, massive or towering, help intensify the effect of spaciousness by their curves or oblique projection; they also lend the figures support and give them impact (*171*). A similar dynamic potency resides in the extended color scale: Tones ranging from light to dark, soft to acid, rich and warm to cutting and cold, and flashes of light provide vivid accents. Color is used, as in classical models, with supreme technical mastery to model form and to create an individual atmosphere in each picture. There are several styles evident in Kahrie Cami, carrying still further the complexity of an art founded on contrast. One style is classicizing and glassily cool, inclining to academic rigidity (*172*); another is keyed up to an almost baroque pathos (*174*). Common to all of them are exceptional quality, the Hellenistic note, esthetic brilliance, and that inimitable nobility that could flower only in the courtly culture of the capital.

Kahrie Cami is a superlative, but in no way unique or isolated monument of High Palaeologan art. Not long ago the remains of related mosaics were uncovered in Constantinople at Fetiyeh Cami and Kilise Cami. Among icons, the splended Annunciation in Ohrid is particularly close to them (*173*), as, in monumental art, are the very important mosaics and frescoes of the church of the Holy Apostles in Salonika of about 1315. Book illumination and mosaic icons confirm the stylistic unity and consistently high level of the art of this period, which also influenced the leading painters' workshop (of King Milutin) in Serbia.

The wall paintings in the King's Church of Studenica of 1314 are notable for their closeness to the art of the capital (*175*). Their tendency to an expressive realism, to the calligraphic depiction of drapery, and to the organization (and constriction) of space within the picture by parallel planes set the course of the development. Typically Serbian qualities are intensified in Staro Nagoričino (1317) and in Gračanica (1321), and came to predominate in the most varied guises in the subsequent occasionally distinguished, decorative painting of Serbia (Decani, Lesnovo, Kalenic).

The wealth of forms evolved in High Palaeologan art in its heyday remained the basis for subsequent Byzantine art, in which they were diminished or intensified but never really forsaken. In the second quarter of the 14th century a tendency to the delicate and intimate, and to a simplification of the construction of the picture and the figures in it, with a pleni-

tude of isolated dramatic and decorative accents, asserted itself—an example is a devotional mosaic icon in Florence (*176*). Landscapes broadened out into painterly panoramas with rugged rocks and a high horizon, into which small, decorative figures were loosely inserted. This late phase of High Palaeologan art has best survived in Mistra, near Sparta. Now a ruined town, strewn over the foothills of the Taigetos, Mistra was in the 14th century and until the Turkish conquest the capital of the despotate of Morea, and a highly important center of Greek intellectual life, with a school of philosophy that was highly regarded even in the West. Only eight of the once innumerable monastery churches have preserved, in whole or in part, their fresco decoration, which bears witness to the competence of several independent painters' workshops. The most important of the decorations, in the Peripleptos Church, of the second half of the 14th century, have a unified ensemble of immense coloristic beauty (*179*). The subdued colors with warm highlights melt into a soft veil, and the wonderful angels of the Heavenly Liturgy glow within their delicately modeled robes as if they had been painted in golden light (*178*). The scenes filled with figures, the fantastic architecture, the romantic landscapes, and the elegant figures represent another peak of neo-Hellenistic art.

The devotional, intimate aura of this late Byzantine painting is probably related to a new kind of personal piety—especially that connected with the mystic and ascetic movement of Hesychasm, which brought about a bitter theological and political controversy around the middle of the 14th century. Light, the godly "uncreated" light of Christ's transfiguration, participatory submergence in which was the mystic goal of this teaching, received a transcendental significance in painting too. A key picture is the miniature of the Transfiguration in the religious work of a friend of the Hesychasts, John VI Cantacuzene (*181*): rays— "energies"—break out of the calm of the aureole of light around the transfigured Christ, which hurl the youths downward, almost out of the picture. The baroque drama of the construction, and the refinement of the painting of light (restricted to nuances of cool blue and white) are fully in the tradition of High Palaeologan art, in which the ecstatic and visionary paintings in the cave church of Ivanovo (Bulgaria) are rooted, as is the mystical philosophy of light put forward by Theophanes the Greek, who was active in Novgorod from the 1380's and a vital precursor of Russian art.

There was also an important school of court portraiture in Constantinopolitan painting (chiefly surviving in manuscripts), which is characterized by a clear, restrained severity of structure, a quasi-naturalistic formation of the faces, and frequently by decorative splendor of costume (*180*). But there are icons, too, on panels of large format, whose essential classicism is mellowed by the fine tracery of the surface design and by the lively play of light and shade (*177*). After the late 14th century this idealized monumentality was gradually lost. Forms became arid, glassy, and stiff. Simultaneously, the strict systematization of programs, types, and techniques began, and this made possible the survival of the old pictorial formulas into the 19th century (especially on Mt. Athos and in popular art) but really impeded further genuine and free development. Constantinople lost its artistic monopoly, and the last surviving Byzantine fresco, a donor's portrait of about 1450 in Kahrie Cami, bears evidence for the first time of influence from the Italian Quattrocento.

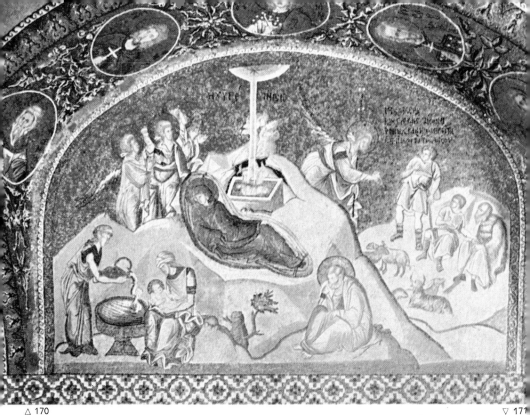

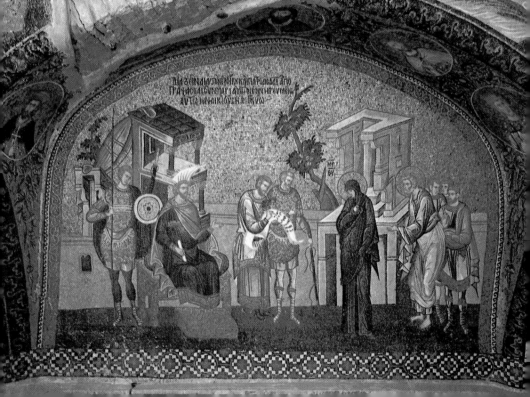

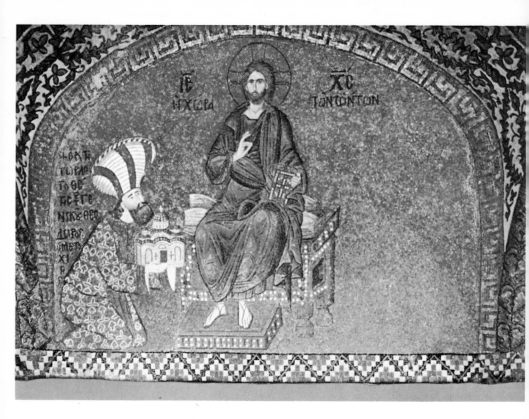

170 BIRTH OF CHRIST. Kahrie Cami (Church of the Redeemer, Chora Monastery), Istanbul. 1310–20. Mosaic lunette in outer narthex. Idyllic scene in spacious, gently unfolding landscape. This is subdivided into incidents by means of pseudo-perspective, and organized in depth. Typical contrasts between slender, idealized figures and common, broadly conceived figures; heavy modeling, and crumpled and scrolled hems. Light tonal values, centered on the blue of the Virgin's robe.

171 THE TAXATION IN BETHLEHEM. Kahrie Cami, Istanbul. Mosaic lunette in outer narthex. An unusual theme is here turned into a powerful picturesque scene. Very elegant figures move freely within the picture space, yet are firmly contained within the firm, lucid rhythm of the composition. The high, slanting buildings (a classical motif) create a sense of spaciousness, though there is an ambivalence as to whether an interior or an exterior view is intended. Strong brilliant color, vivid contrasts.

172 THEODORUS METOCHITES BEFORE CHRIST. Kahrie Cami, Istanbul. Mosaic lunette in inner narthex, over the door to the naos. The donor with a model of the church, in costly official garb (head-covering and style of hair are fashionably Turkish). The figure of Christ exemplifies the classicizing, nobly idealized style. A mesh of lines and nuances of color cover the quiet surface.

173 THE ANNUNCIATION. Beginning of 14th century. National Museum, Ohrid. Icon. 94.5 × 80.3 cm. Front: "Mother of God as the Salvation of Souls." From Sv. Kliment in Ohrid, probably originally from Constantinople. Stylistically close to Kahrie Cami. Masterful in control of form and balance of calm and movement; monumental conception with decorative richness.

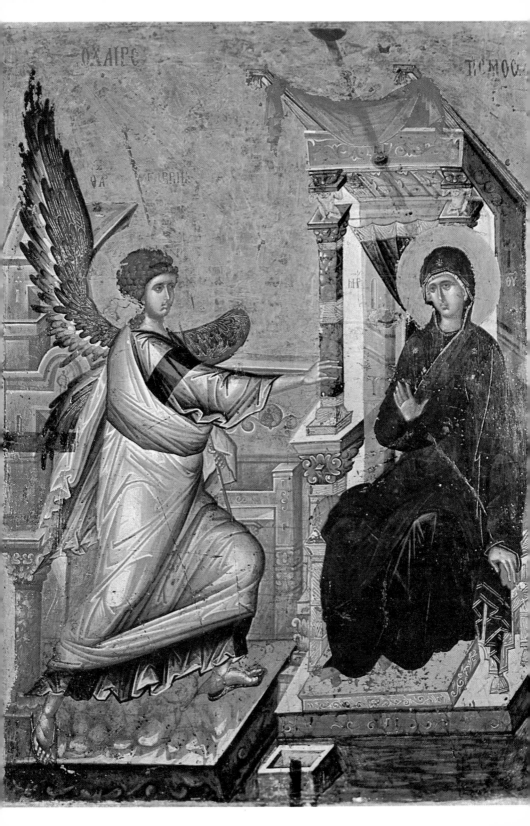

174 ANASTASIS (THE HARROWING OF HELL). Kahrie Cami, Istanbul. Fresco in apse of the Parekklesion, detail. Altogether the most splendid Byzantine rendition of the subject. A dramatic composition of powerful, heavily built figures; explosive contrasts of color, especially of cold-to-warm reds, blues, and violets against the central white and the blue ground. Christ emanates streams of energy, which also pour toward him, fixing his classically beautiful figure in transcendental, timeless repose.

175 BIRTH OF THE VIRGIN. 1314. King's Church (Church of Anna and Joachim), Studenica. Fresco in naos, part of a great Marian cycle. Masterpiece of the painters Michael and Eutychios, employed by King Milutin, whose change of style since their work at Sv. Kliment, Ohrid (see *166*), presupposes study in Constantinople. The style of the capital is modified toward mannerist grace, toward the calligraphic, and sometimes the realistic. Elaborate setting with complex spatial interlinking of the divisions of the pictorial stage.

176 MINIATURE DIPTYCH. Second quarter of 14th century. Opera del Duomo, Florence. Mosaic. Right wing: Entry into Jerusalem, Crucifixion, Anastasis, Ascension, Pentecost, Death of the Virgin. Left wing (not shown): Annunciation, Nativity, Presentation, Baptism, Raising of Lazarus. Each wing 27×16 cm. From Constantinople. Small altar for private devotion. Twelve scenes follow the classic liturgical program for the decoration of churches. Exquisite technique: minute particles of gold, lapis lazuli, and colored glass are bound together with great subtlety into a compact surface that seems painted. Some preciousness in style, too. Flat composition with striking accents. Intimate devotional character.

177 ARCHANGEL MICHAEL. Third quarter of 14th century. Byzantine Museum, Athens. Icon. 110×81.5 cm. Lively, illusionistic modeling with light and shadow. The nearly accurate distortion of script and drapery behind transparent sphere suggests a classical model.

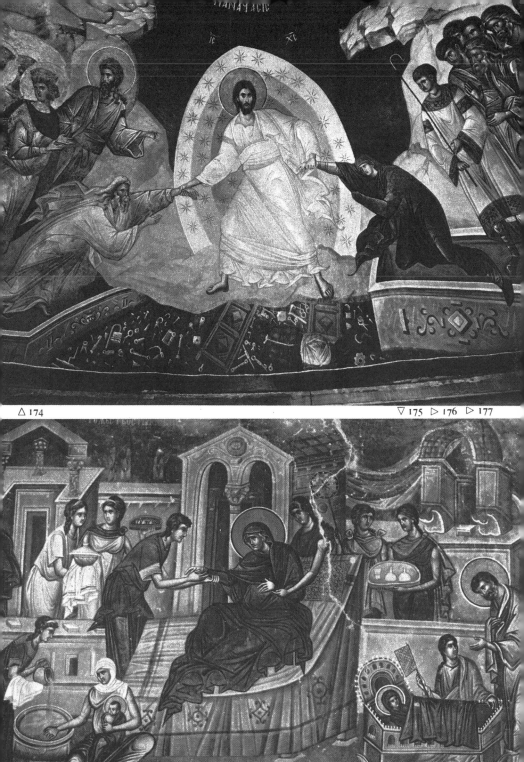

△ 174 ▽ 175 ▷ 176 ▷ 177

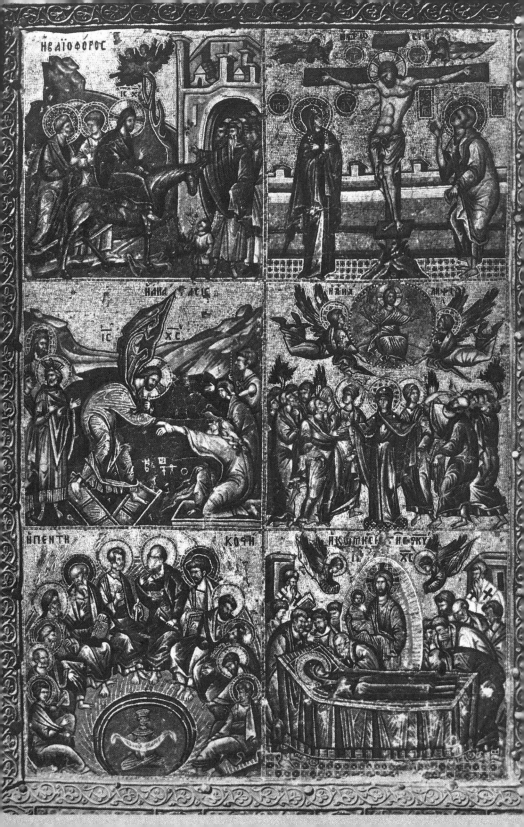

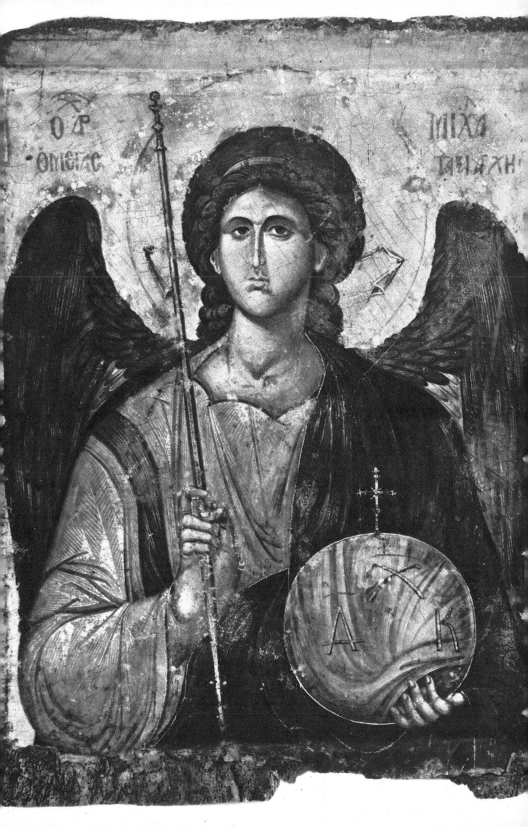

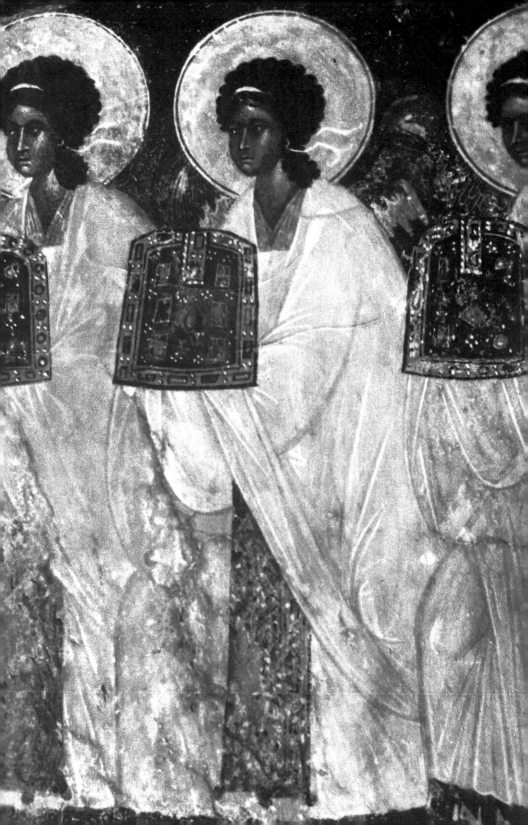

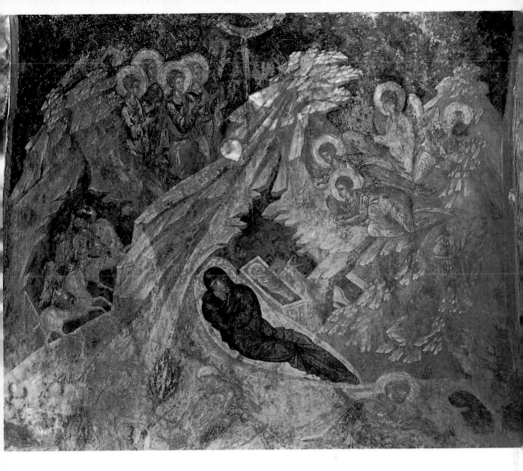

178 PROCESSION OF ANGELS. Last quarter of 14th century. Peripleptos Church, Mistra. Fresco in the prothesis. Detail from a long train of angels, which celebrate (with Christ) the heavenly liturgy, as the liturgy is celebrated in the church below. Wonderfully radiant forms, as if glowing from within. The metaphysical, immaterial being of the angels is captured through the illusion of painted light. Modulations of fragile, transparent tones of white and golden ocher. Fluent draftsmanship, modeling, and movement of the monumental figures.

179 BIRTH OF CHRIST. Peripleptos Church, Mistra. Fresco in naos. Extensive, fantastically distorted landscape, which fully encloses the decorative figures. Painterly and decorative unity, even to the fine tonalities of warm color, in which brown and olive hues predominate.

180 GRAND DUKE ALEXIS APOKAUKOS. Manuscript of the works of Hippocrates. Bibliothèque Nationale, Paris. Before 1345. 41.5 × 35 cm. Typical of court portraiture—an almost realistic likeness, stylized delicacy of the hands and feet, minutely drawn state robe, generously conceived construction.

181 TRANSFIGURATION. Manuscript of the theological writings of the Emperor John VI Cantacuzene. Bibliotheque Nationale, Paris. 1370–75. 33.5 × 25 cm. One of four miniatures, including double portrait of John VI as emperor and monk. The central theme of Hesychast mysticism. The "uncreated" light of the Transfiguration as triple aureole—symbol of the Trinity. Extreme contrasts between classic, idealized figure of Christ and circular composition above, jagged diagonals, explosive movement, distorted figures below.

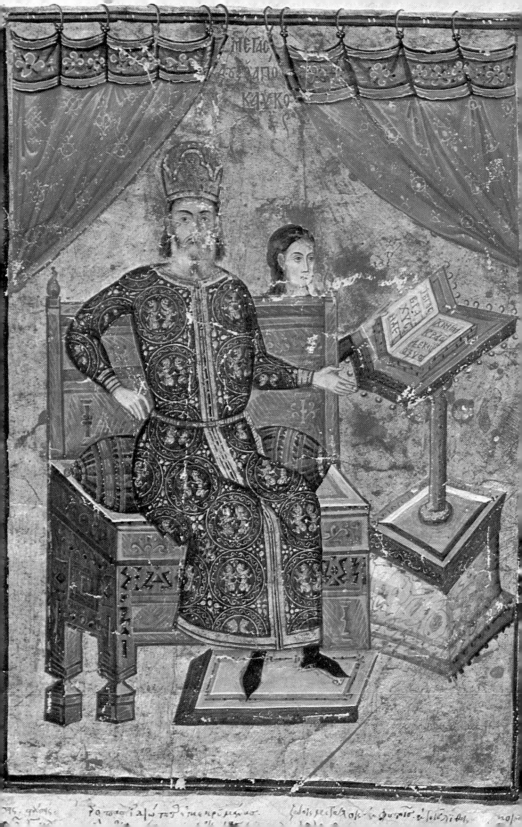

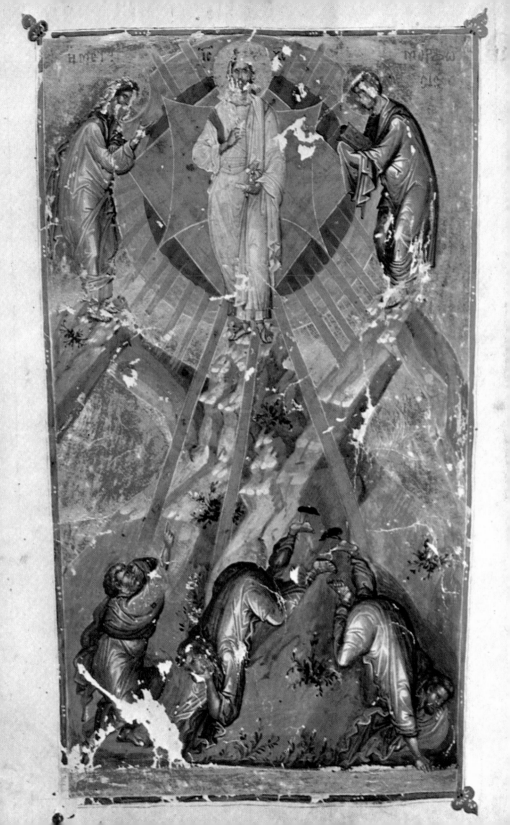

LATE BYZANTINE ARCHITECTURE

A certain slackening of the creative impulse is perceptible in late Byzantine architecture. Many buildings were constructed, but there were few large commissions and grandeur of conception was rare. The few works of high quality seldom rivaled the great achievements of earlier centuries. The domed cruciform church, the ideal type of Eastern Christian ecclesiastical construction, continued to be the most prevalent, especially in the capital and major cities. A simplified variant was built widely over Greece—a good example of which is the Peripleptos Church at Mistra—in which the dome rests on the pillars of the apse, the eastern pair of supports has vanished, and the western arm of the cross is lengthened. In the late 13th century a strongly retrospective attitude brought new life to even older types. The Greek-cross octagon as employed at Daphni was frequently resorted to—at H. Theodoroi in Mistra, at the Paragoritissa in Arta. In the monastery churches of Mt. Athos one finds the three-conched form—Justinianic, in the last analysis—in which the northern and southern arms of the central domed area also terminate in apses. Even the basilica, which had carried on a modest existence in peripheral areas, underwent a distinct revival, though in characteristically modified form. The basilica and the domed cruciform church were combined with one another: A domed cruciform church was, in effect, set on top of a relatively spacious yet compact, basilical lower storey, the piers of the dome rising in a rather unassimilated way from the galleries of the basilica. This type of church came into existence about 1300, and flourished primarily in Mistra. In the Aphendiko Church (*185, 188*), it achieved its most mature expression, thanks to the exceedingly harmonious proportions, which fuse the heterogeneous forms into an esthetically convincing whole. A type

182 KILISE CAMI (Church of St. Theodore), Istanbul. Beginning of 14th century. Narthex (built onto the 10th-century domed cruciform church). Rhythmic articulation by filled arcades grouped in threes and by niches. Relieving arches above. Note the striped decoration of the walls.

183 FETIYEH CAMI (H. MARIA PAMMAKARISTA), Parekklesion, Istanbul. c.1315. View from southeast. Powerfully articulated walls, with blind arches and niches; the contours of the domes and roof echo the decorative structure of the wall. Decorative richness given by alternation in color and pattern of the bricks.

184 TEKFUR SARAYI, Istanbul. Early 14th century. Northwest façade. The only surviving imperial palace in Constantinople. Western (like the Palace of the Despots in Mistra) in its multistoried rooms. Very harmonious

severe façade. Red-and-white pattern of the stones like a textile.

185 APHENDIKO CHURCH of the Brontocheion Monastery, Mistra. Beginning of 14th century. Plan and elevation. Well-proportioned combination of a basilica in the lower building with a superimposed domed cruciform church—that is, of a wide space for assembly with a symbolic plan. Saucer domes over the aisles. Encircling lower subordinate areas: vestibule, separate chapels, domed flanking rooms of the high inner narthex.

186 CHURCH OF THE HOLY APOSTLES, Salonika. 1312-15. View from the northwest. Loose, picturesque grouping of slender towers on a low plinth, the widely separated subsidiary domes typical. Finely articulated, busy, colored wall relief with rich patterns in brick.

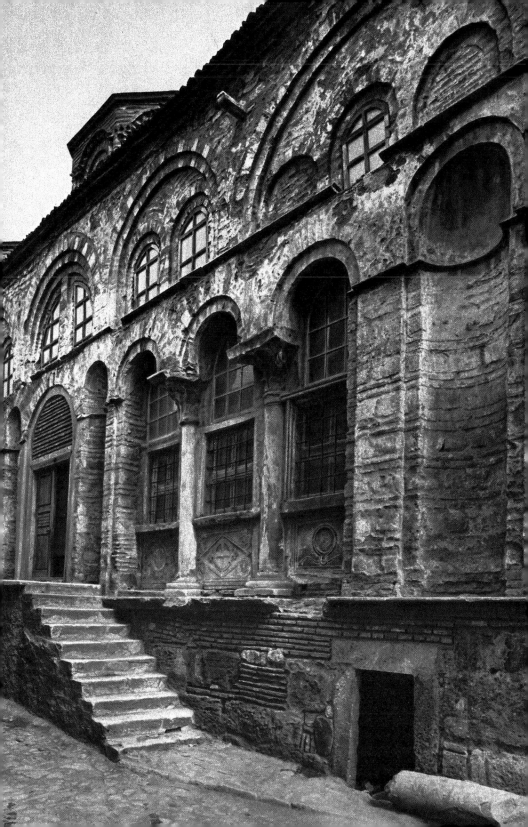

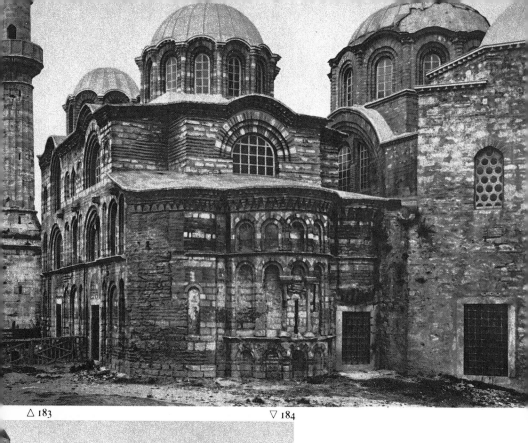

△ 183

▽ 184

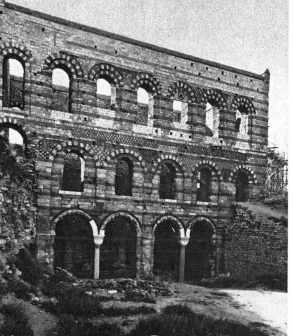

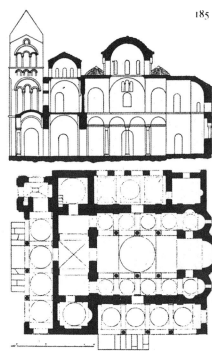

185

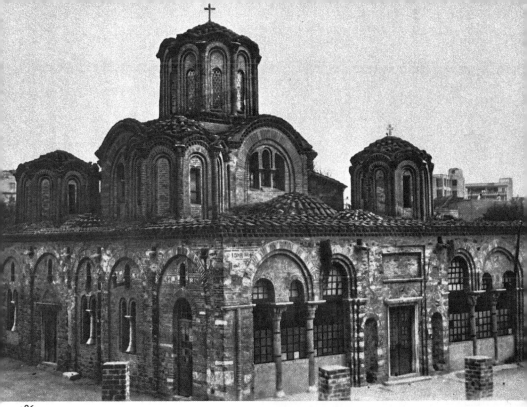

186

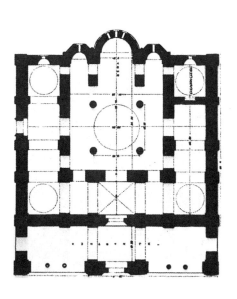

187

▷ 188

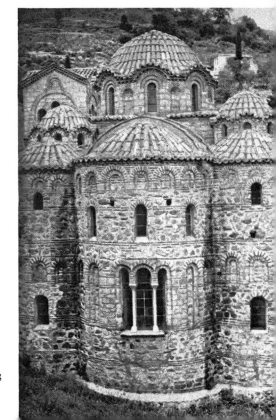

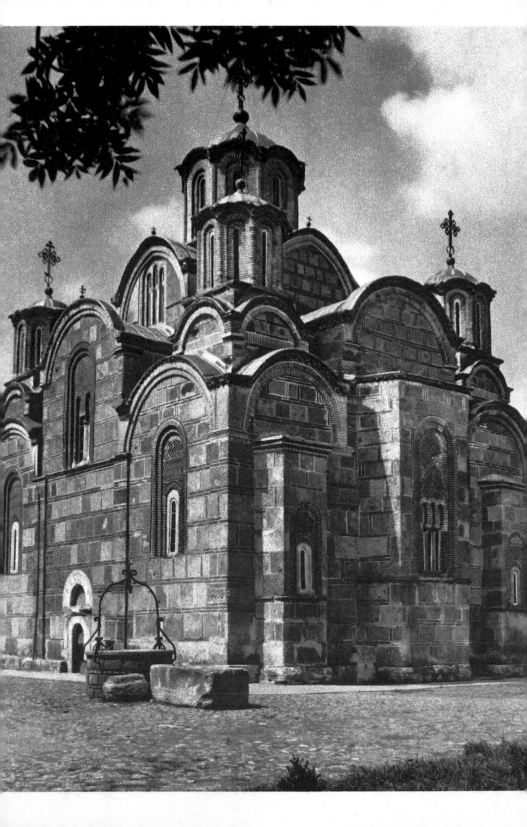

originally diffused in Bulgaria gained in importance in the 14th century in Constantinople and Salonika as well—the single-naved, barrel-vaulted chapel with a dome in front of the apse, one or two stories high, and generally built against the side of a church (as the Parekklesion at Kahrie Cami). These chapels are frequently connected with the narthex, so that, as in the churches of the 7th and 8th centuries, a ring of lower subordinate areas is distributed around the core of a domed cruciform church, as for example at the church of the Holy Apostles in Salonika (*186*, *187*).

The interest in late Byzantine architecture is focused on the exterior, which was complex and decorative. Even the silhouettes of these churches break up in keleidoscopic fashion. Two or four small domes—over the outside corners of the vestibules—accompany the central dome and tower on slender drums high over the many-stepped block of the building and its animated roofline. The walls are given rhythm by means of sculptural and colored decoration and are transformed into a relief enlivened by the play of light and shadow. The windows, especially those of the drums, are deeply embedded in complex relieving arches, with columns before them. Groups of niches and open arcades, pilaster strips and blind arches articulate the façade, often in several stories. Building materials were used with extreme subtlety. Variously colored courses of stone, brick, and mortar alternate, and frequently the bricks are laid in ornamental bands (denticulate, meander-patterned, zigzag, and herringbone). These decorative features are found in all late Byzantine architecture, yet even in this regard Constantinopolitan work is outstanding for its richness and its restrained, structurally appropriate use of them. (See the Parekklesia of Fetiyeh and Kahrie Cami, *183*; the vestibule of Kilise Cami, *182*; and the façade of the palace of Tekfur Sarayi, *184*.) By contrast, the distinguished churches of Salonika—the church of the Holy Apostles (*186*) and H. Katherini—tend to have a looseness of form and delicacy of detail and extended proportions. In the churches of Serbia this latter feature is exaggerated to the point where extreme verticality prevails—for example, at the church of the Virgin at Gračanica (*189*). However conservative or backward-looking late Byzantine architecture is from a structural point of view, it nevertheless displays a close relationship with contemporary painting in its decorative richness and its wealth of detail. By then, of course, painting had become the major art form, and it was painting that gave late Byzantine art its character.

187 CHURCH OF THE HOLY APOSTLES, Salonika. Plan. Classic domed cruciform church with columns; relatively small, but slender and tall. Vestibule surrounding three sides, ending in chapels at the east. Outer narthex opened in an arcade.

188 APHENDIKO CHURCH, Mistra. View from east. Rich, sculptural, graduated building. Picturesque effect of the undulating silhouette and wall relief.

189 CHURCH OF THE VIRGIN, Gračanica (Serbia). c.1320. View from southwest. Like most of the monastery churches founded by King Milutin, this is a domed cruciform church of Greek type (note the narthex dome, picturesque grouping of parts, especially in the zone of the vaults). Of unusually slender proportions and not tall; sculpturally decorated; superimposed, graduated gables intensify the effect of monumentality.

BIBLIOGRAPHY

EARLY CHRISTIAN ART

Berchem, M. v., and Clouzot, E. *Mosaiques chrétiennes du IVme au Xme siècle*. Geneva: Journal de Genève, 1924.

Butler, H. *Early Churches in Syria*. Princeton, N.J.: Princeton University Press, 1929.

Deichmann, F. W. *Frühchristliche Kirchen in Rom*. Basel: Amerbach, 1948.

— *Frühchristliche Bauten und Mosaiken von Ravenna*. Baden-Baden. Grimm, 1958.

Gerke, F. *Christus in der spätantiken Plastik*. Mainz: Kupferberg, 1948.

Grabar, A. *The Art of the Byzantine Empire: Byzantine Art in the Middle Ages*. New York: Crown, 1966.

— *The Beginnings of Christian Art. 200–395*. London: Thames and Hudson; New York: Braziller, 1967.

— *The Golden Age of Justinian, from the Death of Theodosius to the Rise of Islam*. New York: Odyssey Press, 1967.

Grabar, A. and Nordenfalk, C. *Early Medieval Painting from the Fourth to the Eleventh Century*. Geneva: Skira, 1957.

Guyer, S. *Grundlagen mittelalterlicher abendländischer Baukunst*. Einsiedeln: Benziger, 1950.

Kollwitz, J. *Oströmische Plastik der theodosianischen Zeit*. Berlin: W. de Gruyter, 1941.

Krautheimer, R. *Corpus Basilicarum Christianarum Romae*. (The Early Christian Basilicas of Rome.) 2 vols. Vatican City: Pontifico Istituto di Archeologia Cristiana, 1937–62.

Krautheimer, R. *Early Christian and Byzantine Architecture*. Harmondsworth and Baltimore, Md.: Penguin Books, 1965.

L'Orange, H. P., and Nordhagen, P. J. *Mosaics*. London: Methuen, 1966.

MacDonald, W. L. *Early Christian and Byzantine Architecture*. New York: Braziller, 1962.

— *A Selected Bibliography of Architecture in the Age of Justinian*. Charlottesville, Va.: American Association of Architectural Bibliographers, 1960.

Morey, C. R. *Early Christian Art: An Outline of the Evolution of Style and Iconography in Sculpture and Painting from Antiquity to the Eighth Century*. Princeton, N.J.: Princeton University Press; London: Oxford University Press, 1942.

Natanson, J. *Early Christian Ivories*. London: Tiranti; New York: Transatlantic Arts, 1953.

Nördström, C. O. *Ravennastudien*. Stockholm: Almqvist and Wiksell, 1953.

Volbach, W. F. *Early Christian Art*. New York: Abrams, 1962.

— *Elfenbeinarbeiten der Spätantike und des frühen Mittelalters*. 2d ed. Mainz: Verlag des Römischgermanischen Zentralmuseums, 1952.

Wilpert, J. *Roma sotterranea: Le pitture delle catacombe romane*. 2 vols. Rome: Desclée, Lefebvre, 1903.

— *Die römischen Mosaiken und Malereien der kirchlichen Bauten vom IV. bis XIII. Jahrhundert*. 4 vols. Freiburg im Breisgau: Herder, 1924.

Wulff, O. *Altchristliche und byzantinische Kunst*. 2 vols. Berlin: Akademische Verlagsgesellschaft Athenaion, 1914–24.

BYZANTINE ART

Baynes, N., and Moss, H. (eds.). *Byzantium: Introduction to East-Roman Civilization*. London and New York: Oxford University Press, 1948.

Bettini, S. *Mosaici antichi di San Marco a Venezia*. Bergamo: Istituto italiano d'arti grafiche, 1944.

Bihalji-Merin, O. *Fresken und Ikonen: mittelalterliche Kunst in Serbien und Makedonien*. Munich: Reich, 1958.

Budde, L. *Göreme: Höhlenkirchen in Kappadokien*. Düsseldorf: Schwann, 1958.

Demus, O. *Byzantine Art and the West*. New York: New York University Press, 1967.

— *Byzantine Mosaic Decoration*. London: Kegan Paul, Trench, Trubner, 1948.

— *The Mosaics of Norman Sicily*. London: Routledge and Kegan Paul, 1950.

Demus, O. "Die Entstehung des Paläologenstils in der Malerei." *Akten des XI Internationalen Byzantinistenkongresses*, Munich, 1958. Munich: Beck, 1960.

— and Forlati, F. *The Church of San Marco in Venice*. Washington: Dumbarton Oaks Research Library and Collection, 1960.

— Grabar, I., and Lasareff, V. *Early Russian Icons*. Greenwich, Conn.: New York Graphic Society, 1958.

Diehl, C. *Manuel d'art byzantin*. 2 vols. 2d ed. Paris: Picard, 1925–26.

Diez, E., and Demus, O. *Byzantine Mosaics in Greece: Hosios Lucas and Daphni*. Cambridge, Mass.: Harvard University Press, 1931.

Felicetti-Liebenfels, W. *Geschichte der byzantinischen Ikonenmalerei*. Olten: Urs-Graf-Verlag, 1956.

Goldschmidt, A., and Weitzmann, K. *Die byzantinischen Elfenbeinskulpturen des X. bis XIII. Jahrhunderts*. 2 vols. Berlin: Cassirer, 1930–34.

Grabar, A. *Byzantine Painting*. Geneva: Skira, 1953.

— *L'Iconoclasme byzantin: dossier archéologique*. Paris: Collège de France, 1957.

— *Sculptures byzantines de Constantinople (IVe–Xe siècles)*. Paris: Maisonneuve, 1963.

Hamann-MacLean, R., and Hallensleben, H. *Die Monumentalmalerei in Serbien und Makedonien vom 11. bis zum frühen 14. Jahrhundert*. Giessen: Schmitz, 1963.

Hunger, H. *Byzantinische Geisteswelt, von Konstantin dem Grossen bis zum Fall Konstantinopels*. Baden-Baden: Holle, 1958.

Kitzinger, E. "Byzantine Art in the Period between Justinian and Iconoclasm." *Akten des XI. Internationalen Byzantinistenkongresses*, Munich, 1958. Munich: Beck, 1960.

— *The Mosaics of Monreale*. Palermo: Flaccovio, 1960.

Millet, G. *La Peinture du moyen âge en Yougoslavie*. Edited by A. Frowlow. Paris: Boccard, 1954.

Ostrogorsky, G. *History of the Byzantine State*. rev. ed. New Brunswick, N.J.: Rutgers University Press, 1969.

Peirce, H., and Tyler, R. *Byzantine Art*. London: Benn, 1926.

Schneider, A. M. *Die Hagia Sophia zu Konstantinopel*. Berlin: Gebr. Mann, 1939.

Schweinfurth, P. *Die byzantinische Form*. 2d ed. Mainz: Kupferberg, 1954.

Talbot Rice, D. *The Art of Byzantium*. New York: Abrams 1959.

— *Byzantine Art*. rev. ed. Harmondsworth and Baltimore, Md.: Penguin Books, 1968.

Underwood, P. *The Kariye Djami*. 3 vols. New York: Pantheon Books, 1966.

Weitzmann, K. *Die byzantinische Buchmalerei des IX. und X. Jahrhunderts*. Berlin: Gebr. Mann, 1935.

— *The Fresco of Santa Maria di Castelseprio*. Princeton, N.J.: Princeton University Press, 1951.

— *Illustrations in Roll and Codex: A Study of the Origin and Method of Text Illustration*. Princeton, N.J.: Princeton University Press, 1947.

— *The Joshua Roll: A Work of the Macedonian Renaissance*. Princeton, N.J.: Princeton University Press, 1948.

Wetzmann, K., Chatzidakis, M., Miatev, K., and Radojcic, S. *A Treasury of Icons from the Sinai Peninsula, Greece, Bulgaria, and Yugoslavia. Sixth to Seventeenth Centuries*. New York: Abrams, 1968.

Whittemore, T. *The Mosaics of Santa Sophia at Istanbul: Reports*. 4 vols. London and New York: Oxford University Press, 1933–42.

Wulff, O. *Altchristliche und byzantinische Kunst*. 2 vols. Berlin: Akademische Verlagsgesellschaft Athenaion, 1914–24.

REPORTS

The following two publications are devoted to the latest research in the field of Byzantine art and history:

Dumbarton Oaks Papers. Cambridge, Mass.: Harvard University Press.

Acts of the International Congress of Byzantine Studies. Reports delivered to the Congress, which has convened at regular intervals since 1924. Volumes are multilingual and are published in the country that has hosted the conference.

INDEX

Descriptions of the illustrations are listed in italics

188